Watercolor Painting For Dummies®

Circling the Color Wheel

The color wheel shows the primary colors — red, yellow, and blue — and the many colors they can combine to make. The primary colors are the basis for every other color, and you can't create the primaries by mixing other colors.

Use this color wheel to choose color painting schemes, mix color formulas, and make color combinations. Neutralize a color by mixing it with its complement, found opposite it on the color wheel. (*Neutralizing* a color means to make it less bright, more natural toward gray. See Chapter 5 for more on color theory.)

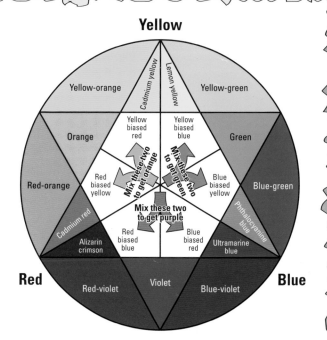

Evaluating Value

A color's *value* measures where it falls on a range between dark and light and is an important aspect of watercolor.

You might want to determine the value of a color to create strong value patterns. However, the color itself can take your attention, making it difficult to determine the value. Here's a handy tool that can help. Use a hole punch to make a hole at each circle in this value chart. Squint through the holes to reduce the color you're looking at to gray and determine its value. Match the color with the same value square by seeing the color in the hole. Move the value squares up and down till the correct value matches the color through the hole.

By knowing the proper value you can mix more accurate colors, design value patterns in your work, and establish exciting focal areas by juxtaposing lightest lights against darkest darks. See Chapter 5 for more on value and how to make the best use of color value in your paintings.

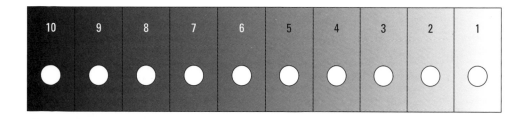

For Dummies: Bestselling Book Series for Beginners

Watercolor Painting For Dummies®

Leaning Toward Color Bias When Choosing Pigments

Each one of the primary colors — red, yellow, and blue — is *biased,* meaning that it leans toward one of the other two primary colors (see Chapter 5 for more on color bias). When mixing the primary colors to get a secondary color — orange, green, or purple — use two primaries biased toward each other. Otherwise, you get a gray, muddy color. For example, to get purple you'd want to be sure to mix a blue biased toward red such as ultramarine blue and a red biased to blue such as alizarin crimson. When mixing colors, keep the following list handy:

- **Reds with a blue bias:** alizarin crimson, carmine, crimson lake, magenta, opera, rhodamine, rose madder, scarlet lake

- **Reds with a yellow bias:** cadmium red, chlorinated para red, chrome orange, English red oxide, fluorescent red, Indian red, light red, permanent red, perylene red, phioxine red, red lake, red lead, sandorin scarlet, Venetian red, vermillion, Winsor red

- **Yellows with a blue bias:** aureolin, azo, cadmium yellow lemon, cadmium yellow pale, Flanders yellow, lemon yellow, permanent yellow light, primary yellow, Winsor yellow, yellow light

- **Yellows with a red bias:** aurora yellow, brilliant yellow, cadmium yellow medium and deep, chrome, gallstone, golden yellow, Indian yellow, Mars yellow, Naples yellow, permanent yellow medium and deep, raw sienna, Sahara, yellow lake, yellow ochre

- **Blues with a red bias:** brilliant, cobalt, cyanine, indigo, mountain blue, ultramarine blue, verditer blue, Victoria blue

- **Blues with a yellow bias:** Antwerp, cerulean, compose, intense blue, manganese, monestial blue, Paris blue, peacock blue, phthalocyanine blue, Prussian, Rembrandt, speedball, touareg, turquoise, Winsor blue

Picking Paint Pigments

This pigment chart shows just a few primary colors available. Take it with you when you buy paints for the first time, and make sure you get at least one primary color from each bias color category so you can make a good six-color palette.

Blue Biased Yellow	Blue Biased Red	Yellow Biased Red	Yellow Biased Blue	Red Biased Yellow	Red Biased Blue
Cerulean Blue	Ultramarine Blue	Cadmium Yellow	Lemon Yellow	Cadmium Red	Alizarin Crimson
Prussian Blue	Colbalt Blue	Gamboge	Aureolin	Light Red	Opera
Phthalocyanine Blue	Cyanine Blue	Chrome Yellow	Flanders Yellow	Red Oxide	Rose Madder

Watercolor Painting

FOR DUMMIES®

Watercolor Painting FOR DUMMIES®

by Colette Pitcher

Wiley Publishing, Inc.

Watercolor Painting For Dummies®

Published by
Wiley Publishing, Inc.
111 River St.
Hoboken, NJ 07030-5774
www.wiley.com

WILEY

About the Author

Colette Pitcher translates her experiences and spirit into art that makes the viewer smile or pause to consider what often is taken for granted. "It is my goal to leave a person or place feeling or looking better after I left than before I came." That goal is communicated through many levels, including art.

Growing up in Colorado, Colette always did art. When it came time to choose a career path, she tried to deviate from art because it was said a person couldn't make a living at art. When the University of Northern Colorado's communications media department was discontinued, she had enough art credits to graduate with a fine art degree a year early.

Her first job out of college was as a graphic designer at an engineering/architecture firm. Her next job was in art in New York City for a Fortune 500 company. She also worked for a well-known children's author and designed video games in New York. While in New York, she lived at West Point and attained an MBA degree from the University of Long Island.

Upon returning to Colorado in 1986, she started the Art Department for companies that didn't have one in-house. "I always was in the art department somewhere, and it just made sense." In the '90s, Colette purchased a 10,000-square-foot building in downtown Greeley, Colorado. Named the Showcase Art Center, LLC, she made a creative space and filled it with other great businesses and art studios. The Showcase encourages all artists to be their best. The Showcase Art Center is a great place to find art and supplies, framing, art-to-wear, piano lessons, art classes, and art studios. The Showcase advertises that people can "Buy art, make art, and be a work of art!"

Colette paints and also sculpts. Colette's husband, Gary, owner of Dragon Casting, a bronze art foundry, is also a creative resource for making the impossible come true daily. Together the couple has installed many monumental bronze public artworks.

Colette has appeared on HGTV's *That's Clever*. Look for *Art For Dummies* kits, which Colette illustrated for Loew-Cornell; there are eight kits in different media. She is a regular columnist for *PaintWorks* magazine, and Colette is a signature member of the Colorado Watercolor Society.

Colette Pitcher
Showcase Art Center, LLC
1335 Eighth Ave.
Greeley, CO 80631
Phone 970-356-8593
E-mail Colette@ColettePitcher.com
Web site www.ColettePitcher.com

Dedication

This book is dedicated to you as an artist. The world is tough on artists. For some reason, people aren't very complimentary or encouraging to those who pursue art as a career. You'll have many days when you'll want to give up. But keep at it. Persistence is the only way to win. One day the rejection slips will turn to acceptance letters. Artists are pitted against each other for every juried show, prize, and competition. We should encourage each other to share unique visions. Then we should appreciate them. If the whole world could learn to communicate through art, there would be no more war. Make a peace of art.

Author's Acknowledgments

I want to thank Wiley Publishing for the opportunity to share my world of watercolor with others in the world. If everyone painted, the world would be a better place. How wonderful if we could all communicate through art using paint and paper. No more war would be allowed either. Countries would express ideas through art and not guns. I think everyone should make this his goal. I still believe in the tooth fairy, too.

A 320-page book was a huge undertaking. I'm usually a quiet person and that was a lot of words to write. My editor Kathleen Dobie constantly coaxed me to write more and elaborate more so that a beginner would feel comfortable with the material. Chrissy Guthrie continued to help where Alissa Schwipps left off. Mike Baker was the catalyst to the project and remained a shepherd through the process. Vicki Adang made sure the final edits were proper. What a team!

Personally, I thank my family for holding my hand through life: my parents, who made me in more ways than one, and my terrific husband, who makes all my dreams come true. My art family: the Greeley Art Association, my wonderful watercolor classes, and my business partners at the Showcase Art Center. All of you tolerated my whines and constant use of the laptop.

Mostly, thank goodness for beginning art students. It takes courage to make art.

Publisher's Acknowledgments

We're proud of this book; please send us your comments through our Dummies online registration form located at www.dummies.com/register/.

Some of the people who helped bring this book to market include the following:

Acquisitions, Editorial, and Media Development

Senior Project Editor: Christina Guthrie

Acquisitions Editor: Mike Baker

Copy Editor: Victoria M. Adang

Editorial Program Coordinator:
Erin Calligan Mooney

Technical Editor: Marilynn Derwenskus

Editorial Manager: Christine Meloy Beck

Editorial Assistants: Joe Niesen, David Lutton,
Leeann Harney

Cover Photos: ©John Wilkes/Getty Images

Cartoons: Rich Tennant (www.the5thwave.com)

Composition Services

Project Coordinator: Kristie Rees

Layout and Graphics: Stacie Brooks, Carl Byers,
Laura Campbell, Alissa D. Ellet, Melissa K. Jester,
Jennifer Mayberry, Erin Zeltner

Proofreaders: Caitie Kelly, Betty Kish

Indexer: Galen Schroeder

Special Help: Clint Lahnen

Publishing and Editorial for Consumer Dummies

Diane Graves Steele, Vice President and Publisher, Consumer Dummies

Joyce Pepple, Acquisitions Director, Consumer Dummies

Kristin A. Cocks, Product Development Director, Consumer Dummies

Michael Spring, Vice President and Publisher, Travel

Kelly Regan, Editorial Director, Travel

Publishing for Technology Dummies

Andy Cummings, Vice President and Publisher, Dummies Technology/General User

Composition Services

Gerry Fahey, Vice President of Production Services

Debbie Stailey, Director of Composition Services

Contents at a Glance

Table of Contents

Introduction

*H*ave you ever looked at a painting and thought, "I could do that"? Or maybe you think, "I wish I could do that." Well, with this book and a little determination, you can turn your wish into a masterpiece.

I have had the benefit of learning from the very best watercolorists in the world. In this book, I share the knowledge they've shared with me. I think each generation of watercolorists improves with time and better materials. The masters have passed the torch, and it's an honor to carry on the gospel of art and keep the watercolor flowing with you.

About This Book

This book is all about painting watercolors. Although you may get an appreciation of the art of painting by reading this book, there's no substitute for doing. You must paint yourself. Yes, you can paint a self-portrait or paint on yourself, but what I mean is, you must paint. It's the only way to appreciate others' work. It can help you see for the first time and always with a new appreciation of what you're looking at.

Nearly every chapter offers at least one step-by-step project that incorporates the theory and the techniques introduced in that chapter. After duplicating my paintings, you can try the projects again with subjects you choose. Although I give you all the instructions to be successful in painting the exercise, you can make your own choices at any point. I give you a paper size, but if you want a different size, just enlarge or reduce the pattern to your preferred size. I tell you what colors I used, but you can use any colors you have.

Most practice opportunities use relatively small paper, almost postcard size. You can keep these assignments together and create a nifty reference book. You can use this book as a workbook, going through the exercises and doing extra paintings on your own. If you do a chapter a month, you'll have a great year of watercolor.

Along with all the painting projects, I also show you how to create interesting effects, compose a good picture, and use color to full advantage, all in an easy-to-access and easy-to-understand format. I don't use art speak. I just tell you in plain English how to plan, compose, design, and paint watercolors. And that's what you were hoping for when you picked up this book, isn't it?

And, in keeping with the *For Dummies* philosophy, this book is organized so that you can dip in wherever the topic interests you and get all the information you need on that subject in one spot. You don't have to read the book from cover to cover, and you don't have to read the chapters in order.

When you're ready to tackle a painting project, I do have one suggestion: Read through the projects from start to finish before you pick up your brush.

This preview gives you a chance to see what supplies you'll need, understand the painting's progression, and know how much time the painting will take. Reading through the steps also gives you the opportunity to look at the pictures that show how your painting should look at different stages. And in the interest of saving the best for last, the last picture in the project shows what the finished painting looks like.

Conventions Used in This Book

When writing this book, I used a few conventions that you should be aware of:

- ✔ *Italicized* text indicates that the word or term is being used for the first time and defined. It also is used in place of quotation marks, as in: The words *pigment* and *paint* are used interchangeably, which, by the way, is another convention.
- ✔ **Bold** text highlights the key word or phrase in a bulleted list and the action steps in a list of numbered steps.
- ✔ The occasional Web or e-mail address appears in `monofont` to help it stand out in the text.

What You're Not to Read

Throughout the book, you'll see sidebars that appear in gray-shaded boxes. This information in the sidebar may be interesting (and I hope it is), and you may want to read it (and I hope you do), but you don't need to read it to understand the topic at hand, so you can skip it if you like (and fortunately, I'll never know if you do). It may be fun to flip through the book and read just the sidebars one day.

Foolish Assumptions

The only assumption I make about you is that you're interested in painting with watercolors. I give you all the very basic information about art in general and watercolors in particular, so you don't need to know a thing about any art-related topic to benefit from this book. If you picked it up, you're already smart enough.

How This Book Is Organized

I arranged this book into four parts that contain chapters with information related to a common theme.

Although the book reads and leads you logically in order from the beginning to the future of your art, you don't have to read it in order. You can skip around to work on parts that interest you. Your mood may be different each time you paint, so you need to choose a painting that fits that mood. Techniques explained in different chapters are cross-referenced, so if you need some technical how-to information, you can turn to that chapter.

You can also use this book as a reference book. You can go to a section and review the contents. In art you get a lot of information up front. You may not be ready for the information until you experience that problem. You may want to read information again after you have painted for a while. You may be painting along when suddenly "That's what she meant!" pops into your head. Then you can go back to read a section or a chapter to cement the concept in your memory. You'll have many "aha" moments in your painting career.

Part I: Getting Your Feet (And Brushes) Wet

If you've never painted, this is the place to start. If you have painted, this section is a good refresher and an explanation of the tools and techniques I use. Every artist has a different setup and approach. In these chapters, I share mine and tell you what techniques and practices have worked well for me.

The basic elements of design are in Chapter 1. In Chapter 2, I cover the materials and products you can get in an art store and give you the information you need to ask intelligent questions and choose your supplies. After you get your supplies, what do you do with them? Well, Chapters 3 and 4 take you by the hand to try out many techniques unique to watercolor. No other medium does as many cool things. Reading these chapters and practicing the projects in them gives you a firm grasp of fundamental watercolor skills.

Part II: Developing a Solid Foundation

This part contains the art school basics that aren't so sexy. Because of this, I sprinkle the foundations of art throughout the book. That way they sneak up on you and before you know it, you know 'em! This is core knowledge that gives you the language to discuss art. As an artist, you benefit from knowing these painting criteria when planning and executing your paintings.

Your watercolor paintings work out better if you do a little planning first. The chapters in this part show you how to mix and use color (Chapter 5), how to break down objects into geometrical shapes that you can then draw (Chapter 8), and how to use balance and variety (Chapter 6 along with the other principles of design) to compose paintings with energy and interest (Chapter 7).

Part III: Painting Projects Aplenty

If you want to capture your cat in watercolor, turn to Chapter 12 on painting animals. If the immovable objects in a still life are more your style, turn to Chapter 9. Landscapes and seascapes are covered in Chapters 10 and 11, respectively, and Chapter 13 offers more painting projects you can copy or adapt for practice.

Part IV: The Part of Tens

After all the other chapters, the chapters in this part are the icing on the cake. Chapter 14 gives you quick suggestions for improving your paintings. At some point you may find that you have a stack of extra paintings and you're willing to part with some. Chapter 15 gives you ideas on selling or marketing your paintings.

Icons Used in This Book

For Dummies books use little images in the margins, called *icons,* to direct your attention to specific text. The icons I use include the following:

The text next to this icon shares a tidbit that helps make your art activity easier. Trust me, I've made every mistake already for you, and I want to save you some energy by not having to make the same unnecessary mistakes.

When you see this icon, get out your paints, brushes, and paper, and either duplicate a small painting project or try a technique.

This icon gives you a heads-up to remember certain information that may be covered elsewhere but is important to keep in mind.

Nothing you can reasonably do in watercolor can hurt you, but you may want to avoid the things this icon points out just to preserve your artistic sensibilities and the beauty of your paintings.

Where to Go from Here

As with any *For Dummies* book, you can start anywhere you like and jump around as you like. But if you're a complete newcomer to art or painting, I suggest you turn to the chapters in Part I. If you want a refresher on how to compose a good painting or how to deal with perspective, the chapters in

Part II can help. And if you want to jump right in and get your paints wet, turn to any of the chapters in Part III for painting projects of all descriptions.

You're about to set sail on a journey that can last a lifetime. Watercolor can take you anywhere, build you anything, elevate your spirit, and calm your soul. Watercolor provides a way to communicate when you can't find the words. It's a companion whenever you require one. Watercolor will take you wherever you let it lead you, so welcome aboard!

And remember: You learn and discover most by doing. The best advice I can give you is to paint, paint, paint!

Part I
Getting Your Feet (And Brushes) Wet

The 5th Wave — By Rich Tennant

"I love the haphazard blotches, random patterns, and unexpected results of using watercolors. It's all the stuff I got with my computer but didn't want."

In this part . . .

The wonderful world of watercolor welcomes you! These first chapters are all about the basics. I share the basic art elements and the basic watercolor painting tools, along with a large variety of basic and more-than-basic techniques.

These four chapters offer design tips, help you set up your workspace, and start you painting, so jump right in!

Chapter 1

Watercolor Is Wonderful!

. .

In This Chapter

▶ Grasping the basics of watercolor

▶ Separating the myths and truths about watercolor

▶ Examining the basic art elements

▶ Dropping into your first project

. .

All paint begins with pigments. To do watercolor painting, you take those pigments, add water, and use a brush to apply the paint to paper. It's as simple as that.

And, painting is a good thing. Your blood pressure goes down, your brain is stimulated, your mind is active, and your body is challenged. It's up to you to express your artistic calling. When you do so, you benefit in big ways.

Two of the most important things to keep in mind as you become a watercolorist are to breathe and to have fun. Breathe? Yes, when you concentrate so hard and focus like you will while painting, you hold your breath. Breathe! And have fun. Art tends to be stuffy, pretentious, and cerebral. Forget the art snobs for now. Have fun by enjoying the colors, how they interact, and the results they yield. Because art is fun. Keep in mind that it's only paper, and you have to mess up some paper to make art.

In this chapter, you discover the interactive nature of watercolor, start to understand its attributes, get a quick overview of art design, get some ideas of what to paint, and then put some paint to work in a quick project.

Appreciating Watercolor

Watercolor has a life of its own. When you apply paint to watercolor paper, it moves. You then add more paint or more water, and again the watercolor responds with a swirl. Painting with watercolor is a dance; it's a relationship between the paint and the artist.

When you paint watercolor on paper, you can make anything in the world happen. Figure 1-1 is one of the latest paintings I've made. To be fair, I probably should show you one of the first paintings I ever made, but I'll spare you the meager beginnings. It was probably a finger painting on the wall. But trust

me, however bad you think you are starting out, I was probably worse. But I wanted to paint so badly that I kept at it. I have done watercolor as long as I can remember. I still struggle to make a great painting. But it's an enjoyable struggle.

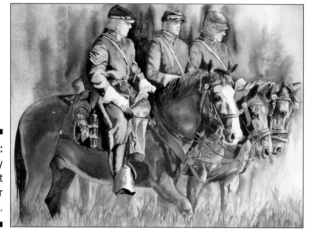

Figure 1-1:
One of my recent watercolor paintings.

Transparent watercolor is what I want to share with you. In my opinion, it's watercolor at its best. Thin, transparent layers of paint are applied to white cotton rag paper. The see-through layers allow light to penetrate the paint, bounce off the white of the paper, and reflect back through the paint to the viewer. The result is a watercolor painting that glows and sparkles.

Opaque watercolor is called *gouache,* pronounced *gwahsh.* Chinese white is added to watercolor to make the *opaque* (not see-through) gouache paint. Acrylic paint is also an opaque, water-soluble medium. All of these can be used together. The big difference is that watercolor and gouache can be rehydrated and moved after they dry. Acrylic is like plastic and doesn't rehydrate. When it's dry, it stays in place on the palette or painting, and it can be painted over in layers. I'll save these mediums for another book.

What aspects attract an artist to watercolor painting? What myths make an artist fear watercolor? There are many old wives' tales and misinformation about the medium, but watercolor is

> ✔ **Permanent:** Watercolor is a permanent medium. But because it's a work on paper, it may seem less substantial than a work on canvas. But good quality watercolor paper is made from 100 percent cotton rag content, which has been found intact in Egyptian tombs thousands of years old.
>
> Watercolor also had a reputation for not being lightfast. And, though it's true that the old masters' watercolors are often stored in museum drawers between black sheets of archival paper so they're not exposed to light, the good news is that today's technology and chemistry ensures that paint pigments are more lightfast than ever. Today's watercolors will last a very long time.

- **Portable:** Watercolor is a portable medium. Paper, paint, a brush, and some water are all you need to get to work. They fit easily into a bag, and you can take them wherever you want to paint. So whether you travel around the world or just to class, you can take your supplies with you.

- **Correctable:** Watercolor is a changeable medium. An artistic myth is that once watercolor is put down on paper it can't be removed or erased. Well, that just isn't true. You can manipulate the medium completely. You can erase. You can make additions and corrections in layers of paint on top of other paint. Chapter 3 talks about erasing.

- **Immediate:** Watercolor dries quickly — in a matter of minutes. Oil paint can take up to six months to dry completely. We live in a culture that appreciates immediacy. Watercolor fulfills that need.

- **Fluid:** Some folks are scared of watercolor because it's difficult to control. Watercolor moves. It ebbs and flows like water does. That very aspect is its charm. It reacts to you. It paints itself if you discover how to give it some room to work.

- **Varied:** Watercolor is technique intensive. There are *lots* of techniques. That's part of watercolor's charm too. (Chapters 3 and 4 explore techniques.)

Watercolor is full of surprises. It's a great experimental medium. Although I spend a lot of time painting realistic scenes, it can be great fun for abstract and experimental painting as well.

Digging into the Elements of Art

Some art basics help get the party started. These basics are called the *elements of design.* You use these pieces to design your paintings. This section is like Art 101 — you can use the information here for all types of art in any medium.

I tell you what to do with these elements of design in Chapter 6, which presents the *principles of design* — the verbs you use to act on the elements of design, which are the nouns of painting.

The basic elements of design that I explore in the following sections and throughout this book are

- **Shape:** A circle, square, or triangle, for example, or any other organic form (blobs and other curvilinear shapes)

- **Line:** A continuous path between two points

- **Size:** The quality of being large or small or somewhere in between

- **Direction:** The overall physical arrangement of the objects within a painting — either vertical, horizontal, or diagonal

- **Texture:** The real or implied tactile quality

One more element of design is color, which is so much fun that I use all of Chapter 5 to talk about it.

Seeing in shapes

You were taught to recognize geometric shapes as a child, so you have a head start on working with this element of design. But I have a few tricks up my sleeve that you can use:

- ✔ **See everyday objects as simplified shapes.** Developing this vision lets you draw more quickly and accurately. (Chapter 8 helps with your drawing skills.)

 For example, a house is a cube with a pyramid on top with a cylinder for a chimney. And even though a rose looks really complicated, you can simplify it into a circle or oval first. A complex garden may begin by breaking down the shapes into many ovals first.

- ✔ **Make shapes more interesting by varying their sides and edges.** Squares, triangles, and circles are equal-sided shapes and are less interesting in a painting than unequal-sided shapes (see Figure 1-2). Try to create shapes that are more intriguing to look at by varying the sides and edges of the shapes.

 You've heard that variety is the spice of life. In art, variety is the essence of interesting design. Chapter 6 covers this concept in more detail.

- ✔ **Group elements in your painting to create a shape.** Some shapes are implied. Take a look at the tree on the right in Figure 1-2. It forms an overall triangle. This tree is more interesting to the viewer because the triangle isn't equilateral — the three legs are different lengths.

Figure 1-2:
Even versus uneven-sided shapes.

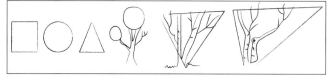

Judging size

Size is just what you expect: big versus little. And yes, in art, size matters. Objects using the elements of line and shape can be different sizes, as can areas of texture.

You can direct the viewer to see what you think is most important by making it larger or *dominant.* (More discussion on dominance in Chapter 6.) One flower bigger than all the others captures the viewer's attention and creates more interest in your painting than having all the flowers equal in size. An example is Figure 1-3. The big flower is the star of the show, and the other flowers are the supporting cast.

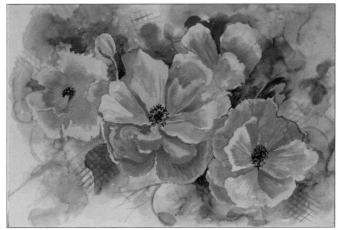

Figure 1-3:
The bigger flower gives the viewer a focal point by using variety in size.

You can influence the viewer with size. For example, Georgia O'Keefe forced viewers to really look at a flower by taking what is normally small and making it huge. Her paintings have a grand impact because of their large scale. Conversely, small paintings can bring your viewer in and create an intimate relationship.

Variety of size is nice. After all, if all the flowers in a painting were the same size, you'd have wallpaper. A nice design for wallpaper, sure, but probably not an exciting painting. (Chapter 7 talks about composition and making more creative painting designs.)

You can also make something small the attention grabber. Check out Figure 1-4 — a Western painting featuring a lone cowboy on a horse in the rain. Everything is dismal gray to make you feel the weather and the cold the cowboy is experiencing. But he's wearing a bright yellow slicker that immediately grabs the viewer's attention, not because the rainwear is so big in the painting, but because it's a small change of color in a big area that is all the same.

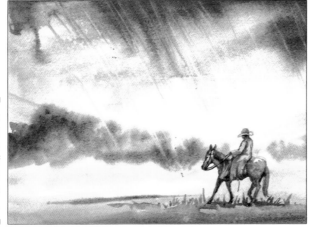

Figure 1-4:
A small size can take up a lot of space in a viewer's eye.

Size is also important to establish *aerial perspective.* Bigger objects appear to be closer, and smaller objects seem to recede into space. (I discuss perspective in Chapter 8.)

Looking to lines

There really aren't many lines in nature. Look closer at edges in real life. Is there a line? Usually there is some type of difference, but generally not a line — often just a change in color or value.

Artists use an artificial line to define edges and contain a shape, which is very useful. Lines help you define an area and create detail in items like hair, grass, the veins on a leaf, and a ton of other things.

Line and shape can be real, as in an outline to indicate where to paint, or implied, as in items in a line of sight. You can also have viewers connect the dots in an implied line. If you make a line of geese in the sky, it really isn't a line, but the eye will see it as a line if the geese are in a row. So the geese become an implied line.

Figure 1-5 shows the three different types of lines:

- **Curved lines:** Arcs, circles, and curvilinear lines form soft edges, round shapes, clouds, figures, and most natural shapes.

- **Straight lines:** Horizontal lines symbolize calm, while vertical lines create upward movement. It's nice to counterbalance one with a bit of the other.

- **Angular lines**: Diagonals and zigzags create a feeling of uneasiness, excitement, and action.

Figure 1-5:
Curvilinear
lines are
round;
straight
lines can be
vertical and
horizontal;
angular
lines lay
diagonally.

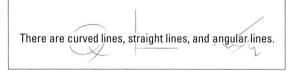

There are curved lines, straight lines, and angular lines.

In fine art, variety is the rule. Even shapes are not as interesting as uneven shapes. Odd numbers are more interesting than even numbers.

Deciding direction

Direction can refer to a line or the thrust of an entire picture. Direction can be horizontal, diagonal, or vertical, and each type of direction performs a different function.

You arrange the various parts of a painting and the objects in it to create direction within the painting. (Find more on organizational formats in Chapter 7.)

- ✓ **Horizontal:** A horizontal format and thrust implies calm and peacefulness.
- ✓ **Vertical:** A vertical format implies dignity.
- ✓ **Diagonal:** A diagonal thrust creates movement.

The diagonal thrust to the bull gives the cowboy in Figure 1-6 extra movement and excitement.

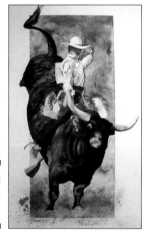

Figure 1-6:
Ride 'em
diagonally!

Adding texture

Texture is a feeling of tactile sensation. You can add things to your paint or things to your picture to create texture. You may want to add real texture by sewing on beads, gluing on trinkets, or employing some other idea. Paint additives give the paint enough body to be thick enough to have texture.

Implied or *faux* (French for *fake,* pronounced *f-oh*) texture is the illusion of texture. For example, by painting rough texture and adding little lines of detail, you make tree bark seem real. If you run your finger over the paper, it isn't rough like tree bark, but simply an illusion. Rough texture is described in Chapter 3.

Traditional watercolor hasn't made much use of real texture. Today, anything goes. Creativity is the name of the game. You can explore texture and invent looks that work for you. You're not limited to the way things have always been done. Just don't overdo it. Like all good things, too much can be chaos (unless you agree with Mae West, who said, "Too much of a good thing is marvelous!").

Deciding What to Paint

You may think you have to wait for inspiration to find you. A true artist can find inspiration in an empty box. It sure doesn't fall from the sky. By painting every day, whether you feel like it or not, you develop inspiration as well as skill. You may have an aptitude for art, but you need to develop it, practice it, and nurture it. If you want to be an artist, you must work for it. The good news? The work is pleasure. You'll experience frustration and produce paintings that embarrass instead of impress. Make more until they work for you. Make a hundred paintings before you judge yourself.

A large part of this book is devoted to subjects to paint. Still lifes, landscapes, seascapes, and animals are just a few of the topics I cover (check out Chapters 9, 10, 11, and 12). After you try the subjects I chose, look around you and see if you can find similar topics to paint, or apply the techniques to your own choice of subject matter.

As you start painting, you begin seeing in a new way. You look at light, shadows, lines, and angles with a painter's eye, and you pick up inspiration for new paintings in the everyday world around you and in the rich arena of your imagination.

Some good advice was given to me years ago: "Paint what you know." So it's also good advice to research and explore your areas of interest because they become sources of painting material. My husband and I are fascinated by muscle cars. I paint the ones I can't afford to own. Figure 1-7 is an unusual view of a Shelby Cobra with reflections of the American flag in the vehicle's paint.

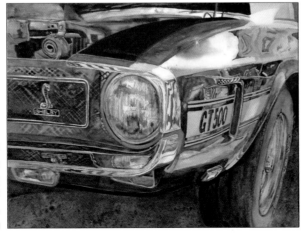

Figure 1-7:
Painting
what I know
I want.

Following Your Artistic Instincts

In the project steps throughout this book, I tell you what to paint, what size to make your painting, and what colors and techniques to use. You can completely ignore what I tell you (who listens to me anyway?) and pick your own size, colors, and techniques.

I give you suggestions to help you create a successful finished piece like the one I painted. You can use your own creativity to pick and choose something you would rather see happen. This is art, and really there are no rules to art.

That being said, I hand you a bunch of rules throughout the pages of this book. Enjoy the rules. Savor them. Analyze them. Get to know them. Then when you're comfortable with them, you can break any rules you want because you can justify why the rules don't apply to you.

Many rules are just words and concepts that artists (that includes you) use to discuss art using the same language. *Art speak* is the eloquent usage of these concepts. The better you become at art speak, the bigger grants you will get and the better you can justify the higher price tags on your masterpieces.

Project: Creating a Garden of Blooms

In a garden, a bloom is a lovely flower. In watercolor, a *bloom* can be a fun technique that happens when you drip wet paint into paint that's drier.

You may be thinking, "I'm not ready to paint anything yet!" but if you have some paint and a brush, you're ready for this fun little project. You simply can't make a mistake in creating this garden of blooms. I tell you how to set up your palette in Chapter 2, so for now just put a few colors out that you can play with. You choose what colors your garden will be. Think fun and abstract, and enjoy how the paint reacts to other paints and to water.

1. **Get a piece of watercolor paper about 5 x 7 inches.**

2. **Cover the paper with clean water using a 1-inch flat brush.**

3. **Pick up the paper and let the water drip off into your water container.**

 The paper should be shiny damp everywhere without puddles.

4. **Choose one color and cover the whole paper with that color.**

 Mix enough water with the paint so the color is transparent. No thick paint needed. Use your ½-inch flat brush so you can work quickly before the paint dries.

5. **Before Step 4 dries, drop water and other colors into the paint one drop at a time.**

 Drop clear water into the paint and watch it make a bloom. You can continue to drop colors or water until the paint and paper dry.

6. **Let the paint dry completely.**

 7. **Sign your name at the bottom.**

 Signatures should be small in the corner, usually the lower right one. Make it legible if you want anyone to know who created the work. If the brush is too difficult to sign your name with, use a permanent pen or pencil that will show up.

 My garden of blooms is shown in Figure 1-8.

 8. **Mount your painting on a card and send it to someone to brighten their day.**

Figure 1-8:
Some water, some paint — a watercolor!

Chapter 2

Preparing to Paint

*B*efore you can put brush and paint to paper, you have to get ready to paint. You have to gather some materials to work with, carve out some time to work, and find a place to do it. Then you can begin the journey of a lifetime. And if you're uncertain about how to start your watercolor hobby, this book is an excellent guide. You can work through it alone or with a friend.

This chapter explains what you need to know to shop for supplies and then how to set them up to prepare to paint.

Shopping for Art Supplies

Give a child a piece of watercolor paper, a set of paints, and a brush, and they're happy. I'm usually quite happy with that combination, too. And basically, that's all you need to start painting. But when you get to the store, choosing which items to buy gets a bit more complicated. The hundreds of choices of paper, paints, and brushes can make your head spin.

The good news is that you can start out as basic or as complicated as you want. In this section, I give you a deeper understanding of these essentials so you can make informed decisions about art supplies and pick out exactly what you want.

Most beginners buy inexpensive supplies thinking that, after all, the painting won't turn out because they're an amateur. The fact is that cheap supplies can actually be so frustrating to use and of such poor quality that what you think is ineptness on your part is actually inferior art materials. One easy way to improve your painting is to purchase better supplies. So my advice is to buy the best quality supplies you can afford and upgrade your supplies as

you can afford to do so. Reward yourself with a quality art supply every so often. You'll see the reward return in your painting.

Art suppliers are always coming out with new products, and they're usually great. So don't be afraid to try someone else's great idea. Go to the art supply store frequently for inspiration. Maybe you'll see a new tool that sparks your creative juices.

Brushing up on your paintbrush choices

Brushes apply paint, so they're a pretty important part of your paint box. And they're a pretty simple tool — some hair glued or held by a metal *ferrule* clamped to a handle.

Splitting hairs: Natural, synthetic, and more

The hairs on a brush can be either natural or synthetic and soft or stiff. The following list gives you the lowdown on hair styles:

- **Natural hair:** Brushes with natural hair are more costly because the hair comes from the fur of varmint-like creatures. *Sable* is the most popular natural hair, with kolinsky sable being the most valuable. These hairs have memory, snap, and spring, meaning they quickly go back into their original shape after you mess with them or paint with them. A squirrel or camel hair brush gets mooshed into a shape and stays in the mooshed shape until you rinse it. Mooshed has its purpose, like mopping out a cloud in a sky, but most watercolorists like a brush that springs back into shape — pointed and ready for action.

- **Synthetic hair:** These manmade hairs are excellent today, and it's often difficult to tell the difference between synthetic and natural brushes. You can buy excellent synthetic brushes that cost one-tenth of what a sable brush costs. If you accidentally ruin the tip of a synthetic brush by scrubbing, you won't pay a lot to replace it.

- **Boar hair:** Stiff-haired brushes are called *bristle brushes,* and they're made from boar hairs. Stiff brushes are good for *scrubbing* (a form of erasing); the softer bristles can't take the abuse.

I recommend starting your collection with some nice synthetic brushes. If you can afford a sable brush, get one; you'll definitely need it as you get more advanced in your painting. As with most things, the difference between beginners and professionals (who are just artists who have sold one painting) is the price of their toys. Enjoy playing.

Handles

Handles are usually wood, although they can be plastic or something else, and are either long or short. Typically watercolorists work closer to their paintings, so they prefer short handles, 9 to 10 inches long. If you want to put more distance between yourself and your work, use a long-handled brush that's 13 to 14 inches long so you can stand back.

Brush shapes and sizes

Brushes come in two shapes: *flat* (like a fan) and *round* (like a crayon). If the shape isn't obvious from the way the hairs lay, just look at the shape of the metal ferrule that holds the hairs to the handle; it will be flat or round. All brush shapes come in different hair choices. You can get soft hairs or stiff bristles in most shapes, just as you can get expensive or cheap brushes in most shapes.

Brushes are sized using a number system in which the bigger the number, the bigger the brush. Tiny brushes are number zero (0), but they can be smaller yet and have more zeros. The more zeros, the smaller the brush. Triple zero (000) is commonly the smallest. The width of a flat brush sometimes is measured in inches rather than numbers.

I find lots of discrepancies in brushes and sizes. I have two brushes of the same brand and size, but even they aren't exactly the same. Many brushes are handmade and vary a little. You can buy a brush and love it. When you replace it with the same brand and size, you may not like it as much. Use the number only as a comparison point. The numbers vary between companies, countries, and even shipments of the same brand.

Figure 2-1 shows the variety of classic brush shapes and sizes. You can experiment with decorative brushes as well, but this basic assortment is all you need to get you started.

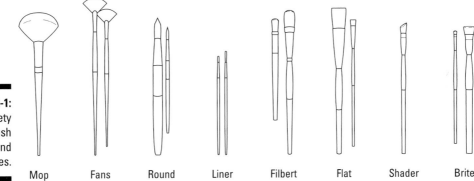

Figure 2-1: The variety of brush shapes and sizes.

Mop Fans Round Liner Filbert Flat Shader Brite

When you're just starting out, the must-have brushes are:

- **#10 round:** The round brush is a workhorse. With its tiny point, you can get details. When you push down or use it on its side, you get a wide stroke. You could spend your whole painting career using a #10 round brush. But the others are so fun that you'll want to have dozens of extras (or maybe that's just me).

- **#000 liner:** A liner is essentially the same as a round brush, but with longer hairs. The extra-long hairs make it great for painting long, thin, straight lines. These brushes are also called *scripts* and *riggors*.

- **Half-inch flat brush:** A flat brush helps you paint rectangles and architecture. A larger flat brush makes a nice big-area background brush. Remember, some flat brushes are sized by numbers; others are measured by their width.

If you're a more ambitious beginner or when you're more experienced, you can try using these brushes:

- **Mop:** As its name implies, this brush is great for mopping in big sky backgrounds, lifting clouds, and making trees.
- **Fan:** These fans won't applaud when you walk in the room. You use them to paint bushes and grasses.
- **Filbert:** This flat brush has curved corners and is good for painting trees and clouds.
- **Shader:** This angular brush is useful for making wide strokes, or you can use just the point on its tip for small areas.
- **Brite:** The short hairs make this a good brush for scrubbing and lifting off color.

Expand your brush collection as you continue to paint. After you've been painting a while, you'll know what you're lacking and can see what newfangled inventions may give you a creative boost.

Picking out your paper

Let me be direct for a moment: You do *not* want to skimp on paper quality. Cheap paper can't take the abuse required of watercolor. Good watercolor paper is made of 100 percent cotton rag, acid-free content. (Acid-free is important because it ensures your paper won't turn yellow.) It lasts a very long time — it's been found in Egyptian tombs in good condition!

A ratty edge, called a *deckle,* is a sign of high-quality, handmade paper. Straight, even edges indicate machine-made paper. Handmade papers are really nice, but you can also find some nice machine-made papers. I use both. Just go with whatever you prefer or can afford.

Watercolor paper is typically white, whether that's bright white or natural white. White provides the most reflected light though transparent color. You can get colored paper in tan, blue, gray, and pink that makes for an interesting background color.

In the following sections, I clue you in on the basics of watercolor paper, such as size, weight, and texture, and provide advice for what you need to get started and to complete the projects in this book.

Selecting sheets, blocks, or pads

Individual sheets are a popular way to buy watercolor paper. Sheets of paper come in different sizes:

- Full sheet is 22 x 30 inches.
- Elephant is 29 x 41 inches.
- Double elephant is 40 x 60 inches.

Dropping acid

Paper is made from fiber suspended in a slurry. Acid comes from wood fiber and is called *lignon*. Lignon causes paper to yellow and get brittle with age. Acid-free paper is lignon-free.

Remember the newspaper you left in the driveway for a week? It probably turned yellow because newsprint is highly acidic. So don't store your watercolors or your watercolor paper near newspaper or even the brown paper that watercolor paper sometimes comes wrapped in.

In addition to sheets, you can purchase paper in convenient pads and blocks:

- A **pad** is several sheets bound with a wire spiral or glue at one end. You can paint while the paper is still attached to the pad, or you can tear off one sheet at a time to use. The edge usually tears out pretty neatly. Paper in wire-bound pads usually has a perforated edge, so the tear-out is clean. You can use scissors to cut the paper to the size you need, though I usually tear the paper as described in the "Dividing your paper for smaller paintings" section later in the chapter. If you end up framing the painting, a mat usually covers the edges, so how they look doesn't matter that much.

- A **block** contains a number of sheets and is glued on all four sides. You paint on the top sheet and remove it with something dull (a plastic knife or credit card works great) when you're finished to reveal the next clean sheet.

You can also buy rolls of paper, which are usually 44 to 56 inches wide by 10 yards long, if you want to paint a mural.

Getting to the weight of the matter

The manufacturer weighs a *ream* of 500 sheets of paper in its uncut state and gives it a number to indicate the paper's weight. *Weight* indicates the quality (and usually the price) of the paper. Typical weights for watercolor paper are:

- **90-pound paper** is a student grade and is rather thin. It buckles when wet and can't endure much scrubbing for changes.

- **140-pound paper** is probably the most popular choice. It's fairly stout, can be stretched to avoid buckling when wet, dries quickly, and is medium price. (See the upcoming "Stretching before you paint" section for info on stretching.)

- **300-pound paper** is like a board. It doesn't require stretching, costs double what 140-pound paper costs, and takes longer to dry.

You can judge the other weights available in comparison with these weights.

Each paper weight has its advantages, and which weight you choose depends on what you want to accomplish. For the projects in this book, I recommend 140-pound cold-press, 100 percent cotton rag acid-free paper in any brand.

In addition to the various weights of paper, you can use *watercolor board,* which is paper adhered to illustration board. It doesn't buckle when wet and is available in 20-x-30-inch pieces or by the case.

Touching on texture

Texture describes the surface finish on paper. The type of paper you choose gives you different effects with the paint. You may want a smooth paper for lots of detail or a textured surface to make sparkling reflections on water. You can choose from three main surface textures:

- ✔ **Hot press:** This texture is even and smooth, and makes a nice surface for prints and drawings. The paper has a slicker finish that you can use to create some interesting results. It's more difficult to make soft transitions when using this paper, so you may have more hard edges than you want. I explain more about hard and soft edges in Chapter 3.

- ✔ **Cold press:** This slightly bumpy texture is the most popular texture for watercolorists. The texture allows paint to settle into the texture pockets or sit on top and skip over the pockets, creating some different technique options. I go into some of these techniques in Chapters 3 and 4.

- ✔ **Rough:** Rough texture has an even bumpier surface than cold press. This surface is good for exaggerated rough texture techniques, which I illustrate in Chapter 3.

Don't forget the paint (er, coloring pigment)

Paint is made up of a couple of elements. *Pigment* is either chemical or natural coloring that has been ground to a fine powder. The powder is added to a *binder* that makes it sticky and allows it to be used as paint. The binder for oil paint is oil. The binder for milk paint is milk. Now, what's the binder for watercolor? That's right, it's gum arabic! Okay, it was a trick question.

Gum arabic is a water-soluble, sticky, clear goo that when added to pigment makes watercolor. Powdered pigment can't be used without a binder, which is already in the paint when you buy it. Most watercolorists just use plain water to dilute their paints and for cleanup, but you can purchase a little jar of gum arabic and use it to thin your paint if you want. It makes the paint shiny and makes it flow nicely.

The words *pigment* and *paint* are used interchangeably in this chapter and, indeed, throughout this book.

Grading pigments

You can purchase pigment in two grades:

- ✔ **Student-grade** paint has less pigment and more filler and is easily identified by its lower cost. You can still produce a nice painting using it, so I recommend starting with this grade if you're on a budget.

One disadvantage of cheaper paint is its lack of *lightfastness,* meaning the color can fade.

✔ **Professional-grade** paint costs about twice that of student-grade because it has a higher quality of pigment, finer grinding, and less filler.

Does the grade make a difference in the painting? Yes, so upgrade to professional paint when you're ready. How can you tell the difference between student-grade and professional-grade paint? Price. A tube of student-grade paint ranges in price from $1 to $5 per tube. Professional-grade paint ranges from $9 to $30 per tube.

Higher grades of paint are usually more permanent or lightfast. *Permanent,* as applied to pigment, means that the color won't fade in light. *Fugitive* means that light will cause the color to fade (sometimes completely). Some pigments rate very high in lightfastness. For example, earth colors in the brown family, like yellow ochre and burnt sienna, get the highest rating for lightfastness, even in a student-grade pigment. Bright colors, reds, and purples tend to be more fugitive.

Check for a star rating on your paint labels. More stars (the highest is four stars) means the pigment is more permanent.

Knowing how paint is packaged

Watercolor paints come in two types of packaging:

✔ **Tubes:** Tubes prevent the moist watercolor paint from drying out while it's stored. The paint is soft and easy on brushes. Some artists prefer the rich soft color straight out of the tube. Tubes come in 5-milliliter and 14-milliliter sizes. Some brands even make a larger tube.

If you have a tube that dries out and gets hard, don't throw it away. Cut open the tube and use it like a pan of paint. You can rehydrate it with water.

✔ **Pans:** Pans are prefilled containers of paint. Sometimes called *cakes,* these are dry or semi-moist. Children's watercolors are usually pans. You can also buy pans of student- and professional-grade paints. Pans are sold in sets and individually. If you run out of room on your palette, glue a pan in for more colors. Pans come in whole and half sizes depending on the manufacturer.

I like the travel sets with pan paints for painting on location, but I usually use tubes with softer paint in the studio. The soft paint from tubes yields rich, intense color without having to grind the tip of your brush into the paint.

To start out, I recommend a nice set of watercolors that you can afford. Try both tubes and pans because you may prefer one.

Checking your paint's character

Different pigments have some built-in characteristics. By understanding and anticipating what they do, you can get some interesting effects. You may find an effect happening when you paint and you don't know why. You can choose

pigments that either have the characteristic or don't, depending on what you want to happen. All watercolors have at least one of these characteristics:

- ✔ **Sedimentary pigment:** Some pigment chemicals weigh more than others. Heavy pigment sinks into the pockets of rough paper and makes a granular texture when dry. It's an interesting look only achieved in watercolor. Some sedimentary pigments include ultramarine blue and Payne's gray. If you don't want a sedimentary texture, use a smooth paper or avoid sedimentary pigments.

- ✔ **Staining pigment:** Some pigments leave color behind even when they're washed off the paper (I discuss this technique in Chapter 3). A faint stain of color is a tell-tale sign of a staining pigment. Reds, violets, and phthalocyanine blue and green are very staining. Staining pigments are rich and make deep darks.

- ✔ **Transparent versus opaque pigment:** Watercolor is usually painted *transparent,* meaning that light actually penetrates the paint, reflects off the white paper, and bounces back into the eye. The effect is glowing, fresh, sparkling watercolor. Any pigment is transparent if you add enough water.

 Opaque pigments are ones you can't see through. Some pigments are more opaque than others. Cadmiums are opaque; however, if you add enough water, they can be transparent. Opaque paints can cover other paint. Opaque colors tend to get muddy quickly, so use them with caution. You can control where light bounces back by using more or less opaque pigments.

Purchasing paint

Each *primary color* (red, blue, and yellow) has two *biases* (or leanings) — that is, an underlying tone of one of the other primary colors. So red can be biased blue or yellow, for example. Chapter 5 covers colors and bias in more detail.

To start painting, you need two tubes or pans of each of the primary colors, one tube or pan in each bias. Armed with these six colors, you can paint the world. A bare-bones paint set would include cadmium red, alizarin crimson, ultramarine blue, phthalocyanine blue, lemon yellow, and gamboge. You may find a kit that contains everything.

You can purchase plenty of luxury colors too. Tubes or pans of these free up your time from having to mix them. My favorite luxury colors are burnt sienna, hookers green, and burnt umber.

Gathering up the extras

After you have the basics of brush, paint, and paper, you still need a few extras to make painting more than a possibility. The good news is that you can find most of these extra supplies around the house.

- ✔ **Water container:** You need water to rinse your brush, so you need a container to hold water. Your container doesn't have to be fancy. It can be as simple as a plastic cup, as long as it's stable enough not to tip over. You can go the fancy route and buy a container with ridges in the

bottom to give you something to rub your brush over to loosen sticky paint, although watercolor paint is pretty gentle and rinses completely and easily. Divided containers let you have a dirty-water rinse well and a clean-water rinse well. Some containers have a rim with holes where you can stand brushes upright for easy access.

✔ **Palette:** A *palette* is a white container to put paints on. You need a white palette because white is the best color to gauge colors against. (When you think of a palette, you may imagine a kidney-shaped wooden board hand-held by an artist wearing a beret. That's an oil painter's palette. Oil paints are thick and don't run. Watercolor is liquid so you need a deeper palette.)

A very simple watercolor palette is a disposable foam plate, but you can choose from many styles if you want to purchase one — round and square shapes are the most popular. Figure 2-2 shows a variety of palettes.

Most palettes have a mixing area and wells around the perimeter to hold paints. The number of wells varies, so decide whether you want many wells to hold lots of different colors or fewer but larger wells to hold more paint and accommodate bigger brushes. Some palettes have lids to prevent paint from spilling, which is especially nice if you plan to take your supplies to classes.

I tell you how to set up your palette in the aptly named section "Setting Up Your Palette for the First Time" a little later in the chapter.

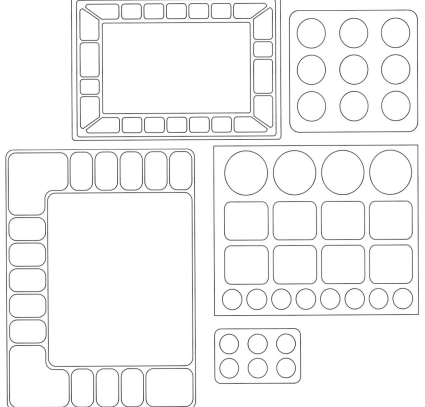

Figure 2-2:
A pile of palette of choices.

✔ **Sponge:** I talk about a variety of sponges you can use to create special effects in Chapter 4, but your basic, everyday cellulose sponge in any size or color is a must-have to help you control water as you paint. Dampen the sponge, wring it out, and place it beside your water container. You rinse your brushes in the water container and touch the brush against the sponge to get rid of any excess water. This prevents getting too much water on your painting. When you finish painting for the day, place the damp sponge in your lidded palette to keep the paints moist for the next day.

✔ **A box of tissues or a roll of paper towels:** Tissues are handy as blotters when you have too much water on the painting. Paper towels or old cloth towels work well too. Having a tissue at the ready in your nondominant hand is a good plan. You can control water in your brush or dab at a puddle in your painting.

✔ **Spray bottle:** You need to have some type of spray bottle handy so you can wet down paint on your palette when it dries out and wet down your paper as needed. My favorite spray bottle is an old pump-action window cleaner bottle. Unfortunately, this type of bottle may be difficult to find. A trigger sprayer is a handy tool. It can be fun to collect different spray patterns for different splatters in the paint.

✔ **Miscellaneous goodies to collect:** Here are more items I use in different projects in this book: a stapler and staples, masking fluid, bar or liquid soap, a blow-dryer, old toothbrush, brush holder for storage, pencil, graphite paper, a red ballpoint pen, credit card or plastic knife for scraping, razor blade, sketchbook for thumbnail sketches, tracing paper, and a kneaded eraser. Optional supplies include gum arabic, a board to stretch paper on (½-inch Gatorfoam), and gloves for handling paper. You don't need all of these supplies at once. Acquire them as needed.

Setting Up Your Palette for the First Time

Setting up your palette is something it pays to do right the first time so you can put the same color in the same well again and again without having to think about it. This section offers tips on making your palette artist-friendly.

If you have a new plastic palette, take a minute to scrub it gently with a scouring pad and a little scouring compound. This removes the shiny surface and prevents the paint and water from beading up when you try to mix them.

Most palettes have *wells* around the outside edge to hold pure pigments and a *mixing area* in the center. You use the mixing area to add water to paint to make it flow better or to mix paint colors to create a new color.

To set up your palette, follow these steps:

1. **Get out all the tubes of paint you want to put on your palette.**

2. **Imagine your palette as a color wheel, as shown in Figure 2-3, and set each tube next to the well that it may occupy.**

 If your palette is square, start on one side and arrange the colors by ROYGBV (red, orange, yellow, green, blue, and violet). If you want, you can include your browns between the reds and oranges because browns are a form of orange and red.

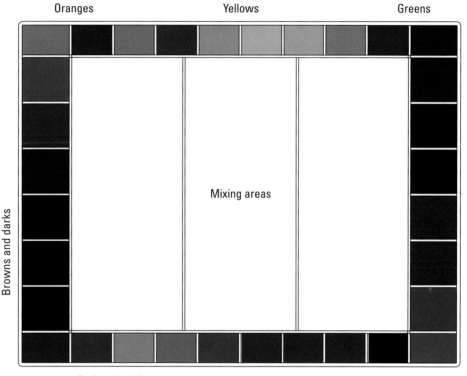

Figure 2-3:
The palette
as color
wheel.

By setting all the tubes out before you fill the wells, it's easy to change your mind, and you can rearrange the colors until they're in their best positions.

If you have more wells than paint tubes, leave a well between the colors to allow some expansion later. Anticipate where you might want to expand your paint colors.

3. **Squirt half a tube of paint in each well.**

 If the paint is dry enough to hold the shape of the hole when it comes out of the tube (like toothpaste does), add some water and mix it until the paint relaxes and fills the bottom of the well.

 Use a permanent marker to label each paint color on the outside of the well it's in. When paint is dry and dark, it's hard to remember which color is which without a name. If you change colors later, you can remove the name with a scrubber sponge or steel wool.

4. **Replace the caps on the tubes and start painting.**

Make sure paint tube lids and the threads on the tubes are free of paint before replacing the cap. Paint can act like glue when it sets on the threads of the tube, and the next time you try to loosen the cap, it'll twist the metal tube, possibly breaking it open.

Arthritic hands will enjoy smoothly turning lids if you smear a little petroleum jelly on the threads before resealing.

There's no waste in watercolor pigment. If paint dries out, just add water to rehydrate it. So don't be afraid to put a generous amount of pigment in the well. A tiny pea size will just be inadequate.

Prepping Your Paper

Paper is the foundation that your painting will live on. It's pretty important to understand. In this section, I give you some tips on treating paper properly and getting it ready to accept a painting.

Respect your paper. You'll probably respect it automatically after you pay $5 to $10 a sheet for it. But you need to handle your paper with respect, which means trying not to crease it. If it must be rolled, make sure you roll it gently. Also try not to touch it with your hands because your hands have oil on them. You may be painting along only to have a big thumbprint show up in the middle of an even wash you were hoping to achieve. Carry paper by the edges, or use a wrapper you can touch. And wash your hands before handling paper. Avoid resting your hands directly on the paper. Use a tissue or tracing paper to rest your hands on when painting or drawing.

Store paper flat. Storing paper upright fatigues paper and makes wrinkles. Of course, storing large sheets of paper flat takes some room. You can get flat drawer files that store a lot of paper. That's the goal, but to get started, just buy a few sheets at a time that you'll use before they get banged around too much. Store the paper in a *portfolio,* which is a big, flat container, usually zippered with handles, that you use to store or transport artwork. A portfolio keeps paper safe. You can choose from many styles and materials — from leather to plastic with prices to match. You can even get an acid-free cardboard portfolio for cheap storage. Or make your own using a couple of sheets of mat board or foam core board hinged on one side with tape.

Dividing your paper for smaller paintings

When I went to school, we had to paint on full sheets of paper — bigger was better. Personally, I think we wasted a lot of paper. Most of the projects in this book are set on small paper sizes. It lets you get a lot of mileage out of a full sheet, and you don't have to invest a lot of time either.

To reduce handmade paper, follow these steps (and put gloves on first or otherwise protect the paper from the oils in your hands):

1. **Fold the paper in half and crease the edge.**

2. **Fold it back the other way to weaken the fold.**

3. **Repeat Steps 2 and 3 a few times.**

4. **Dip a finger in water and run your damp finger along the fold.**

5. **Place the paper fold on the edge of a table and gently tear along the fold.**

 By dividing paper in this manner, you get the deckle edge on your new smaller sizes.

You can divide a half-sheet in half to make a quarter sheet and keep dividing for miniature pictures. Do you have to divide the paper evenly in halves? Of course not. You may want a thin vertical painting or a long horizontal painting, or you may want a shape other than a rectangle. Anything goes in art. Many of the exercises in this book look nice on a $\frac{1}{16}$-sheet (or 5-x-7$\frac{1}{2}$-inch) size.

Stretching your paper

Water on paper makes the paper buckle. The more water you apply to paper, the more wrinkles and buckles you make. To get rid of wrinkles and buckles, you can stretch the paper flat either before or after you paint on it.

The bigger the sheet of paper, the more important it is to stretch it. A bigger sheet of paper has more room to expand and contract; therefore, it gets more wrinkles when it gets wet. The wrinkles get in the way of watercolor washes being able to flow, so stretching minimizes the wrinkles. As the stretched paper dries, it goes back to flat. The stretching is subtle, so the painting doesn't get distorted when you stretch paper that's already been painted on.

Stretching before you paint

If you think wrinkles will bother you while painting, stretch your paper before you paint. You can stretch paper a gazillion ways, but this method is my favorite, and it works great:

1. **Thoroughly soak the paper.**

 You can mist it with your spray bottle or soak it in the tub for five minutes. Just make sure it's completely wet.

2. **Place the paper on a piece of $\frac{1}{2}$-inch thick *Gatorfoam board* that's an inch or two larger than the paper on all four sides.**

 Gatorfoam board is thicker and sturdier than foam core board, which will bend if you use it to stretch paper. You can use the same Gator board many times on both sides to flatten paper.

 Most art supply stores carry Gator board. If your local store doesn't, ask a frame shop to order some for you. Gator board comes in 4-x-8-foot sheets. I cut it in my frame shop to accommodate full sheets, half sheets, and quarter sheets. Watercolorists love it.

3. **Staple the paper to the foam board while the paper is wet.**

 The staples should be about ⅛ inch from the outside edge.

 1. Staple one edge in the middle.

 2. Go to the opposite side and staple in the middle near the edge.

 Before you staple each side, lift and pull the paper gently to ensure that it's wrinkle-free. When paper is wet, it's fragile, so do this with caution.

 3. Staple the other sides in the middle at the edge.

 4. Staple the corner edges down.

 5. Staple the rest of the edges about every inch.

4. **Lay the Gator board flat, paper side up, so the paper can dry.**

 If the board is placed on its edge to dry, the paper will tear as it dries.

 Wet paper expands. As the paper dries, it shrinks and pulls against the staples and stretches, becoming super-flat.

You now can paint on the paper while it's still on the board. The board gives the paper rigidity, keeps it from wrinkling, and is lightweight for easy portability. After you're finished painting, you can remove the staples.

Stretching after you paint

You can stretch paper after it's painted as well:

1. **Turn the painting over onto a clean surface.**

2. **Dampen the back side of the paper with a damp sponge.**

 Don't make any puddles that may run over the edge and accidentally ruin the painting.

3. **Cover the painting with a piece of glass and place some weights — books are good — on top of the glass.**

4. **Leave overnight or until dry.**

 Your painting is now flattened.

A framer can flatten your watercolors before framing them, too.

Preparing Your Painting Area

You need certain things in your painting area: a table and comfortable chair for starters. Most watercolorists paint flat on a table, though you can place a small box or a deck of cards under your paper to give it a slight incline so that the water flows down and doesn't create puddles. Even a card table you

can leave up lets you have a place to paint without having to put everything away after each painting session.

Lighting is a consideration. Daylight is best but not always available, so take advantage of the excellent daylight lamps on the market that help you evaluate color correctly. Place the light above your work space so it won't cast shadows that interfere with your painting.

Place your palette of paint, water container, and sponge together in a triangular arrangement on the table within easy reach of your dominant hand. Put your paper in a clean area next to your palette.

Don't put water on the left side of your paper and paint on the right because you'll drip in the middle — on your painting. Keep all the dripping in one area and then you'll only drip where you want to drip. Of course, you can fix accidents, but the easiest thing is to avoid them in the first place. Chapter 3 takes you through getting familiar with using your paints.

You may be a messy painter. If so, wear a painting shirt, which can just be a shirt you don't mind getting dirty, to protect your clothes. Watercolor doesn't stain as badly as other paints, but it still may remain on a white shirt. Save your best clothes for a different day than paint day. If you get paint on the table, just wipe it up with water and a sponge.

Breaking In and Maintaining Your Brushes

If you take care of your brushes, they should last your lifetime. I still have my first serious brush I bought in college some 20, ahem, 30 years ago. Usually the only reason I buy a new brush is because I have scrubbed and worn the tip out on an old one so it doesn't hold tiny detail any more. I try not to scrub with my good brush to prolong its life.

When you use your good pointed brush constantly to soften hard, dry paint, you wear out the tip on the brush. Some watercolorists only use fresh soft paint, but they have more money to spend on paint. Moistening the paint makes it more pliable and less destructive to your brushes (I talk more about this in Chapter 3).

Don't use other mediums with your good watercolor brushes. Oil and acrylic paint aren't as gentle on brushes as watercolor pigments and will ruin watercolor brushes immediately. Likewise, keep your fingers off the hairs of your brushes. Your hands are full of oil, and your face is even worse. I actually see uninformed customers fondle new brushes and touch them to their face like a makeup brush. It takes all the finesse, patience, and diplomacy I have to not scream. Good brushes are expensive and should be respected, not fondled.

Prepping a new brush

New brushes are protected for shipping by being dipped in *gum arabic,* the binder in watercolor pigments, and/or covered with a tight, clear tube. When you get a new brush, discard the plastic tube. Don't be tempted to replace it on the brush for protection. It's too small, and you'll end up bending back hairs and damaging the brush.

If the brush is stiff with gum arabic, dip the hairs in water and gently roll the brush on a table surface (not your good cherry dining furniture, but something you can wipe up liquid from like a kitchen countertop) until all of the gum arabic stiffener is removed. You may have to dip and roll several times until all the hardener is soft.

Washing, drying, and storing

Watercolor is pretty gentle, so you don't need to wash brushes using soap very often, if at all. Rinsing with water is usually sufficient. Simply swirl the brush in water to rinse it, and then lay it flat to dry. Do this in between using colors. At the end of your painting session, do this really well. You want the brush to air dry, so don't cover it with anything.

Never leave a brush standing in water. When brushes are wet, they are at their most vulnerable to damage. Prolonged exposure to water may damage the handle and loosen the ferrule. And, if you leave a brush in water for a long time, the hairs adapt to the shape of the bottom of the container. Result? Bent brush.

When dry, your brushes should be stored where they will be safe. You can buy storage containers like brush quivers, canisters, and rolled pouches. *Quivers* are like an arrow quiver; they're usually a box with a carrying strap and a hinged lid. *Canisters* secure the end of the brush so the hair end doesn't touch anything. *Rolled pouches* can be bamboo mats (or other fabric) that hold brushes in a pocket; they can be rolled up to take less storage room. These are great for travel because they allow the brush to breathe if wet and still protect the hairs from mashing. I store my brushes in the studio in a nifty jar filled with sand. The hairs point up, and the handle end is in the sand.

Repairing a worn brush

Gum arabic is handy if you need to retrain your brush back into shape or repair a damaged brush:

1. **Dip the hairs into gum arabic and let it dry to a gummy state.**

2. **After making sure your hands are clean, use your fingers to sculpt the hairs back to a point or edge, and leave the brush to dry.**

 The gum arabic becomes stiff when it's dry, which usually takes just a few minutes. Leave the brush with the gum arabic in it for a few weeks. Store the brush on its side or upright standing on its handle.

3. **Remove the gum arabic by dipping the brush hairs in water and rolling it out like you do with a new brush (see the "Prepping a new brush" section).**

 If the reshaping worked, hooray! If it didn't work and the brush is still out-of-shape, you can try using gum arabic again or go shopping for a replacement.

Finding the Time to Paint

Do you have a time of the day when you feel more fresh and creative? That's your best time to paint. Ideally, what you're looking for is regular, uninterrupted time you can devote to your art.

Even if it's only for ten minutes, paint every day. You'll be surprised at how much you can accomplish with ten-minute sets of time. Ten minutes is good for quick exercises and planning. Increase your painting time as you can.

To encourage yourself to paint every day, set up your paints and leave them out. Packing and unpacking supplies sometimes is enough to make you avoid painting. Find a spot that you can devote exclusively to painting. Using the kitchen table isn't good because you eventually have to pick up your paints so you can eat dinner. But if you have a place where the paints are always ready, it's easier to take ten minutes to paint.

If you're having trouble finding painting time, look for a local art association that conducts classes, and sign up for a regular class. Then you're assured at least that class time every week. An added benefit is that your instructor and classmates can provide inspiration as well as instruction.

You can set your schedule to accommodate your needs. If you're lucky enough to have lots of time, you'll be surprised to see how quickly time goes when painting.

Sharing your painting practice

If you feel that you don't have enough time to paint because you care for younger or older individuals, get them involved with painting too. People less versed in verbal skills can often communicate quite effectively visually.

The Alzheimer's Association offers a program called Memories in the Making, which pairs artists with people afflicted with Alzheimer's. The paired artists tell stories through art and enjoy time together. People with dementia can sometimes express feelings and emotions through art that otherwise are trapped inside. The artwork is auctioned as a fundraiser with the families' permission.

The program was started in 1986 and has spread internationally. For more information, contact the Alzheimer's Association through the Web site www.alz.org.

Of course, every child loves to paint. Make it a family project. Each child gets a toolbox to fill with painting supplies, including a painting apron to keep clothes safe from stray paint. Kids are less inhibited about art, and adults can gain much from this attitude. Pick a set time when everyone paints together, and put classical music on in the background (Mozart is supposed to stimulate creativity).

Chapter 3

When the Paint Hits the Paper

*Y*ou have all your supplies at the ready; now it's time to do something with them. If you have a few butterflies in your tummy, relax. You'll be transferring those butterflies to your paper in no time. This chapter gets you started with some basic watercolor techniques and introduces you to some simple terminology.

You can't improve your skills without using up some paper. So as not to break your budget, I designed the projects and practices in this book for small pieces of paper you can get by dividing a full sheet of watercolor paper (see Chapter 2 for more on dividing your paper). The paintings you make may be gems, and you may frame a mini-masterpiece. Or they may be learning experiences that only you want to see.

Keep an open mind, have fun, remember to breathe, and grow with each exercise. If you've never attempted watercolor, you're in for a treat. You'll be building new skills before you know it.

Activating Your Paint

Before you paint, you need to get the paints in your palette ready for painting, or as I say, you need to *activate* your paints. (Chapter 2 shows you how to put your pigments into your palette using the color wheel as a guide.) When paint sits, it dries out. You can still use it; you just need to get it juiced up and ready to go. Add water by dropping it in with your brush or spraying the paint with your spray bottle. You can mix the dry pigment and water in the well, or you can make a puddle in the mixing area of the palette until the paint is the consistency of ink and the color is what you want.

Get in the habit of having paint ready so you don't have to stop in the middle of painting to mix more. When you're starting out, you may not know how much paint to mix, so mix more than you think you'll need if you don't want to stop and make more in the middle of the painting. If you have to call a halt while you're in the middle of a wash, the wash may dry and cause you to miss the opportune time to add paint while it's still damp. I often spray my whole palette so all the colors are damp and ready to paint. If you know you only need a couple of colors to execute a painting, then just activate those.

To activate your paint,

1. **Dip a clean, damp #12 round brush into the well of pure pigment and get a half pea–size amount out.**

 If the paint is dry or in pan form, gather paint by wriggling the wet brush hairs on the pigment and the paint will transfer. You won't get a measurable size (like a pea), but you'll pick up enough paint to move to the mixing area.

 Use a clean brush every time you change colors. Clean the brush by swirling it in your filled water container to remove any previous paint. You want to keep the wells of pure pigment uncontaminated by other colors.

2. **Place the pigment on the mixing area and add a little water by dipping the hairs of the brush into the water container and bringing it back to the mixing area.**

 Add this brush load of water to your pigment in the mixing area. Water dilutes the paint. You can get a wide range of *value,* light to dark, by the amount of water you add to paint. (Chapter 5 explores values.) You can adjust the color by adding more water or more pigment. The paint should become liquid.

 After a bit of time, paint dries out and forms little chunks of hard pigment. If you apply paint straight from the well onto your paper, the brush may pick up a chunk of pigment that can leave a streak of color behind. This all happens in the blink of an eye. Avoid streaks by pulling the paint into the mixing area and adding a little water and mixing it until it's smooth and chunk-free.

3. **Swirl the water and paint together with the brush.**

 You should have a nice even mix of color with no lumps. Test the color by painting a brush stroke on a scrap of paper. Add more water if it's thick and too dark. Add more pigment if the color is too pale. Evaluate the color after it's dry because it will dry lighter.

Use several brushes — one for each color — to activate your paint. You save pigment by not constantly rinsing out all the color. Just set the brush by the color without rinsing, and it will be ready to go when you need that color.

The mixing area should be large enough to be able to mix several puddles of color without them flowing together. If you need more mixing area, use the lid from your palette.

Getting a Grip on Your Brush

For most applications, you hold and use your brush like you do a pen or pencil (see Figure 3-1a). However, holding your brush other ways produces other techniques:

- **On the side:** Try holding your brush like you would grip a stair railing. The bristles should come out next to your thumb as you use all four fingers to hold the handle (see Figure 3-1b). The brush lines up parallel to the paper so that when you apply paint, the side of the brush creates wide strokes.

- **Toward the end:** You can get more movement when you grip the brush loosely near the end of the handle (see Figure 3-1c). Think like an artist here and step away from the paper. Stand back, hold your arm out, and use your whole arm to paint.

Beginning with Brush Strokes

The way you apply paint is called a *stroke*. Because oil paint is thick, the strokes are visible, and an oil painter has to think about brush strokes that remain in the paint. As a watercolorist, you don't have that concern. Watercolor strokes don't show because the paint lies flat. You can get several types of strokes from the same brush, and the many types of brushes can help you produce a vast array of strokes. (See Chapter 2 for more on brushes.)

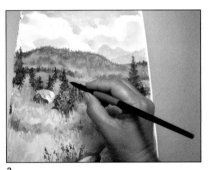

a

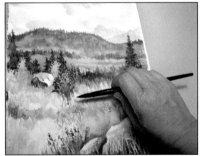

b

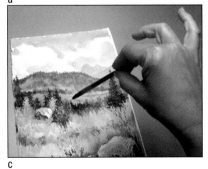

c

Figure 3-1: Several ways to hold your paintbrush.

Cleaning your palette

The mixing area of your palette can get messy. When it's too messy, you may not be able to mix fresh clean colors. The solution is easy: Take the damp sponge that always sits by your water container and sponge up the dirty watercolor. Don't forget to rinse the sponge until it's clean again.

If the palette is really dirty, you may want to clean it beside the sink. Scoop any old and chunky paint out of its well, clean the well with your water-soaked sponge, then put in fresh paint.

After you use a palette for a long time, it may become discolored by staining paint. If the stain bothers you, scrub it with a little bleach mixed with water to make it white again. Clean the bleach off completely so it doesn't influence future paint.

Like your house, cleanliness is a matter of style and taste. I have seen beautiful paintings come from disgustingly dirty palettes. I have also seen artists who keep their palettes neat and tidy at all times. Most of us live somewhere in between.

Experiment with your brushes to explore the strokes that are possible. You may want to use brush stroke paper available in art supply stores. The paper is gray but turns black when clear water is applied to it, so you can see what your stroke looks like. When the water dries, the color reverts to gray, so you can use the paper over and over. And water is all you should put on this paper; you can't use it again if you put paint on it. If you don't want to buy special paper, you can do the same thing with water and regular watercolor paper. If you want a permanent record of different strokes, use paint on regular watercolor paper.

Most brushes fall into one of two categories: rounds and flats. The following sections tell you how to use different types of brushes to produce different types of strokes.

Using your flat brushes

Flat brushes are good for wetting paper for backgrounds and foregrounds and for applying color quickly to large areas. Flats are good for making buildings and other rectangular shapes. The edges make lines, and the corners make details.

Bigger brushes work for bigger spaces and paper. If you're working on a big painting, a ¾-inch flat brush makes painting a big, sweeping sky go quicker. For a looser style, use a bigger brush than you think you need for longer than you think you should. Start big and work your way down in brush size as you develop detail. Some artists simplify shapes and leave the detail out altogether, so they need big brushes. Some artists like to paint every hair on the cat, so they need itty-bitty brushes for loads of detail. I keep a ¼-inch, a ½-inch, a 1-inch, and a 2-inch flat brush in my brush kit.

Try a variety of brush strokes with your flat brush (see Figure 3-2):

- For a **wide stroke,** hold the brush so that the wide part is flat against the paper and pull down.

- To get a **thin line,** have the wide part of the brush facing you, then pull the brush either left or right so that you're painting with the thin edge.

Figure 3-2:
Brush strokes using a flat brush.

- Make **circle, fan,** and **hourglass shapes** by holding the brush handle perpendicular to the paper and touching the brush hairs lightly to the paper so that they remain flat and don't get mooshed out of shape. Turn the handle in place. Keep turning for a complete circle, or stop halfway for hourglass and fan shapes.

- Achieve **fine detail** by tilting the brush so that only the corner touches the paper.

- To make **scallops,** shown in Figure 3-3, hold the brush at a 45-degree angle (so that the thin edge points to opposite upper and lower the corners of the paper), pull down, round off the bottom, and curve the brush stroke to pull up moving toward the right (or to the left if you're left-handed).

A calligrapher uses this same stroke to make thick and thin lines in a single stroke. Make a whole border using this stroke. It will look like a scalloped edge of thick and thin lines.

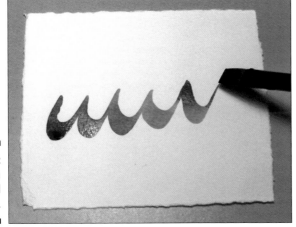

Figure 3-3:
Painting a scalloped line.

Running with rounds

Even though the ferrule on a round brush is round and holds the hairs in a round shape, the brush tip is very pointed. You use this pointed tip for tiny detail, and then you can push the brush down to use all the hairs for a big mop area. I can paint an entire painting using a #14 round sable brush. It looks big, but it has a delicate tip.

Try some brush strokes using your round brush (see Figure 3-4):

- ✔ See how small you can get. Make a line using just the tip of the brush.

- ✔ See how big you can get. Push the hair down to the paper and pull a stroke.

- ✔ Make a combination of small and big. Start small and grow big.

- ✔ You guessed it. Do the opposite. Start big and diminish the area.

- ✔ Make a row of commas and apostrophes by pulling up and down on the brush.

- ✔ Put your thumb at the base of the hairs right at the ferrule and splay the hairs out like a fan brush. You use the brush like this for ratty texture like grass.

Figure 3-4: Brush strokes using a round brush.

The *liner brush* is a relative of a round brush, only the hairs are twice as long. Use a liner brush to make long thin lines. Hold this brush near the end of the handle and flick your wrist to make the line. These brushes are great for drawing sticks, twigs, grass, and any long lines.

Painting with the Brush's Other End

You do most of your painting with the paint on the hairs of the brush. But the other end of the brush is a great tool too. Following are a couple of tricks for the other end:

- **Round ends:** A brush with a normal round handle end can make polka dots or just a quick dot. Dip the end of the handle in paint, then touch it to paper for a dot. Different size brushes make different size dots.

 You can also draw with this end. It may be jagged but that looseness may be pleasant.

- **Chisel ends:** Some brushes have a slanted or *chisel* end. This type of end is a functional tool for scraping paint. When paint is wet, just before the shine is about to dry, use the chisel end to scrape away paint and leave a light line. You hold the brush nearly parallel to the paper and push off paint with the curved edge of the chisel end.

 If you use the sharp edge instead of the curved edge, you'll carve a line in the paper that will fill in with paint and make a dark line. If the paint is too wet, you get the same result.

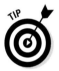

If you don't have a brush with a chisel end, try using a plastic knife or a credit card to scrape paint. This technique is perfect for quickly creating veins in a leaf or blades of grass in a field. It will look as if you spent hours painting around the lines.

Controlling the Water

Remember the story of Goldilocks and the three bears, in which the porridge was too hot, too cold, and just right? Switch the porridge with water, and the same is true for watercolor paper and brushes. It's too wet, too dry, or just right. When you know how to deal with each condition, your watercolor painting will be much easier. That's what I help you do in the next sections.

When you paint, you'll start with a damp brush. Sometimes you'll dampen the paper with water and thereby make the brush damp. Next scoop up some paint in the hairs of the brush. Apply the paint to the paper that is dry or wet, depending on the look you want. When changing the color, first rinse the previous color in water, and then pick up the next color.

A big key to success is even wetness. And sometimes to achieve that, you have to let everything dry and start fresh on the next layer. Especially if you're painting a large area, it's difficult to have the same wetness everywhere. You

may get puddles in one area, while another is beginning to dry out. When you see parts of the painting becoming dry, the best plan is to let everything dry and start again in another layer. Say this with me: "When in doubt, dry it out."

Watercolor has a *magic time*. It's just as the shine is about to leave the paper, when the paper is damp with no puddles or dry spots. This is the perfect time for all the techniques described in Chapter 4 or using a chisel-ended brush to scrape paint away as described in the "Painting with the Brush's Other End" section earlier in this chapter.

Dropping wet-in-wet

One way to let watercolor work for you is to paint *wet-in-wet*. The paint is wet and the paper is damp. The paint travels a little on damp paper. You can even paint on damp paint. I sometimes think that what scares people from using watercolor is the perceived lack of control — the paint moves! But that movement is precisely the fun of watercolor. Lose control and enjoy it.

This wet-in-wet technique can be a garden of flowers, an abstract, or a cool background. What will yours be?

1. **Use a quarter sheet of watercolor paper.**

2. **Choose and prepare as many colors as you want to use.**

 By having your colors ready, you won't waste valuable time mixing paint while your paper dries prematurely.

3. **Dampen the paper with clear water.**

 Apply the water with a brush or sponge. Wet the back of the paper, too, so that the paper lies flat and stays wet for a while. This gives you plenty of time to play with paint before the paper starts to dry.

4. **Apply your colors by dropping them randomly onto the wet paper, dripping color from a #12 round brush, or painting a line and letting it spread.**

 Let the colors mix. Rinse your brush between picking up new colors. If your paint doesn't drip, lightly touch the tip to the paper to see if it will transfer the paint to the paper. More water may make the paint drip better. The drier the paper becomes, the less spreading the paint does.

Wet-in-wet technique is a great way to make backgrounds that have a softer edge and are less detailed. I painted the following painting in two stages. The first stage (see Figure 5-3a) was painted wet-in-wet using a blue-gray mixed from ultramarine blue and burnt sienna. I painted all the trees, fields, and hills while the paper was very damp. Then I let the background dry. I added the pheasants, fence, and grasses when the paper was dry so the paint would hold a hard edge (see Figure 5-3b). The hard edge and details help create the illusion of space.

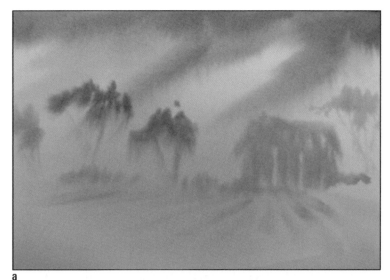

a

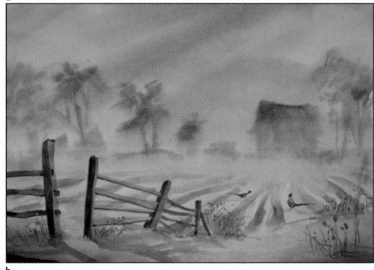

Figure 3-5:
A landscape
using wet-
in-wet for a
soft, less
detailed
background.

b

Stemming the flow of water

Too much water on the paper creates *puddles*. Puddles are loads of water. Having puddles and lightly damp areas together creates uneven wetness. The puddle will travel into the dry area and create a line where it can't travel anymore. Puddles also can take forever to dry. To solve this, pick up the paper and pour the water off. Or you can blot it off with a damp brush, a paper towel, a clean sponge, toilet paper, the sleeve of your shirt — whatever's handy.

When your brush is too wet, you introduce more water than you need into the painting. To limit the amount of water, tap the brush on the damp sponge

after you rinse it. The sponge absorbs any dripping water, and you don't go back into the painting with more water than is there already.

Watering blooms

When you get more water than pigment, the water dries at uneven rates and creates blooms, blossoms, cauliflowers, backwashes, or happy accidents, an example of which is shown in Figure 3-6. Sometimes these look really cool and create a fun, juicy watercolor look, especially in a sky. Enjoy and have fun creating them. But trust me on this: If you want a smooth, flat wash and you get a bloom in the middle, it's no "happy" accident. So figure out how to control blooms right now so you get them only when you want them.

Figure 3-6: Blossoms created by uneven wetness.

You need to know how to control or create blooms (or whatever you choose to call them), and the first step toward that is knowing how they form:

1. **Get a 4-x-6-inch piece of watercolor paper.**

2. **Activate your choice of pigment color.**

 Add water to make a puddle of color in the mixing area of the palette.

3. **Using a large flat brush, cover the entire surface of the paper with paint quickly so it's all the same dampness.**

 If the paper absorbs the water and dries, reapply the paint until it's damp everywhere.

4. **Wait until the paint shine is just about to disappear. Drip a brush of clean water on the painted surface.**

 Because the water is introduced into the damp paint, you get uneven wetness, and you should get a bloom, probably immediately. Resist the temptation to fiddle with it.

 If you don't see a bloom, you probably dripped the water too soon or too late. Let the whole thing dry and try Steps 3 and 4 again.

5. **Let the paint dry.**

Fun with a blow-dryer

Any hair dryer is a friend to the impatient watercolorist. It speeds up your waiting time until the next layer is dry. When you use a blow-dryer, dry from the front and back of the paper. Hold the dryer about a foot away and move it around for gentle, even drying. Any temperature seems to work. I've even used the high temperature from a distance and for short amounts of drying time.

You can even experiment with pushing paint with air. If the paint is liquid enough, you can push it into running shapes. Remember blowing around paint with a straw in school to make an oriental art copy? Another experimental technique is to put the dryer close to the puddle of paint and force dry it so the paint makes concentric circles as it dries.

Try the exercise again with other colors to see what blooms look like in a rainbow of shades. You can also try dripping wet color into nearly dry color to see the results.

Repairing an unwanted bloom

The easiest way to fix a bloom is to avoid making one. And the best way to avoid making one is to ignore those who speak ill of watching paint dry and baby-sit your painting as it dries. Until it's dry, your painting can change and do some weird things. If you can see a bloom forming where you don't want one, nip it in the bud by using your brush to pull the wetness and pigment around the perimeter of the area so it's evenly wet.

Never leave a puddle unless you plan on a bloom. Blot puddles and excess liquid from the painting's edges and especially table surfaces. You are in control of the painting. You can enjoy the surprises that blooms can deliver, or you can make even, smooth washes. You control the water so it will deliver the result that you want.

Blooms can be fun texture in the right place: trees, clouds, mountains, water, you name it. But sometimes a bloom happens where you don't want it: on a face, in a smooth area, or some other surprise.

Depending on the pigment and paper, fixing blossoms may be easy or impossible. You can try three possible solutions:

- ✔ **Add another layer of color.** If the pigment is pale, another layer of paint may camouflage the blossom.

- ✔ **Try to lighten the blossom.** Wet the entire area with clear water. Take a stiff paintbrush and nudge the offending area. Blot with a towel to lift the paint.

- ✔ **Scrub the area using a stiff brush — even a toothbrush.** As a last resort, if you're using 100 percent cotton rag paper, dampen the area with clear water. Let it soak a little. Gently take a toothbrush that you have designated to watercolor and scrub. When little paper bits start to pile up, stop. It's possible to rub a hole in your paper, and if you're using cheaper paper, you can rub a hole even quicker, so keep an eye on the paper. Cotton rag paper can take a lot of abuse, though, so if that's what you're using, try it.

Of course, you can always start over. Remember, experience is what you get when you don't get what you want.

Dealing with dry

Some techniques require wet paper, but for hard, crisp edges, you need drier paper and a drier brush. Of course, a dry brush in watercolor painting is a relative term because it's watercolor and everything is wet. But having your sponge absorb most of the water from your brush before you dip it into paint lets you execute those very controlled, every-hair-on-the-dog type paintings for the control freak in you. To stay in control of your detail, stay dry.

To dry your brush, touch the base or heel of the hairs on the damp sponge beside your water container. This absorbs excess water from the brush but leaves pigment in the tip of the hairs to paint with. Choose a small brush when you want lots of detail and control.

If you want a hard edge, you must be patient. If one area of your paper is wet and you touch it with another wet, the wets will run into each other. Goodbye hard edge. Have patience, or use a blow-dryer to dry your painting so you can keep working.

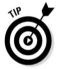 And, speaking of dry, to test the paper to see if it's dry yet, use the back of your hand to gently touch the surface of the paper. If it's cool to the skin, the paper is still wet. Notice that I said the *back* of your hand. If you use the palm of your hand, the paper may feel dry before it really is dry. The palm of your hand has been used so much — burned, blistered, lotioned, and so on — that it's no longer as sensitive as the back of your hand.

Tackling Three Basic Painting Techniques

Master these three watercolor painting techniques, and you'll know all you need to paint anything you want. These techniques really are all you have to work with. I have no idea why it took me 40 years to figure that out. Truly, the rest of this book is just refinement and details. Here are the basics:

- ✔ **Flat wash and hard edges:** A *wash* is pigment in water. A *flat wash* is an even color with no variation in color value (light or darkness). A *hard edge* is a crisp, abrupt change, like a line.

- ✔ **Graded wash and soft edges:** This wash is a *gradation* of color from light to dark. The *soft edge* is a slow change that may not even be perceptible.

- ✔ **Rough texture:** You need a paper with some texture — a cold-press paper or one with a bumpy surface (see Chapter 2 for more on paper textures) — to stand up to the rough texture technique.

To achieve rough texture, use paint that is slightly dry. Make a quick stroke with the side of your brush so the paint just coats the paper's surface bumps and leaves the pockets between the bumps paint-free. You want white paper showing through. This rough texture can simulate sparkle on a lake or tree bark.

Make a chart to explore the three techniques on wet and dry paper. Figure 3-7 shows what you're aiming for.

1. **Draw six 2-inch squares on cold-press or rough watercolor paper.**

 Make two 2-inch-wide columns that are 6 inches long. Divide each column into thirds. You have three rows of 2-inch squares.

2. **Label the columns *dry* and *wet*.**

 The first column will be techniques on dry paper, so write *dry* at the top. Label the second column *wet,* because you're going to do the same techniques after you wet the paper.

3. **Label the rows *hard-edge, flat wash; soft-edge, graded wash;* and *rough texture.***

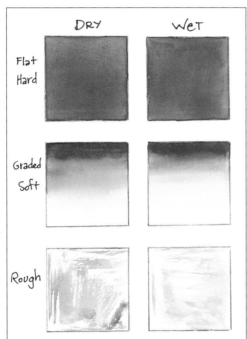

Figure 3-7: The three basic paint techniques on dry and wet paper.

4. **Prepare your paint.**

 Use a paintbrush of your choosing to gather one color of pigment and mix it with water in the mixing area of your palette. I used burnt sienna, but any dark color works. You want a dark paint, but not so dark that

you can't see through it. Add just enough water to make the pigment move like ink, but still remain dark.

5. **Paint the top square in the dry column with a flat wash with hard edges on dry paper.**

 Fill in the square with the paint. Try to fill it in with even color. If you use a flat 2-inch brush, this could be one stroke. If the brush is smaller, it may take several strokes. If you get puddles, dry your brush with a paper towel. This makes the brush a *thirsty brush* that absorbs liquid from the paper instead of dispensing it. Or if you touch the top of a puddle with the edge or corner of a paper towel, it will absorb just water, leaving the heavier pigment on the paper.

6. **Dampen the top square in the wet column with clear water and paint a flat wash with hard edges on wet paper.**

 Use your brush to paint clear water over the square. Try to make even wetness, no puddles, just a shiny surface. Absorb any excessive puddles with a paper towel. Apply paint as you did in Step 5. The object is to make an even tone throughout the square.

7. **Paint the middle square in the dry column with a soft-edge, graded wash.**

 Paint at the top of the square. Rinse your brush and apply a stripe of clear water at the bottom of the square, leaving dry paper between the two. Dry the brush on the sponge to make a damp, not drippy, brush and use it to introduce the two stripes by painting a stripe of clear water between them. Your goal is to make a dark-to-light gradation from top to bottom. The transition is a smooth, soft edge. Here, the soft edge is in the middle of the square, as opposed to the hard edges on the outside edges of the square.

8. **Dampen the middle square in the wet column and paint a soft-edge, graded wash on wet paper.**

 Paint clear water over the square as you did in Step 6. Then apply your pigment to the top of the square. Rinse the brush and move the paint down the square making the color lighter as it approaches the bottom of the square. Pick up unwanted puddles with a thirsty brush. Apply more paint if needed. Your goal is dark to light, top to bottom.

9. **Paint the bottom square in the dry column with rough texture on dry paper.**

 Pick up some pigment in your brush and touch the base of the hairs near the ferrule on the sponge to absorb excess water. Use the side of the brush and quickly stroke over the square, leaving little valleys of white paper. Try again until you get some rough texture.

10. **Dampen the last square in the wet column and paint rough on wet.**

 Dampen the square first (as you did in Step 6), then apply paint as you did in Step 9. This technique works better on dry paper and may not work on wet paper, but because you already have a square, you may as well try it.

Along with hard and soft edges, both of which you need in every painting to make it interesting, you may hear about lost edges. Who lost them? Where

did they go? A *lost edge* is a type of soft edge that disappears into another area. A lost edge makes the viewer decide where the edge is because the artist doesn't spell out every detail. The viewer gets to participate in the painting experience. "Lose that edge" might be an artistic directive. To do so, gently nudge a hard edge with a stiff bristle brush to soften it. If you completely soften it so it disappears, you make a lost edge.

Lifting, Layering, and Glazing

This section covers the three techniques every watercolorist uses to modify his basic painting. You can erase watercolor. It's called *lifting*. You can continue painting to improve your work by adding *layers*. You can create focus and dimension on a final painting by *glazing*.

One, two, three, lift!

Want to remove or erase paint? You can! At least you can make an area lighter. You can *lift* (remove) paint to correct excess paint or create a highlight.

How much paint you can lift depends on the paper and pigment. Some papers lift more easily than others. Some paper brands have a softer finish and lift very easily. Some brands absorb the pigment and are more difficult to lift; however, these papers can be layered with paint without disturbing what lies underneath. Your paper dealer can advise you on which brands to purchase for your needs. Earth-colored pigments are pretty forgiving and lift easily; staining pigments are a bit less forgiving and may never lift completely. (See Chapter 2 for more on pigments.)

You can lift paint wet or dry:

- **Lifting wet paint:** If paint is damp on the watercolor paper, use a clean, damp brush and touch the area that you want to remove paint from. Follow the shape you need lightened with the damp brush: Draw a line, touch a dot, or use the side of the brush for a large area.

 After you lift out the paint, blot the area with a paper towel. If you want it lighter still, wait until the area is dry and then follow the instructions in the next bullet point.

- **Lifting dry paint:** Use a round brush with clear water to dampen the area you want to lift and blot the area with a towel. Turn the towel to a clean spot and rub the area vigorously and quickly using a bit of pressure. This usually is enough to lift what you want, but if you want more lifting, use a damp brush with stiff bristles and rub the area. Blot with a towel. Continue until the paper peels up in little crumbs. At this point, stop and let the area dry.

Watercolor dries 30 percent lighter than it looks when wet. So wait to see if the area you want lifted is light enough when it's dry before trying to lift more paint.

Layering on top

You can, and often will want to, paint on top of other paint. You usually wait until the *underlayer* is dry before adding another layer of paint.

What you put on top influences what is underneath, and layering is one way to mix colors. Keep the paint transparent so you can see through it and into the layers. This makes deep, interesting paintings.

Create several rainbows of color with this layering exercise.

1. **Get a quarter sheet of watercolor paper.**

 This can be a square piece of paper.

2. **Activate all your paints.**

 You want to become familiar with the entire palette of colors, so use them all.

3. **Paint a stripe of each color on your palette from the top of the paper to the bottom, leaving a small stripe of white between each color so they don't mingle (see Figure 3-8a).**

 A ½-inch flat brush is just the right width for each stripe. Keep the colors strong by not diluting them with too much water. You could make another chart with pale colors and see what happens with those, too.

Figure 3-8: Exploring your palette by making a layer chart.

a b

4. **Let the stripes dry completely.**

 Use a blow-dryer, or be patient and make a cup of tea.

5. **Paint a stripe of each color horizontally, moving left to right across the paper (or right to left, your preference). See Figure 3-8b.**

 This puts each color underneath and over the top of all the others.

6. **Let the paint dry and analyze the results.**

7. **Label the paint names for a handy reference chart.**

This simple chart gives you a wealth of knowledge about colors and color combinations. Each intersection displays a new color. Look at the differences

when a color is on top of rather than underneath another color. Some colors are *transparent* (see-through); others are *opaque* (solid), no matter how much water you dilute them with.

For bonus points, try lifting a small area out of each stripe of color (the previous section tells you how). This shows you which colors are easy to remove and which are staining. The staining colors never lift back to white.

Glazing over (Nope, not bored looks)

A *glaze* is a very transparent layer of paint applied over an area that's already painted. Glazing has lots of possibilities. You can glaze over an area to make it less or more prominent. If you're painting a landscape and the background isn't staying far enough back, you can glaze over the whole area with a cool color, like blue, because cool colors recede. Conversely, you can glaze over the foreground with a warm color, like yellow, to make it come forward. (I talk about color temperatures in Chapter 5.) You may find other reasons to add a glaze over something. I added a yellow glaze to the foreground of the painting in Figure 3-9a to add depth to the painting. Figure 3-9b shows the result.

Figure 3-9:
Before (a) and after (b) a yellow glaze was applied to the foreground.

a b

To glaze:

1. **Mix enough paint so you don't have to stop midway and mix more — that's a sure recipe for hard edges where you hadn't planned any.**

2. **Make the paint as transparent as possible.**

 Glazes are usually very transparent (add more water for more transparency) unless you want to obliterate what's underneath.

3. **Use the biggest brush you can manipulate into the space and apply the transparent glaze.**

 Don't go over the area more than you need to avoid disturbing the layer underneath. If the layer beneath starts to move, stop or endure the change.

Some colors run when you put water on top of them, so work very quickly and use the lightest of touches so as not to disturb what lies underneath.

Some papers tolerate glazing better than others. Glazing requires a paper with less lifting ability (see the "One, two, three, lift!" section for more on these papers).

Finishing Up

When you finish your painting, you can do several things with it. No, you can't toss it. How will you know how you've improved if you don't keep your early works to measure your progress? Keep building that stack of paintings. The great artists you admire have really big stacks that you never see.

If you produce a painting that you want to present properly, here's a quick bit about the final presentation of watercolors. Works on paper usually get a mat, glass, and frame around them to preserve them for posterity. Work with a professional framer for the latest trends and choices.

Putting out the mats

A *mat* is cut from mat board and makes an aesthetic border around the painting. You can have more than one mat to provide a transition from frame to painting. The mat color can set the painting apart from the wall, match the sofa, or be neutral.

The mat is functional as well as ornamental. It creates a pocket of air between the art and the glass. If the glass were allowed to touch the art, it would harm it in time. The proper amount of mat for conservation purposes is 8-ply. One mat is 4-ply, so a double mat is the best choice for conservation.

The width of mats can vary. Don't scrimp. Set the painting apart with a 3-inch width. More can look even better depending on the statement you want your artwork to make.

When choosing a mat, decide on the purpose of the painting first. If it's decorative, you can consult the interior decorator and mat with a color that works for the room. If you're entering the painting into a juried show, the mats should be white or off-white. Some shows even dictate what colors are acceptable. After you know the purpose of the painting, you can choose a mat color that best shows off the work.

Looking at glass

Regular glass is for the budget conscious. Conservation glass prevents ultraviolet light from penetrating the glass to fade the art. Reflection-control glass is nonglare. And museum glass does it all. The down side is cost. More is more. But it is original art, and it deserves to be treated with respect.

Fixing on a frame

This wood- or metal-border molding holds everything in place and adds an artistic element of its own. Tour a frame shop to see what's out there, and don't be afraid to ask for advice. Professional framers have a lot of experience to offer and can help you make a good choice.

Peeking behind the art

Whatever touches your art should be acid-free. If you go cheap, you may get a cardboard backing, which will turn the paper brown in a short amount of time. Cardboard, masking tape, and newsprint are the most acidic products available. They should not be near your art. Make sure your art is backed with Artcare board, sealed on the back, and has a wire for hanging. You are ready to hang in the Louvre!

Project: 30-Minute Miniature

This quick painting project puts the techniques in this chapter to use making a miniature landscape. In fact, you can mount this little cutie on cardstock and send it and its cousin paintings as holiday cards to your closest friends. That would be great practice, especially if you're popular.

1. **Get a 4-x-6-inch piece of watercolor paper and turn it so it's taller vertically.**

 See Chapter 2 for tips on dividing a sheet of paper if you're starting with a larger sheet.

2. **Activate and mix two batches of blue-gray paint (see "Activating Your Paint" earlier in this chapter).**

 Mix ultramarine blue with burnt sienna to make a blue-gray. Add a little water to make it the consistency of ink. Mix another puddle of blue-gray with less water so that the paint is almost black.

3. **Dampen the background down to the hilly horizon — roughly the top half of the paper.**

 Use a ½-inch flat brush to quickly dampen paper with clear water. Dip the brush in the water and apply it to the paper until it's damp. Leave the foreground dry.

4. **Using a ½-inch flat brush, paint a graded wash for the background.**

 Brush on the diluted blue-gray near the horizon and let it get lighter as it rises toward the top of the paper by diluting it with more water (see Figure 3-10a). Tilt the paper slightly so gravity helps you with the process. At first you may need to tilt the paper one way, then the other, so

the darker paint accumulates toward the horizon. When the background is the way you want it, leave it flat to dry, but don't let it dry completely before moving to the next step.

 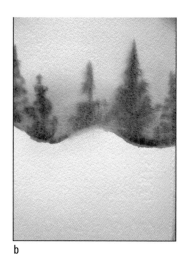

Figure 3-10:
The finished
background
and
background
trees.

a b

5. **Paint the background trees wet-in-wet.**

 Before the background you painted in Step 4 dries completely, add the gray trees in the background, using Figure 3-10b as a guide. (You add the dark trees in the foreground later.)

 Pick up some blue-gray paint and touch the base or heel of the hairs to the sponge to absorb excess water. Touch the tip of the brush to the background. If the paint disperses into the background too quickly, the paper is still too wet, so let it dry a bit so the paint can hold a soft (slightly blurred) edge. You want the paper wet enough so the trees hold an edge, but not dry enough to hold a hard (crisp) edge.

 To make a tree, paint the trunk the full height of the tree and then dance the brush down the trunk, sweeping it from side to side and gradually increasing the size of the foliage from a point at the top to wide at the bottom. Leave some spaces on the trunk. Repeat this process, making the trees different heights and leaving different amounts of space between them.

6. **Paint the stream while the background trees dry.**

 Use the same blue-gray with a flat brush. Make a backwards "S" shape, starting with the thin side of the brush placed at the horizon near the center. As you pull the brush down and make the first turn, allow the shape to widen by turning the brush. Make one more curve and let the brush be at its widest point. Figure 3-11 shows a curvy stream. If you don't make the shape quite right on the first pass, go back and touch it up so it's the shape you want.

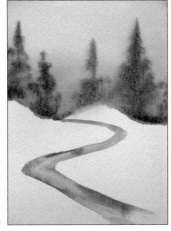

Figure 3-11:
Adding the
stream in
the
foreground.

7. **Lift some color in the center of the stream near the foreground while the stream is still wet.**

 While the stream is still wet, touch a damp, clean brush on the paint to absorb it and leave a lighter area in the center of the stream (see Figure 3-12). If the paint dries too fast, lift the color after it's dry by dampening the area with clear water and blotting with a towel. (For more specifics on lifting, see the "One, two, three, lift!" section earlier in the chapter.)

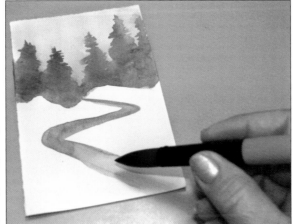

Figure 3-12:
How to lift
color from
your wet
painting.

8. **Let everything dry.**

 Start another painting or drink a latte, but let everything already painted dry completely.

9. Add rocks.

Using the dark paint and a #12 round brush, make a couple of rock shapes along the stream (see Figure 3-13a). When the paint is almost dry, try scraping the top of the rocks flat, using a chisel handle or a credit card. Figure 3-13b shows how it's done. (For more details on scraping, see the "Painting with the Brush's Other End" section earlier in the chapter.)

Figure 3-13: Adding some rocks along the stream.

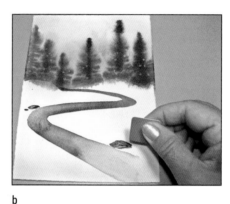

a b

10. Paint the dark trees in the foreground.

Use a round brush and the dark mixture of paint to paint the trees. First, make the trunk the full height of the tree. Then, starting at the top of the trunk, sweep your brush back and forth to make branches that gradually increase in size as they near the bottom.

11. Paint the grass and the reflections in the water.

Using a liner brush or the end of the brush handle, make some dark blue-gray lines resembling grass. Soften the bottom edges with some water. Paint the lighter blue-gray in the water to represent the reflection of the pine tree. Figure 3-14 shows these details.

Figure 3-14: Painting in some grass and water reflections.

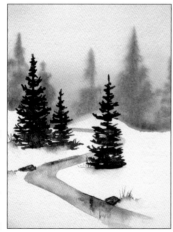

12. Paint a tree of twigs using the lighter blue-gray paint.

Use a liner brush to practice making lines. Make the lines get smaller as the tree grows upward. Hold the brush at the end of the handle and flick the stroke away from the tree trunk. By doing this, the part of the branch nearest the trunk will be thicker, and the part that reaches toward the sky will be reduced in size. Avoid making branches get wider as they grow taller. See Figure 3-15 for guidance.

Figure 3-15:
The final details of a landscape suitable for sending.

You use just two versions of one color to create a multihued landscape. As the two colors separate and mingle in the painting, they seem to make more colors. If you had used one gray color out of a tube instead of mixing it yourself using blue and brown, the color wouldn't be nearly as interesting. The white of the paper makes snow with no painting effort. Magic.

Chapter 4

Techniques and Tricks to Keep Up Your Sleeve

*O*ne of the best attributes of watercolor is the vast number of techniques available. Watercolor moves and reacts to your command. That may sound a little scary, but actually it's the best quality of the paint. In this chapter, I want you to forget about making anything that looks like something. The pressure to make perfect drawings or identifiable objects is off. In experimental, nonrepresentational work you simply enjoy the colors, textures, and surprises that result when playing with the medium. *Play* is a good word. It sets the mood for how you explore these techniques.

In order to play, set up your palette and paint area as noted in Chapter 2. Get some watercolor paper ready to play upon. You can tear up small pieces about 5 inches by 7 inches and use one for each technique experiment, or you can just use little areas on any scraps available.

Sometimes these experimental techniques just don't work. Sometimes they work better than you planned. That's why they're called experimental. Not every work of art works. There's a reason some pieces win prizes — the artist got lucky that day.

Preserving White in Your Paintings

Typically, you paint on white watercolor paper. And ideally you save the white of the paper as the white in the painting, painting around the white areas to leave the paper showing. Although you can buy white watercolor paint, it looks a little chalky, and unless you're going for the unnatural look, my advice is to avoid using it. Watercolor is very different from oil or acrylic painting where paint is applied for white areas.

It's a good plan to paint light areas first and continue with successively darker colors. Work light to dark.

This section covers the tricks available to keep white in your painting.

Waxing on

Wax resists watercolor, so using a white crayon or a candle is a quick and easy way to save a bit of white when painting. Say you don't want to go to the effort of painting around an area for a tiny highlight in a flower. Just a touch of a crayon saves the dot, stays invisible, and keeps you from needing a steady hand to paint around that highlight.

Any substance that prevents or resists paint is known as a *resist,* and wax is one type of resist. (Colored wax acts a resist as well, but it obviously leaves a colored area on the paper, so unless that's the effect you're going for, be sure to use white wax.) Figure 4-1 shows a wax resist.

Figure 4-1:
Squiggled
white
wax lines
under a
watercolor
wash.

To save white in a painting with a wax resist, follow these steps:

1. **Find a white crayon or a white candle.**

2. **Draw on the watercolor paper using your crayon or candle.**

 Your design is hard to see — invisible in fact. If you tip the paper, you can see by the matte finish where you applied the wax.

Sending secret messages

Creating wax resists can serve more than your artistic side. Kids will love this technique to send a secret message:

1. Write a message on white paper using a white crayon. The white is invisible on white paper.

2. Give the paper to your friend.

3. Tell your friend to apply paint on the paper to reveal the secret message.

In an actual painting, you'd put the wax anywhere you want to save a highlight, perhaps for a glint in an eye or a sunspot on a leaf. Just cover where you want white, but remember the wax stays on the paper. If you want the paper clean later, use a masking fluid (described later in this chapter) because it peels off after you've saved the white area.

3. **Using a brush of your choice, paint over the top with a diluted paint of any color.**

Voilà! Your secret design is revealed.

Keep these points in mind when you use wax to preserve white in your watercolors:

✔ The darker the paint you use over the wax, the more vivid your design will be.

✔ Smooth paper holds a better wax line. If your paper is really textured, the wax may not coat the paper entirely. If only the top surface of textured paper gets wax, the result is another spotty texture, which may be just the effect you're looking for.

✔ The wax stays on the paper because it's not removable. It's essentially invisible except for the waxy buildup. If used in small amounts, it may not be visible at all.

Masking over

Most art supply stores carry a product called *masking fluid* (mask) that saves white. You apply the liquid to your paper where you want to preserve the white. You can then paint over the protected area — slop, spray, drip, whatever — then peel off the mask to reveal fresh, white paper underneath that is unaffected by your work on top.

Masking fluid is an acid-free product that's archivally safe for your paper. Rubber cement would work, but it's very acidic and will discolor your paper.

Most masking fluids come in a jar with a screw-on lid, and you apply it like paint by using a brush. One type of mask, however, comes in a bottle with a hypodermic needle–like top that allows you to apply thin lines of mask easily. No extra application tool required.

Masking fluid comes in clear, blue, gray, orange, pink, and yellow, depending on the brand. There's even a permanent mask designed to remain on the paper. Colored mask makes it easier to see where you applied the mask, but I have seen some sad results where the colorant stained the paper. I recommend the colorless masking fluid because if you're saving white, it's difficult to judge color values when the white is saved as orange, gray, or some other color.

If you use colored mask, look at the bottom of the mask container to check that the color is even before using. You shouldn't see any bright dots of undissolved color. Shake up the product to mix the color if needed. However, try not to shake the bottle unnecessarily because air solidifies the product. Shaking and introducing air to the mask causes it to harden prematurely.

Mask dries in your brush quickly, and if it dries completely it won't come out. So don't use your very best brushes to apply masking fluid. If you do get mask stuck in your brush, you can purchase a masking fluid cleaner product.

To use masking fluid to save white, just follow these steps:

1. **Dip a cheap synthetic round brush in liquid dish soap or swirl it on a bar of soap to coat the hairs.**

 This aids in rinsing out all the mask. If your brush starts to solidify, rinse it out in water, recoat with soap, and start again.

2. **Dip the brush coated in soap (no rinsing out the soap) into the jar of masking fluid.**

 Cover the hairs but try not to cover the metal ferrule, which makes it more difficult to clean the brush.

3. **Apply the mask to your paper.**

 Apply enough of a layer to protect the paper. If the mask is too thin, it won't resist liquid painted over the top.

4. **Allow the mask to dry before painting over the top.**

 Gently touch the mask to see if it's dry. If it doesn't come off on your finger, it's probably dry. The mask remains slightly tacky because it's a rubber-like product.

 Be patient! Sometimes overnight is a good amount of time to make sure it's dry, especially if you use thick mask.

 Resist the temptation to use a blow-dryer to speed up the drying time on masking fluid. The heat can cook the mask into the paper and create a permanent bond.

5. **Clean your brush in water and lay it flat to dry when you're finished.**

6. **Paint over and around the masked area.**

7. **Let the paint dry completely.**

8. **Rub your finger over the dried mask to peel it up.**

 You can feel with the palm of your hand when all the mask is removed.

 Remove the masking fluid within six months or it may become permanent.

Practice the masking technique a couple of times before committing the method to a time-intensive artwork.

Keep in mind that you can use mask to protect colors too. Paint mask on top of a flower, let it dry, and then loosely paint over the masked flower to make a background. Peel the mask off when the background is dry; the flower has been protected.

Negative painting

Negative space is the space around and between the positive shapes in a painting. Negative space is as important to consider as the positive shapes. The object, or subject, in the painting (a flower, for instance) is the positive shape. The area around the flower, the background, is the negative space. *Negative painting* is painting the negative space — the area around the positive shape. In watercolor, you do lots of negative painting to save white and light areas.

Try out negative painting. If you have a daisy to look at, get it out now. I have a bunch of silk flowers to use as inspiration. Real ones are even better if you have access to them. The daisy in Figure 4-2 is simplified. I used the daisy as an inspiration, but didn't closely follow all the detail that the flower showed.

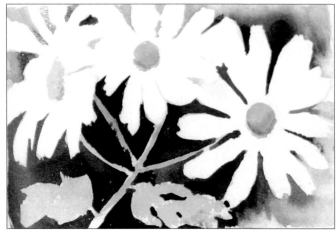

Figure 4-2: Negative and positive shape.

1. **Draw the outline of a white flower on a 5-x-7-inch piece of watercolor paper. Don't forget the stem and leaves.**

 The flower is the positive shape. Take a minute or two to really look at the flower shape. Take time to make the edge interesting with all the irregularities that you observe.

2. **Activate your paints.**

 Choose the colors you want for the background and activate them if they're dry. I used alizarin crimson, hookers green, phthalo blue, lemon yellow, and cadmium yellow.

3. **Paint clear water over the background.**

 As the paper soaks up the water, rewet the area until the background is shiny damp with no dry spots. If you get a puddle of water, pick up the paper and tip it back and forth, allowing the water to dissipate through the entire wet area. You want to have an even wetness everywhere in the background. Leave the flower, leaves, and stem dry.

4. **Paint the background before the water dries**.

 A. Take your round brush, pick up some green paint, and float it in the damp background. The paint will explode in the water. Put green in other areas quickly.

 You must apply the background colors while the paper is still wet. If the paper dries in an area before you're done, stop and let it all dry. Start again with Step 3.

 B. Rinse your brush between colors and get red and drop it next to the green. The red and green should mix to a dark green. Add blue in some areas.

 C. Use your brush to manipulate the colors where you want them to go. Pick up the paper and tip it one way, then another, to let the water blend the colors together.

 When you like the background, lay the paper down flat and let it dry.

5. **Add the flower details.**

 The center of the daisy is an oval of lemon yellow. Add a cadmium yellow shadow to the center while it's still wet for a soft, rounded look.

6. **Glaze the stem and leaves green.**

 After the flower center is dry, mix a yellow-green with water so it's very transparent (a glaze; see Chapter 3 for more details) to paint over the stems and leaves.

 If the background got on your stem, flower, or leaves, you can remove the paint with a stiff brush and clean water. Blot to lift off the paint with a tissue. See Chapter 3 for more on lifting paint.

7. **Finish with the shadows.**

 Paint a blue transparent shadow under the yellow daisy center.

Experimenting with Textures

You can use a number of tricks to create some unexpected textures. It's one of the endearing qualities of watercolor. Have an experimental attitude and you'll make many fun discoveries. Many of the techniques in this section are like revealing surprises and presents at a birthday party. Most techniques are deceptively easy and quick. Not knowing the secrets, your audience will

marvel at how difficult it was to complete your painting and how long it must have taken!

These texture techniques can add interest to an otherwise bland area, or they can create the illusion of depth. You may or may not want to use all your tricks in one painting.

The magic time for making these tricks and techniques work successfully is to do them just as the paint shine is about to leave the paper. You don't want puddles of wetness or areas that are too dry. Shiny damp is perfect. The other challenge is even wetness. Things will work only in the damp area. If you have some areas in your painting that are damp, some wet, some dry, you'll have a variety of effects too.

Sprinkling salt

A little table salt sprinkled on damp paint creates a delicate flower-like spot. Each crystal of salt chases away the pigment to make a lighter area beneath it. You can use this texture to create a field of flowers, snow, or leaves on a tree. It also creates interest in a background or foreground where not much else is going on.

Figure 4-3 demonstrates the beauty that simple table salt can produce.

Figure 4-3: The surprisingly delicate effect of table salt.

Using salt is an experimental technique. Salt doesn't always work like you hope it will. It involves a formula of the right pigment at the correct dampness, and the paper and air to dry at the proper moment. Sometimes you just can't predict what to expect, and that's half the fun. But if you use the following steps, you should get an interesting result from salt. Cross your fingers and practice.

Try salt for some texture:

1. **Get a piece of 5-x-7-inch watercolor paper and wet it with clear water.**

2. **Place the painting on a flat surface, and paint the area where you want to use the salt.**

 A variety of colors lets you see which colors work better with salt.

3. **Wait for the magic time when the paint is damp and shiny.**

 If the paint is dry, this technique won't work. If the paper has puddles, pour them off or absorb the excess water with a paper towel corner.

4. **Add the salt.**

 Less is more. Take a small pinch of salt in your fingers and sprinkle a few grains rather than dumping a whole shaker on your painting.

5. **Let the painting dry without disturbing the salt.**

6. **Brush away the salt after the paint dries.**

If you apply the salt too thickly or add it when the paint is too wet, it tends to stick and not brush off when dry. The salt won't hurt the painting, but it will give it some real texture and a little crystal sparkle.

Soaking up sponges

Watercolorists become sponge connoisseurs. You already should have a cellulose sponge beside your water container to help you control the water (I talk about essential supplies in Chapter 2). You can also use a variety of natural sponges to apply paint or lift it off the paper. Figure 4-4 shows some of the sponges you can use to create fun effects.

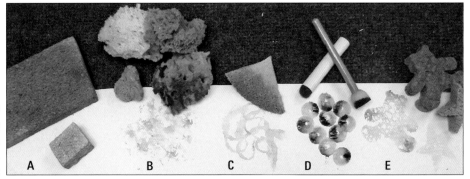

Figure 4-4:
A squeeze of sponges.

A. **Cellulose sponges** are good for soaking up liquid, cleaning palettes, squeezing water onto dry pigments, and stamping sponge texture.

B. A **natural sea sponge** has a variety of hole sizes and can be a quick way to make foliage.

 To make foliage, tap a damp sponge into paint on your palette. Choose several colors to load onto the sponge. Lightly tap the paper with the

sponge to apply the paint. Repeat the tapping, turning your hand to make different patterns and shapes. Reload the sponge as needed. For a softer effect, spray water onto the colors while wet.

You can also use this sponge to layer colors. Apply one color of paint, let that layer dry, then apply a second layer over the top. Continue until you are happy with the result.

C. An **elephant ear sponge** is shaped like its namesake and usually is quite thin. You can wad up this sponge to apply paint and create a cool texture.

You can also use it to lift out clouds in a sky. Apply a sky color to your paper, say blue. Before the paint dries, take a dampened elephant ear sponge and blot up some of the blue paint. Turn your hand so the sponge makes different patterns. You are simulating clouds.

D. A **sponge on a stick** isn't some new, deep-fried county fair concoction. It's a sponge attached to a handle like a brush. A round sponge attached to a wooden handle is great to make circles quickly. Because these brushes come in a variety of sizes, you can use them to make everything from a bunch of grapes to a whole solar system. Try putting different colors on each side of the sponge and twisting it. Fast food! I made the grapes in Figure 4-4 by dipping one side of the round sponge in purple and the other side in green, stamping the brush onto the paper, then twisting to make the circle.

E. **Specialty shaped sponges** come in animal shapes, alphabets, cowboy boots, you name it. Put the sponge in the watercolor and use it like a stamp to make a quick image.

Making a mountain out of a . . . grocery bag

Here's a great way to recycle all those plastic grocery bags. Actually any plastic will work: dry cleaning bags, kitchen food wrap, newspaper sleeves, and so on. The plastic is crumpled and pushed into wet paint. After the paint dries, the plastic is removed and leaves behind lighter areas and a textural pattern. This technique makes great texture for rocks and mountains. It can also be fun to just enjoy the interesting textures.

To use plastic in your painting, follow these steps:

1. **Tear or cut the plastic into a manageable piece and wad it up.**

 If you're cutting sheets, about 6 inches square is a good size. Don't be too precise — anything will work.

2. **Wet your watercolor paper and paint some colors onto the surface using a ½-inch flat brush.**

 You get to choose the colors. If you're unsure of what might look good, try using three colors that are next to each other on the color wheel (analogous colors). Make the colors fairly dark and intense while still being transparent. The plastic will lift off some color so the paint will

become lighter when it dries. If you use pale colors, the result will be subtle but still effective.

3. **Set the wadded plastic on damp paint applied to your paper.**

The paint must be damp to make this work. Don't bother applying plastic to any areas that are dry because nothing will happen.

You can manipulate the plastic on the paper. Use your fingers to pull it around until you like the shape. If you use clear plastic, you can see what's happening. The plastic wrap makes a shape where it touches the paint. The paint is darker where the plastic is crinkled and doesn't touch the paper. You want lots of crinkles for texture. Let some plastic touch and some plastic not touch to create little shapes all over. You can form leaf shapes or creases where you might want a rock. Or you can just put the plastic down at random. If the plastic won't stay in contact with the paper, set something like a can or bottle on it to weight it down.

4. **Leave the plastic on the paper until the paint dries, then lift it off.**

It takes a while for the paint to dry; after all, you covered it in plastic! The plastic leaves a shape behind wherever it touched the paper.

Figure 4-5a shows some plastic wrap textures. Check out the little circles on the top — recognize bubble wrap? Figure 4-5b was created by painting over some of the shapes again with another layer of darker paint.

Figure 4-5:
Close up textures from various types of plastic wrap and an abstract painting using the plastic technique.

a

b

Creepy cobwebs

This isn't an excuse for not cleaning. The cobwebs used for this technique are the ones available at Halloween time to decorate with. These make way-cool textures when put in damp watercolor. One bag lasts approximately forever.

When the polyester strands are pressed into wet paint and allowed to dry, they make unique lines and texture. You can apply paint on top of the cobwebs, too, so they become saturated. The paint is left where the strands of cobwebs were placed, and this technique creates a slight blooming effect, which leaves a bit of a shadow.

1. **Pull apart a small bunch of the cobwebs so they make thin strands in random patterns.**

2. **Stretch the cobweb strands over the edges of the dry paper to hold them in place.**

 Cover the area where you want the effect. If you don't want the whole page covered with the effect, prepare just the area you want.

3. **Use a big brush to apply paint on top of the cobwebs, making sure the paint soaks into the paper.**

 Saturate the cobwebs first so that their wetness makes them stick to the paper. Then cover the rest of the area with paint. You can use a lot of paint because it will be absorbed by the cobwebs.

 In Figure 4-6, I used a bunch of colors that were pretty dark. Lighter colors will produce a subtle effect. You really can't go wrong. Try not to overmix your colors; otherwise they'll blend to mud. Just quickly stroke the colors over the cobwebs, splash and spatter, and let them dry.

4. **Let the paint dry without removing the cobwebs.**

 Overnight might be a good idea if you have the patience to wait.

5. **Pull off the cobwebs.**

 Even though they are colored now, you can reuse them for this technique.

Figure 4-6 shows the results of the cobweb technique. After the cobwebs were removed, I outlined some of the patterns with white ink.

Figure 4-6:
The cobweb technique highlighted by white ink.

Cobwebs can be a lot of fun, though other items work as well. Anything that leaves a mark in wet paint is worth trying. Cheesecloth, for example, used as is or torn apart for a ragged look gives an interesting texture. I have used a fishing net, lace, antique doilies, and the netting that fruit is packaged in at the grocery store.

Spraying, Spattering, Stenciling, and Stamping

Two of the easiest and most used techniques are spray and spatter. You can spray and spatter plain water, masking fluid, or watercolor paint. You can also use stencils and stamps in your masterpieces. A *stencil* is usually made from paper and can be used to contain paint inside an area, or to protect the paper from paint where you don't want it. A *stamp* is a tool that you can use to repeat a shape consistently.

Spraying your art out

You mostly use spray bottles with water, but you can also spray paint for interesting and useful effects.

The different types of spray bottles and their effects include:

- ✔ **Pump sprayer:** Pump sprayers give an irregular spray pattern, which is exactly what watercolorists want at times. These bottles have the pump at the top, and you use your index finger to pull down against a spring to pump the liquid out of the bottle to spray. Remember washing windows with a similar bottle? When you use them, push halfway down to make the spray even sloppier. This looks good in backgrounds and fore-grounds, and makes interesting watercolor texture.

 You can simulate the same pattern by dipping your fingers in water and fast flicking them against the thumb and opening the fingers in a wave hello. When I can't find the spray bottle, this digit-al technique works almost as well.

- ✔ **Trigger sprayer:** Trigger sprayers are the squeeze triggers that release water in a strong stream, like a squirt gun. When you spray water against dry paint, it lifts the paint and makes a light streak. How handy to make a ray of light in the sky? I recommend you do this over the sink because it releases a bunch of water. Have a towel nearby to blot any areas of paint that may run.

- ✔ **Fine atomizer-type sprayer:** These fine-mist small bottles are better to use with paint than water. Because of the small spray pattern, they act like a poor man's airbrush. Spray around the edges of a painting for a vignette look. Darken an area quickly with a spray. You can find these bottles in the cosmetics area of a drug or department store, but art stores carry them too.

To make sprayable paint:

1. **Choose what type of spray bottle you want to use and fill it half full (or half empty, depending on your philosophy of life) with water.**

2. **Add a 1-inch ribbon of paint from the tube.**

 Adjust the pigment-to-water ratio if you want a stronger or weaker color.

3. **Shake the bottle until the water and paint are mixed.**

Mix up as many bottles as you want to have colors to spray. I like to have several colors available — red, yellow, and blue at least.

Spray one color and a different color next to it and see them mix and combine on the paper. There's no end to experimenting with spray bottles.

Figure 4-7 shows what happened when I sprayed paint over a tatted lace-edged cloth dish towel.

Figure 4-7:
Tatted lace
used as
a stencil
with paint
sprayed
over the top.

Flicking your wrist and your brush

You *spatter* with a wet paintbrush and the flick of your wrist. Some artists have made a career out of flinging paint around in this manner. Spatter is more irregular than spray, which may be why it's also known as *fly specking*. Spatter is good for foregrounds of weeds and foliage or abstract texture. You can also use a toothbrush to spatter dark dots in a foreground for interesting texture.

You can spatter with a variety of brushes:

- ✔ **Any watercolor brush** can be loaded with dripping paint and flicked.

- ✔ **An old toothbrush** flicked with a thumbnail produces a fine spray. The upcoming project explains the technique more fully. Don't use your good toothbrush or someone else's. You should replace that one every three to four months; so instead of tossing it, recycle it into your paint kit.

- ✔ **Specialty tools** that look like a bottle brush make perfect spatter, and are, in fact, advertised as spatter brushes.

General spattering technique

The fine points of spattering, if that's not a contradiction in terms, are as follows:

1. **Pick up a juicy amount of paint in your brush.**

 Most brushes work for this technique. Try several to compare.

2. **Hold the brush handle at the end opposite the hairs with the paint-loaded hairs pointing up.**

3. **Make a quick downward motion with your wrist so the paint flies off the hairs onto the paper.**

 Hopefully your paper catches most of the spray, but you may want to wear an apron and cover the furniture for protection.

Sometimes the paint drips. If you don't want a big drip on your painting, try spattering with the paper in a vertical position leaned up against something. That way you don't have to contort your wrist quite as far and the drips will land on the table instead of your painting. Most watercolor wipes up with water, but be sure to protect your table if needed.

Here's a trick to help spatter only go where you want it: Have several old towels in your watercolor painting kit. Washcloths or hand towels are perfect so long as they're dry and clean — never mind the stains. Lay them over the areas of the painting you want to protect from flying spatter. Then spatter. If the paint is too wet, it may soak through the towels, so use a little restraint.

Spattering some texture into your still lifes and landscapes

The following steps show you a great trick for creating the look of granite, snowflakes, speckled enamel, or stars in the sky. As an example, I painted an enamel coffeepot as part of a still life. You need an old toothbrush, soap, masking fluid (discussed earlier in this chapter), paper, and paint.

1. **Dip the old toothbrush in the liquid soap or rub it on a bar of soap to coat the bristles.**

2. **Dip the toothbrush in liquid masking fluid without rinsing the soap off.**

 Shake the excess masking fluid off into the container to avoid drips. If dripping is still a problem, avoid drips on your flat paper by holding the paper vertically or by using an easel while spattering so the drips land on the table or floor instead of your paper. If you want to protect those surfaces, try newspaper.

3. **Hold the toothbrush near the bristles and draw the thumbnail of the same hand through the bristles so the mask sprays off the brush onto the paper (see Figure 4-8).**

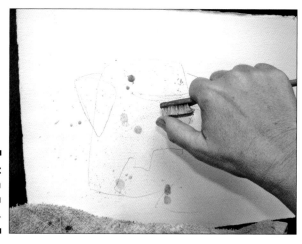

Figure 4-8:
Using a
toothbrush
to spatter.

4. **Let the dots of liquid mask dry.**

5. **Remove any dots you don't want.**

 Did you get a big drop by accident? Not to worry. Just rub the dry mask dot to remove.

6. **Repeat Steps 3, 4, and 5 if you want more dots.**

7. **Paint watercolor over the top of the dry mask dots (see Figure 4-9).**

 I simulated the coffeepot's navy blue enamel using Payne's gray and ultramarine blue.

Figure 4-9:
Painting watercolor over the mask.

8. **Let the paint dry completely.**

9. **Remove the mask.**

 Figure 4-10 shows a closeup of what my coffeepot looked like after I removed the masking fluid.

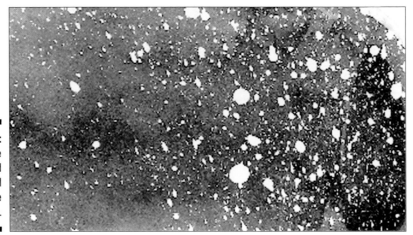

Figure 4-10:
The speckled enamel effect on the coffeepot.

10. Touch up as needed.

For my coffeepot, I toned down some of the dots by painting the white area with a little more watercolor. Depending on what you're painting and what you want to accomplish, you can paint over the white dots, you can soften edges by nudging them with a bristle brush, or you can leave them alone. You are the master of this technique's destiny. Figure 4-11 shows you what I ended up with in the final still life.

Figure 4-11: Spattered mask helps create the look of an old coffeepot in this still life.

Covering stencils

A *stencil* protects what is underneath from paint or provides an area to paint while protecting the surrounding paper. Stencils provide a quick way to achieve a look. And who couldn't use some extra time today?

Anything can function as a stencil: hardware, coins, paper cut or torn into shapes, mesh, doilies. Figure 4-7 in the earlier "Spraying your art out" section was painted by resting lace on the paper and spraying paint over it. The lace served as a stencil. You can make your own stencils out of paper or anything else you have on hand.

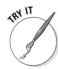

Stenciling is fairly straightforward:

1. Position your stencil(s) on the paper.

You may be laying raggedly torn strips of paper to outline tree shapes or putting a penny where you want a circle to appear.

2. Mix up paint and water in your spray bottles.

The earlier "Spraying your art out" section gives mixing tips.

3. **Paint.**

Often spraying is the preferred method with stenciling, but you can use a brush or a sponge as well.

4. **Let the paint dry before removing the stencil.**

Using stamps — no trip to the post office required

Stamping is a method of creating or finding an item that becomes a paint carrier that can re-create an image multiple times. You know what a rubber stamp is. Same idea. However, rubber stamps are designed and copyrighted by someone else, and you're interested in creating original fine art. Stamping is a time-saving device that can produce a random, loose look.

Follow these steps for a cheap, easy way to make your own stamp:

1. **Get a piece of mat board or illustration board about 2 inches square.**

Your neighborhood frame shop can give you a handful of scraps of mat board for free. Quarter-inch thick foam core board or illustration board also works.

The board needs to have a smooth surface, so corrugated cardboard isn't good, and it's also highly acidic.

2. **Use a cutting tool like a razor blade or utility knife to cut in your design.**

You can create a stamp to produce realistic grass in a matter of seconds. The line you cut is the line that stamps, but it will be backwards. So if you cut a line that curves right on the stamp, it will curve left on your paper.

3. **Attach a tape handle to the back of the board.**

To create the handle, fold a piece of tape in half short-wise and sticky sides together, leaving both ends free to attach to the back of your board.

4. **Mix some puddles of paint in your palette.**

5. **Dip your stamp in the paint and press it on your paper.**

You can stamp numerous times to repeat a pattern if that's what you're aiming for.

If the edge of the square stamps into the paper, try bending the corners upward to prevent them from touching the paper.

Figure 4-12 shows some grass and the stamp I used to make it. You can do the same by scribing a few lines in a stamp to represent grass and repeating the pattern. To add some fence posts in the grass, use the edge of a piece of foam core to apply paint; for wider posts, drag the paint to the desired width.

Figure 4-12:
Stamped
grass
texture and
the mat
board
stamp that
created it.

Painting on Rice Paper

Painting on crinkled rice paper helps you produce watercolors with an artsy look and sometimes an Asian feel. *Rice paper* is a thin, absorbent, see-through paper usually made in Japan. Some papers have designs embossed or imbedded in them. There are many beautiful types available at most art supply stores, and you can use other types of thin paper as well.

Applying paint to rice paper forces the artist to let go of rigid edges and allow a little randomness to take over. Nature scenes work nicely on this type of paper.

To prepare a painting surface for a project using rice paper, follow these steps:

1. **Choose pieces of mat board and rice paper the same size.**

 Mat board is a 4-ply board used to mat artwork when framing. The mat board can be any color, but it will show through the rice paper, influencing the color — which can be part of the fun.

2. **Paint the mat board with diluted white glue.**

 Dilute the glue with enough water to make it the consistency of whole milk.

3. **Wad up the rice paper into a ball and then smooth it back out and place it on the gluey mat board so that it adheres to the mat board.**

 Wrinkles are okay; they add character.

4. **Let the glue dry overnight.**

5. **Start painting.**

Your paint reacts very differently on this surface. It's looser and may have a mind of its own. Paint shows up darker in the cracks of the wrinkles, giving

the image a unique appearance. It's difficult to get a hard edge, but the wrinkles are an interesting design element. Figure 4-13 shows an iris painting using this technique.

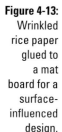

Figure 4-13:
Wrinkled
rice paper
glued to
a mat
board for a
surface-
influenced
design.

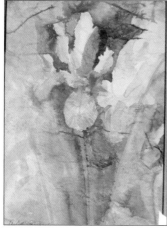

Mixing Watercolor with Other Media

When you use another art medium with your watercolor you automatically have mixed media. (Yes, it's true: I'm good at both art and grammar. *Medium* is singular, and *media* is plural.) Because watercolor is so versatile, it's a natural to mix with many other media.

Watercolor is used on paper, so I don't recommend mixing watercolor with oil paint, which is used on canvas. Remember the old truism: Oil and water don't mix. Oil can also discolor and leach into paper, disintegrating it over a long period of time. Not good.

Including ink over or under your watercolors

Using an ink pen in your watercolor painting adds a dimension of hard, precise lines that you just can't replicate with watercolor paint and a brush. Think of it as making your own coloring book pages and then adding the watercolor. You can do it the other way around too. Paint with watercolor first and then emphasize shapes with lines using a pen.

You can use any pen that you like. It can be a dipped calligraphy pen or a disposable felt-tip. You can go with waterproof ink or not. Your local art supply store offers a vast variety of choices and colors.

If you want your lines crisp, use a waterproof pen. But don't count out the pen that blurs, because it produces a different look that can be very pleasing. You

also see pens described as *permanent,* which means that the ink won't fade over time or in sunlight.

The cityscape in Figure 4-14a was drawn with a waterproof pen and then watercolor was added on top. The boat in Figure 4-14b was drawn with a non-waterproof pen, and the lines blurred when watercolor was added.

Figure 4-14:
You can use a pen to get either hard or blurred lines into your painting, depending on what look you're going for.

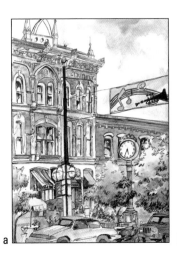 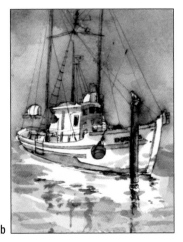

a b

To test pens, take a piece of watercolor paper, write the brand of each type of pen on the paper, then take a damp brush and paint a line of water over the writing. You can tell quickly which ones are waterproof. Waterproof pens should also be labeled as such.

Pairing watercolors with pastels

Watercolor also works quite well with *pastel,* which is a chalk-like, opaque drawing medium. You can use a watercolor wash as background and apply pastel over the top to draw on or to cover over the watercolor. When I first started to watercolor, the results were sometimes less than fabulous. Adding a layer of pastel over the watercolor frequently saved a painting. A white pastel can return white to an area where it was lost.

Pastels come in different shapes. The stick allows you to draw a wide area using the side. The pencils have a nice point and are good for detail and tight spots. They're also especially good for signing your name when you finish a painting. You can use pastels in any scene. I used it in Figure 4-15 in the engine's steam.

If you're using pastels, do your watercolor painting first. Watercolor doesn't go over pastels without making a slight mess. I should also warn you that pastels will rub off — on your hands, on your clothes, on anything it touches.

Figure 4-15:
A puff of steam gets some help from pastel chalk.

Mixing in acrylic paint

Acrylic paint is a polymer-based paint that is water-soluble until dry. When dry it's permanent and can't be easily lifted. It can be painted *opaquely,* which means that you can't see through it.

Some artists mix acrylic with watercolor. For example, say you want something to not be removable. Maybe you want a background that won't lift when you add the next layer. Acrylic is permanent after it's dry and would be a good choice. You can also use acrylic to paint over the top of — dare I say? — a mistake. In Figure 4-16, I painted the poppies with acrylic paint over a water-color wash background. The white is from paint instead of saved paper.

Figure 4-16:
Using watercolor and acrylic paint in the same painting.

Part II
Developing a Solid Foundation

The 5th Wave By Rich Tennant

NAOMI CHANNELS HER EATING DISORDER
THROUGH WATERCOLOR PAINTING

©RICHTENNANT

"I'm working from the spicy side of the color
wheel, blending ketchup red and cheddar cheese
yellow to get the orange sorbet highlights on
the hot dog colored barn."

In this part . . .

These chapters contain the nuts and bolts that hold your art together. The first chapter in this part explores the color part of watercolor. The other chapters help you decide how to arrange your painting subjects according to accepted principles of design. They also offer tips on how to turn what you want to paint into a drawing that you can use as a guide for your painting.

After you have a handle on how all of these tools work together, you can rearrange the components to suit your own style and interpretation.

Chapter 5

Working with Color

. .

In This Chapter

▶ The care and feeding of a color wheel

▶ Getting along splendidly with complementary colors

▶ Breaking the concept of color into its various parts

. .

*E*nglish uses nouns and verbs to convey information. Nouns are people, places, and things. Verbs are the action that happens to the nouns. In art, elements of design are the "nouns" or things (not people and places) that you use in your art. The art elements you can work with include color, shape, size, line, direction, and texture. (Yes, art has "verbs" too — the principles of design. You can read about them in Chapter 6.)

In this chapter, I introduce you to the foundational element of color, and I show you how to create lots of color charts that you can reference in the future. (***Note:*** I spend this entire chapter discussing color because there's so much to say — we are talking about water*colors,* after all. But don't fret: I introduce the other design elements, too, in Chapter 1.)

The exercises in this chapter help you understand your paint. Make the color charts and write the color names beside the paint samples so you can refer to them over and over. These charts are for *you.* Put as much information on them as *you* need. Make the charts the size *you* like. If you need them big, use a full sheet of paper. If you want the pocket-size version, make the charts smaller so you can keep them with your paints for handy reference.

Taking a Spin around the Color Wheel

You know your colors. You learned them in kindergarten. But as an adult, you may have forgotten some of the rules about color, like which colors mix to make other colors or which colors complement each other well. The rules aren't complicated, but you need to know them so you can organize and take control of color in your paintings. One tool that can help is the color wheel.

When light passes through a glass prism or raindrop, the light is split into colors of the rainbow: red, orange, yellow, green, blue, and violet. You can remember their order with the acronym *ROYGBV,* which you can remember as a man's name, Roy G. Biv, with the addition of one small *i. (*The *i* can also stand for *indigo,* a dark blue color.) Artists take this rainbow and curve it into

a circle that becomes the color wheel. The *color wheel* is a guide to organizing your palette of pigments. It can also help you choose colors that make better painting designs. Best of all, the color wheel reminds you of recipes for other colors.

Arranging primary, secondary, and tertiary colors

Before you can start mixing colors, you have to know how colors are created. After you have the basic understanding, you can mix any color you want.

You can buy hundreds of tubes of different watercolor paints, each color with a different name. But if you use a color wheel, you can mix hundreds of colors from just the basic primary colors! What a money savings.

In this section, you figure out primary, secondary, and tertiary colors and then cap off your knowledge by creating your own color wheel.

Primary colors

All color begins with *primary colors.* From primary colors, you can mix secondary colors, and then tertiary colors, and thousands of varieties thereafter. With these color recipes and theories, you can cook up any colors you desire. Primary colors are:

- Red
- Yellow
- Blue

Primary colors are so named because you use them to make all the other colors, but no other colors make them. Nothing you can mix produces primary colors. You can, however, find a vast variety of each of these three primary colors in paint pigments. Check out the positioning of red, blue, and yellow on the color wheel in Figure 5-1. The primary colors are equal distances apart. Figure 5-1 is a guide to follow to begin your own color wheel using the colors in your palette.

Secondary colors

When two primary colors are mixed in equal amounts, they create *secondary colors.* Secondary colors are:

- Orange (mix of red and yellow)
- Green (mix of yellow and blue)
- Purple (mix of blue and red)

Secondary colors are located on the color wheel between the two primary colors that were mixed to create it.

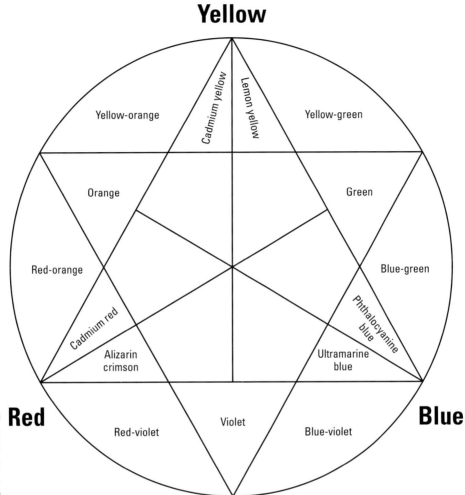

Yellow

Cadmium yellow

Lemon yellow

Yellow-orange

Yellow-green

Orange

Green

Red-orange

Blue-green

Cadmium red

Phthalocyanine blue

Alizarin crimson

Ultramarine blue

Red

Blue

Red-violet

Violet

Blue-violet

Figure 5-1:
A template
for a basic
color wheel.

Tertiary colors

When a secondary color is mixed with a primary color, they produce a *tertiary color.* Tertiary colors are:

- Red-orange
- Yellow-orange
- Yellow-green
- Blue-green
- Blue-violet
- Red-violet

Tertiary colors are located on the color wheel between the secondary and primary colors that were mixed to create it.

In life, someone must be first, and someone must be last. So it is with color names. The color is the same whether you call it yellow-green or green-yellow.

Making your own color wheel

Make your own color wheel. Follow Steps 1 to 3 to draw your own color wheel or copy Figure 5-1 on cardstock and continue with Step 4. Use the colors you own to fill in the color wheel. You need to buy the primary colors, but you can mix your own secondary and tertiary colors, which I call *luxury colors*. Luxuries make life easier. The purchased "luxury" colors are more intense, but the mixed versions of secondary and tertiary colors create a unity in your painting (more on unity in Chapter 6).

1. **Draw a circle with a pencil on a piece of watercolor paper.**

 Trace around a plate or something round. You choose the size you want.

2. **Using a straight edge, make two triangles inside the circle.**

 Make the first triangle's points touch the circle with the bottom leg horizontal, and try to make all three sides equal in length — an equilateral triangle.

 Make another triangle upside down so the points fall on the circle between the points of the first triangle.

3. **Label the first triangle's points with the primary color names — red, yellow, and blue.**

 It doesn't matter which point gets which color, but it may be easiest to follow Figure 5-1.

 Divide the triangles whose tips point to the primary colors by drawing a straight line from the point to the middle of the triangle leg on the opposite side of the wheel.

4. **Paint each primary color where named.**

 Apply a little water to the paint (if you haven't set up your palette yet, refer to Chapter 2). Mix enough pigment with water to get a rich color in the mixing area of your palette. Fill in the whole little triangle with the color that corresponds to the label name. Use a round brush and practice making a graded wash in the little triangle. Let the paint be darker near the outside edge of the triangle, but keep it transparent enough to read the name of the color through it. (Chapter 3 has more on graded washes.) Adding more water makes the paint lighter; less water makes the paint darker.

 Follow the model in Figure 5-1. You now have a primary color wheel.

5. **Mix secondary colors next.**

 If you have tubes of paint that are secondary colors, skip to Step 6. To mix primary colors to get secondary colors, follow these steps:

 A. Add water to two primary colors and mix a little puddle of each color on your palette leaving an inch or two between. Rinse your brush between using each color so you don't contaminate your pure pigment puddles.

B. Rinse your brush again, then bring a little of each of the two colors together in the middle.

Equal amounts of primary color should produce a nice secondary color, but sometimes one primary is more potent.

You can adjust the color by adding more of one or the other primary. By gradually mixing the colors, you get a variety of color choices as opposed to mixing both whole puddles together and having only that one color. Don't be afraid to experiment. Play. Label. Discover.

Write down the names of your mixed colors and their recipes or formulas. After you add your secondary colors to your color wheel, you can refer back to it to remember how a color was made.

If you have tubes of paint in secondary colors, compare the color you mix and the tube color. Which one do you prefer?

6. **Fill in the points of the second triangle you drew with the secondary colors. Make sure to put the colors between the correct primary colors.**

Use the mixtures from Step 5 or pure paint pigments that correspond with the secondary color names.

Getting along with complementary colors

"You look so nice today" is a nice compliment. Opposite colors on the color wheel are *complementary* (notice that the two words are spelled differently), which means they also look nice together and can help neutralize each other.

Creating complements

A *complementary color* of a primary color is the secondary color opposite it on the color wheel (take a look back at Figure 5-1). They look nice together; maybe that's why they're complementary. Tertiary colors can also be complementary — any colors opposite each other on the wheel are complementary colors.

You can use analogies to remember complementary combinations. For instance:

- ✔ **Orange and blue** are the colors of sunsets. Living in Colorado, I remember the colors of the Denver Broncos football team.

- ✔ **Yellow and purple** are the colors of spring and Easter eggs.

- ✔ **Red and green** are Christmas colors.

Make a chart of complementary colors.

1. **Draw a 4-x-1-inch rectangle on watercolor paper using a pencil.**

2. **Use a 1-inch flat brush to paint clear water in the rectangle area so the area is damp — no puddles, no dry areas, just a shiny, even, wet surface.**

3. **Paint ultramarine blue on one short side of the rectangle, rinse your brush, then paint burnt sienna on the other end. Blue and orange are complementary.**

 Burnt sienna is a red-orange-brown color. You can use any complementary combination you want.

4. **Before the clear water dries, brush the two colors toward the middle of the rectangle to make a smooth transition between the two. Let the colors mix in the middle.**

 The middle should mix to gray if the colors are diluted with water, or the mixed colors should be nearly black if you're using thicker colors with less water in them. You may even want to try mixing colors using more or less water to see the variety of new colors you can discover.

5. **Label the colors you used with a pencil.**

6. **Repeat these steps with other complementary colors and label your choices.**

 Try mixing black and yellow. These two colors usually turn green because black has a lot of blue in it.

 Make a chart of as many greens as you can figure out to mix, using whatever blues and yellows you have. Write down the names of the colors you use so you can remember your formulas when you want to create these colors again. Now observe a landscape in the summer. How many greens are in nature? It's probably infinite. Now you are aware and really seeing that landscape. Marvelous!

Practice making a gradual change from one color to the other. (If you have trouble controlling the water, remember to blot excess water in your brush on a sponge after rinsing it in clean water. Refer to Chapter 3.)

When you mix complementary colors together, they make a *neutral gray.* After you make several complementary color bars, look at all the gray colors you created. Use the chart to remember how to obtain those colors when you need them in a painting. These colorful grays are more lively than straight-out-of-the-tube grays.

Neutralizing with complements

You can make a color less intense, tone it down some, or *neutralize* it by adding a little of the color's complement. Neutralizing the color makes it look a little more natural. For example, green paint right out of the tube is usually too bright. Landscapes look more natural when you calm down a bright green by mixing in a little red (the complement of green). You can mix hundreds of wonderful greens this way.

Even though yellow and blue make green, if you mix equal parts of yellow, blue, and green's complement, red, you get gray. So first mix yellow and blue to get a green you like. Then add a small amount of red if the green is too bright or intense. Experiment with the different reds you have.

Other colors can need a bit of neutralizing too. Say you're painting a drizzling English sky. Bright clear blue just isn't working. Add a bit of blue's complement, an orange like burnt sienna, to knock down or neutralize the color and make the sky grayer.

You can neutralize any color by adding a bit of its opposite or complementary color.

Getting to white and black and tints and shades

So where do white and black fit into the color wheel? Surprise! They aren't considered colors. White is the *reflection* of all color, and black is the *absorption* of all colors. Black and white also help to get tints and shading into your colors, so they're extremely important even though they aren't colors per se.

Making black and white

Now that you have the physics of creating colors down, what do you do when you want black and white in your painting? You can buy tubes of black and white paint, but in transparent watercolor painting, you traditionally include white by using the white of the watercolor paper. The best way to achieve white is by carefully painting around the area you want to remain white. Because you must "save" the whites, you need to plan paintings by sketching where white will go. Another way to save white is to use masking fluid. (Chapter 7 talks about planning your painting; Chapter 4 tells you how to use masking fluid and talks more about keeping white in your paintings.)

Of course, you can buy white paint, but it can produce a chalky, dull look that isn't as nice as the beauty of a glowing transparent watercolor paint. Some watercolor snobs frown on the use of white paint, and some watercolor exhibitions even prohibit its use. But white paint is available, and if it looks good, go ahead and use it.

White looks white because of the darks surrounding it. Sometimes an area that looks white has a lot of color painted in it.

You may think you can use a tube of black paint, but be careful. Black straight out of the tube can be lifeless and look like you punched a hole in your paper. You're much better off mixing your black from other dark colors. My favorite black formulas include:

- Ultramarine blue and burnt sienna for a blue-gray. Add some violet for a transparent blue-gray.
- Violet and Payne's gray for a purpley-gray.
- Hookers green and alizarin crimson make a green-black.

To get solid, dark black, you may want to build up the color by layering the paint, allowing the layer to dry before applying the next layer. It's difficult to get dark blacks on white paper on the first try. Just like painting a room, sometimes you need a second or third coat.

Tints and shades

You can also add white or black paint to another color. When you add white, the new color becomes a *tint* of the original color. That's how red becomes pink, for example. When you add black, you make a *shade* of the original color. That's how you get maroon from red.

Make a chart of tints and shades. You can use Figure 5-2 as a guide.

1. **Using watercolor paper, grab your pencil and draw a 4-x-1-inch rectangle for each color exploration.**

2. **Choose a color and place it in the middle of the rectangle. Rinse your brush.**

 A flat ½-inch brush makes painting these rectangles easy because of its shape.

3. **Paint black on one short end, rinse your brush, and then paint white on the other.**

4. **Blend a *gradation* (a slow, smooth transition) from black to the color and from white to the color.**

 Rinse your brush between colors.

 You must blend the colors while they're still wet. If they dry, you may be able to blend them by rewetting the area with clean water and rubbing with a stiff brush like a bristle brush. Even wetness is the key to blending colors. If you get a dry area while another area is wet, let it all dry. When it's dry everywhere, rewet evenly and try to blend again. Uneven wetness is dangerous territory. When in doubt, dry it out!

 Try to leave some of the center color pure without black or white. Practice making the transitions smooth. (For more blending instructions, review Chapter 3.) When you're finished, you should have a chart showing the color in a range of tints and shades with the true color in the middle.

 You can also paint the color and gradually add water until the color fades to just the white of the paper. Compare the tint you create using white paint and the pigment diluted with water.

5. **Label your color name in pencil, and repeat the exercise with other colors.**

 Try as many colors as you want to explore. Tint red with white to achieve lovely pink colors. Shade blue with black for the colors of a night sky. Tint and shade all the colors to see what other discoveries you can make. Label the color names you use.

Figure 5-2:
Example of
cadmium
red tinted
and shaded.

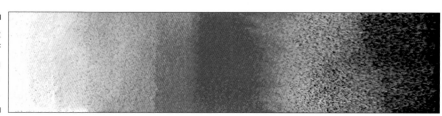

Transparent versus opaque

Transparent watercolor is what appeals to me. It "glows" from the light that bounces through the paint and is reflected back to the viewer.

You can also buy opaque watercolor called *gouache,* which is pigment with Chinese white added.

Some watercolor pigments can be opaque too. Cadmiums, for example, can be opaque. More water added makes every paint transparent. Both types of watercolor make beautiful results. Each is just a matter of style.

Avoiding mud: The bias color wheel

As you begin to mix colors, sooner or later you encounter (cue sinister music) *the ominous mud. Mud* is the result when the colors mix up just plain ugly. You can get mud when mixing a neutral color from complements (see the "Getting along with complementary colors" section earlier in the chapter). Or mud can appear when paint is *opaque,* meaning you can't see through it. *Transparent* paint allows the viewer to see through the paint. Light bounces through the paint to the white paper and back into your eye so you see glowing colors. You can't see through opaque paint, so the light can't bounce off the paper and no light is reflected. The result can look chalky and dull — like mud.

Mixing complementary colors neutralizes colors, which looks like a gray-brown color. Sometimes this is a useful, beautiful color. Mud or neutral? It depends on your intention — but it's important to know how to get what you want or avoid what you don't want.

So why do you sometimes mix colors and get a color that isn't what you hoped it would be? Here is the secret:

Paint pigments are not pure colors. They may have a little bit of another color in them. So when you mix red and blue and hope to get purple, it sometimes comes out brown. Mud. How did that happen? You need to have the correct red and blue. For example, if I mix cadmium red and Prussian blue together, I should get purple, right? Yes, according to what the color wheel says. Instead, I get a muddy brown. Why? Those two colors have a tiny bit of yellow in them. So essentially, I mixed yellow, red, and blue, a formula for neutral gray. Without knowing it, I mixed the wrong blue and red. So it is important to understand which primary colors to mix to achieve secondary colors.

Each color contains a primary color adjacent to it on the color wheel, and that adjacent color is called the *bias.* The red and blue in my example each had a yellow bias.

So each primary color has two biases:

- ✔ Cadmium red is biased yellow; alizarin crimson is biased blue.
- ✔ Cadmium yellow is biased red; lemon yellow is biased blue.
- ✔ Phthalocyanine blue is biased yellow; ultramarine blue is biased red.

Figure 5-3 shows a bias color wheel.

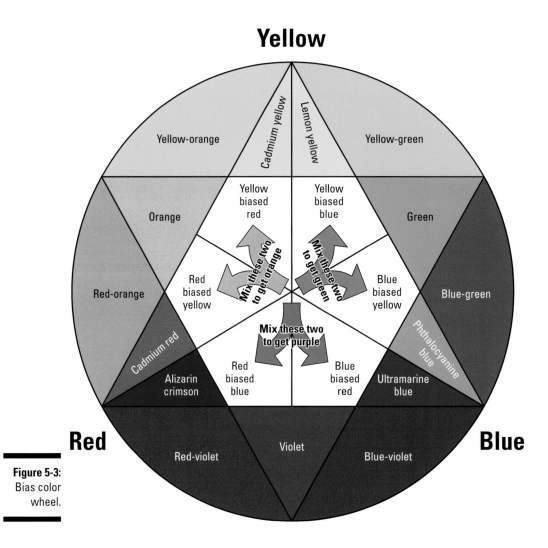

Figure 5-3:
Bias color
wheel.

So, you need to have two of each primary color on your painting palette so you can mix colors that have the right bias. Sometimes you have to visually evaluate the color to determine the bias. Compare it and see which color it leans toward to determine bias.

When you mix two primary colors to get a secondary color, use the primaries biased toward each other; for example, use a blue that is biased red (ultramarine blue) and a red that is biased blue (alizarin crimson) to make a nice purple. That way you have only two primary colors involved. Three primary colors mix mud. Say the primary and its bias out loud when mixing. If you mention three primaries, you have mud.

Breaking Down Color into Parts

Color is one of the most attractive elements of art. Color has four parts:

- ✔ **Hue:** Basically another word for color.
- ✔ **Value:** Describes how light or dark the color is.
- ✔ **Temperature:** Relates to the feeling of warmth or coolness the color evokes and to whether the color recedes as cool colors do or comes forward as warm colors do.
- ✔ **Intensity:** Measures the range of a color from dull to vivid. Synonyms are *chroma* and *saturation.*

Another important aspect of color is the psychological or emotional effect that color plays. By understanding all the parts of color, you control what you say in your painting and how you say it.

Hue goes there?

Hue is simply the name that describes the color: red, blue, yellow. The words "color" and "hue" are similar in meaning. Hue also refers to a family of color based on the primary and secondary colors. The tint pink is a hue of red. We may have cute names for pigments, like daffodil, but it's a yellow hue.

Value: What's it worth to ya?

Value is the lightness or darkness of a color. Each color has a *range of value.* Think of white as step 1 and black as step 9. Each of the seven steps of gray in between is one shade darker than the one before it.

It's easy to see value in black, white, and gray, but colors also have steps of value. However, most of them don't have all nine steps. The number of steps is the range of value. Some colors, like yellow, have a narrow range of value. Full-strength yellow may be only the same value as step 3 in gray. Blue, on the other hand, has a deeper range of value. A dark blue can be a step 8 or 9 in the value range. Figure 5-4 shows the value ranges of some common colors.

Squint your eyes when looking at a color to reduce the hue into a value. As you squint, you see the lights and darks and eliminate the color. You can also reduce color to just value by looking through a piece of red transparency film. Everything will be red, sure, but you can see the values.

To change a color's value, add water to lighten the color, and use less water to darken it. A transparent watercolorist only uses water to change value. A nontransparent watercolorist may use white pigment to tint the color.

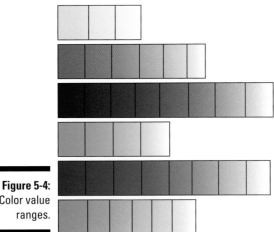

Figure 5-4:
Color value
ranges.

Seeing the lighter side of colors

To make any color lighter, add water to the pigment.

Explore the value range of each of your colors, and see how many steps of value you can find for each.

1. **Choose a color and squirt paint from the tube into your palette.**

 If the paint is too stiff to brush out, bring a dab out onto the mixing area of the palette and add enough water to make it slightly soft. You don't want to dilute the color yet, so add very little water.

2. **Paint the pure pigment on the paper in a 1-inch square.**

 A ½-inch flat brush makes rectangles easily because of its shape. This pure pigment is 100 percent as dark as the color will go.

3. **On your palette, add a little water to the paint in the mixing area. If you get too much water by accident, add a little more pigment.**

4. **Using that value, paint a second 1-inch square that is one step lighter than the first pure-pigment square.**

5. **Add a little more water to the paint on the palette, and paint another square that is a step lighter than the previous one.**

6. **Repeat Step 5 until you can't make the color any lighter.**

 Try to make each consecutive step lighter than the last, as shown in Figure 5-4. This figure shows you how many steps of value you can get from a color. Make a value range for each of your paint pigments.

Turning to the dark side

Getting a rich, dark value with watercolors can be tricky. The paint is diluted with water and it evaporates as the paint dries. The color can dry 30 percent lighter than you thought it was when you applied it wet.

You may think that piling on more of the color is the way to make it darker. Instead, the color becomes opaque and chalky — the opposite of the transparent look you're aiming for — and it still isn't dark. The color only becomes as dark as the value range will allow. In other words, lighter colors like yellow will only be so dark; they'll never be as dark as colors like blue or green.

You can make values darker two ways:

✔ You can control the value by using less water to dilute.

✔ You can combine colors to produce dark values.

Black seems like an appropriate color to use to darken another color. But sometimes black just makes the color lifeless. Instead, add a color with a deeper range of value to darken a lighter color. If you're painting an apple, alizarin crimson is a good hue to begin using. For the shadow area, add a darker color like ultramarine blue.

Make a chart to mix dark colors. Make triangles with the two paired colors from the following list at the top two corners, and bring the mixture down to the bottom point of the triangle. Label the colors. Can you find other combinations that make a rich dark?

✔ Hookers green and alizarin crimson

✔ Ultramarine blue and burnt sienna

✔ Burnt umber and phthalocyanine blue

✔ Cadmium red and Prussian blue

✔ Burnt umber and phthalocyanine green

Temperature: So cool, it's hot

Temperature is the feeling of warmth and coolness in colors.

✔ **Warm:** The colors of fire are warm colors: reds, yellows, and oranges. Warm colors give the illusion of forward movement in a painting. A red sports car will get a speeding ticket before the blue one because it appears to be going faster because of its warm color. Warm colors advance.

✔ **Cool:** The colors of water are cool colors: blues, greens, and violets. Backgrounds like sky are the hue blue. Cool colors help create the illusion of distance in backgrounds, forests, and bodies of water. Cool colors recede.

On the color wheel, warm colors occupy one half, while cool colors are on the opposite side. Now that you can find them, here is a way to use them. Warm colors seem to come forward. Cool colors seem to move away. You can use these temperatures to "push" and "pull" space. Create the illusion of depth in your painting by using warms in the foreground to make them seem to come toward the viewer and use cools in the background to make the scene look like it has distance.

You may hear warm and cool used to describe the same color. You can have a warm red — a red that has yellow in it — and a cool red — a red with blue in it. Although red is a warm color, it can be labeled cool if it has blue in it. It's similar to color bias (see the "Avoiding mud: The bias color wheel" section earlier in this chapter). Red biased blue is cool. Red biased yellow is warm. Artists use this information to push and pull space within the same color area.

Intensity: In your face, or not

Intensity describes how vivid or dull a color is. Other terms for intensity are *saturation* and *chroma*. A color is at its most intense straight out of the tube or pan. Anything you do to that color — adding water or mixing in another color — lessens the intensity. You can choose to have a bright, intense color by using the pure pigment, or you can make your colors a bit more natural by muting them with water or other colors.

Few items that you paint are as pure in intensity as paint straight from the tube. Usually, you need to mix a color with water or another color to make it look more natural.

Some exceptions, like flowers and sunsets, are very intense or bright, so you can use pure pigments as bright as you want. In the painting of roses in Figure 5-5, I used the most intense colors I could find straight out of the tube to simulate the beauty and chroma Mother Nature uses in flowers.

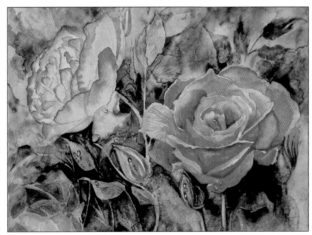

Figure 5-5: Intensely colored flowers.

By adding water or another color, you also change value. Value is light to dark (see the "Value: What's it worth to ya?" section earlier in the chapter). Intensity is brightness. Changes in one part of color affect other parts of color. Adjust with water or other colors until you get the color you want to match.

Influencing emotions with color

Color has implied meanings and can evoke certain feelings. You can say volumes without any words just by the colors you choose in your painting. To see what specific colors mean, take a look at Table 5-1.

Table 5-1		Colors and Their Emotional Content		
Color	**Meaning**	**Use**	**Spectrum**	**Pigment Names**
Red	Powerful, attention getting, passionate, very emotional, speedy, aggressive	An attention-getting device that draws the viewer's eye to the main point of interest. Notice that paintings of Western scenes always have a red kerchief around the cowboy's neck.	Deep red, like maroon, looks rich; light red, like pink, is romantic.	Crimson, lake, alizarin, carmine, rose madder, cherry, scarlet, opera, cadmium, vermillion
Blue	Loyalty ("true blue"), calm, serene, clean, dignified	Sky color backgrounds, great as snow shadow as well as other shadows, water.	Light blues are sporty and youthful; dark blues are business-like and wealthy.	Cerulean, ultramarine, manganese, compose, peacock, cobalt, Prussian, phthalocyanine, viridian, royal, indigo
Yellow	Happy, sunny, lively, cheerful	Used in package design as an attention grabber; can be overpowering.	Bright yellow is lemon, while yellow ochre is brown earth tone.	Cadmium, gamboge, lemon, Indian, aureolin, Naples, jaune brilliant, raw sienna, yellow ochre
Green	Natural, healthy, organic, tranquil, spring, soothing, positive, can be associated with envy ("green with envy")	Most commonly used in landscape painting.	Modern greens are lime, chartreuse, and forest green. Dull greens are olive and drab green.	Olive, leaf, sap, viridian, permanent, emerald, compose, terre verte, bamboo, hookers

(continued)

Table 5-1 *(continued)*

Color	Meaning	Use	Spectrum	Pigment Names
Purple	Royal, unnatural, creative, eerie, sophisticated	Traditionally regal, recently recognized as a freedom color for ladies over 50 paired with red.	Light purple is cobalt and biased blue. Dark purple is violet and biased red.	Lavender, cobalt, mineral, lilac, Mars, and dioxazine
Orange	Fiery, warm, glowing, citrus, fall	Used in sunsets, fall foliage, and landscapes.	Light tones are peaches; dark tones are rusts.	Cadmium, vermillion, brilliant, permanent
Brown	Earthy, rich, fertile, sad, natural, wistful	Called earth colors and are nonstaining; used in land-scape and architecture.	Light browns are beiges and tans. Dark browns suggest hardwood and leather.	Burnt sienna, raw umber, burnt umber, vandyke, sepia
Black	Night, death, evil, elegance, wealth	Popular with artists, the "goth" crowd, and fashion. Often avoided in paintings because of its harshness.	Absorption of all color, black can be made by mixing dark values of color to make color-ful blacks.	Payne's gray, lamp, ivory, neutral tint, peach black
White	Purity, innocence, peace, medical, sterile, cleanliness, winter	Clouds, moving water, and snow. White paint added to color makes a tint.	White paint is usually not used in trans-parent water-color; white is achieved by leaving the white of the paper.	Chinese, zinc, titanium

Chapter 6

Practicing the Principles of Design

In This Chapter

▶ Keeping your balance when juggling painting elements

▶ Introducing subtle changes

▶ Pursuing repetition

▶ Being more dominant, but in a nice way

▶ Creating unity in your paintings

*R*emember in school learning to spell *principle* and *principal?* The name for the "pal" who ran your school is spelled with *-pal* on the end. The other "principle" means "rule," and both of these words end with *-le.* Although most artists may not like rules, they are important as guidelines to begin your art hobby or career and can be broken when you feel confident. With these rules of art, you can make design principles your "pals" too.

Chapters 1 and 5 talk about the elements of design, or the "nouns." The principles of design are the "verbs." In this chapter, you take the elements and use them in art actions like the verbs take nouns and give them action in sentences. Each principle can be applied to each element of design. In this chapter, you get to know how you can mix and match elements with principles.

The possibilities are endless using the few short rules of design. You can have more than one element and principle working in your art. In fact, you may have too many. To figure out if the art is working or can be improved, look at it and discuss it with others. The elements and principles are the language artists use to discuss and critique art. You can come up with unlimited design and painting solutions by using the principles I talk about in this chapter.

Every rule can be broken. That's why art is so fun. Play around, and make up your own rules.

Going Back to the Playground to Keep Your Balance

Remember the teeter-totter? I remember playing on one with a kid who was much larger than I was. The big kid thought it was hilarious to sit on one end and hold the equipment down while I dangled helplessly above. Things were definitely out of balance. I got help from another friend, and teaming up, we two little kids could bring the teeter-totter to a level position. We were back in balance. Balance in your painting is similar, but it's a visual balance rather than a physical one. And, just like with a teeter-totter, you can achieve balance in two different ways:

✔ Something with **symmetrical** or **formal balance** is equal on both sides. People are symmetrical, for the most part. If you draw a line down the middle of your face, or the middle of your body for that matter, the two halves mirror each other. A checkerboard is another example — it has an equal balance of red and black.

Keeping things equal on both sides of your picture definitely provides balance, but a painting with symmetrical balance may not be as interesting as one with asymmetrical balance, which I discuss next. The trees in Figure 6-1 are in symmetrical balance.

Figure 6-1:
Trees in symmetrical balance.

✔ With **asymmetrical** or **informal balance,** you achieve equality in each half using different numbers, weights, or shapes on each side of the center line. Asymmetrical balance is often more artistically interesting than symmetrical balance.

Instead of identical trees on each side of a painting, you can paint one large tree on one side and two smaller ones on the other. Or you can blur the lines between the two trees as in the paintings in Figure 6-2.

Figure 6-2:
Trees in asymmetrical balance.

The teeter-totter example at the beginning of this section talks about asymmetrical balance in which two small kids balance one larger kid on the other side of a teeter-totter. An uneven number of parts creates equal balance because of differing sizes and weights. Now, switch kids with circles. One big circle on one side of a painting can be balanced with a bunch of small circles on the other side. Visually, the page looks balanced.

Pictures can be top- or bottom-heavy as well. If the picture feels heavy in one area, move the elements to make it more visually comfortable or in balance. If you can't move the elements, remember the lesson and use your knowledge in the next painting. You gain experience with each painting that you make.

 Save yourself from discovering your painting is out of balance after you're too far along to make many changes. Plan your paintings by first making a *thumbnail sketch* (more on thumbnails in Chapter 8). By planning the painting, you create a road map to your destination — a great painting.

Because asymmetrical balance is so much more pleasing to the eye, I show you in this section how to put asymmetrical balance in your paintings using the various elements of design. I focus especially on ways to balance color.

Balancing the elements

Every element of design can be balanced or unbalanced (Chapters 1 and 5 talk about the elements in more detail). The following list goes through the elements and offers ways to asymmetrically balance each element:

✔ **Color:** A small bit of intense color can balance against a big area of gray.

✔ **Direction:** A few slanted angles can balance many verticals.

✔ **Line:** One wriggly, energetic line can balance against a bunch of horizontal, calm lines.

✔ **Shape:** A big triangle can balance against a whole page of circles.

✔ **Size:** One big can balance against a bunch of littles.

> ✔ **Temperature:** A small bit of warm red can balance against a big area of cool blue.
>
> ✔ **Texture:** A bit of rough can balance against a lot of smooth.
>
> ✔ **Value:** A small dark can balance a large area of light.

These are by no means the only ways to reach asymmetrical balance. The solutions are infinite. After reading my list, think of some ways you can use asymmetrical balance with each element to make an exciting picture.

Weight is a visual determination, not an actual weight in grams or pounds. Look at the elements you have to work with and decide which are heavier and which are lighter. Some elements look heavy. Some elements appear light. So several light elements can balance out one heavy item visually.

Focusing on color balance

You can balance any of the elements, but balancing color needs a little more attention. I talk a lot about color in Chapter 5 and define the properties of color as hue, value, temperature, and intensity. Each of these aspects of color can help you achieve balance.

Highlighting hue

You can't actually weigh colors, but depending on how you use them, some colors are heavy and some are light. You have to go by how the viewer will react to the color. (*Hue* names the color: red, yellow, blue, and all the others.)

How important a color is in the painting and how much attention it attracts determines how much it weighs. Red, for instance, is always attention getting and associated with danger through cultural teachings, so consider red a heavy color. A little dab of red can weigh as much as a big bunch of a light, airy yellow. Yellow often seems visually light, but a bright yellow can grab attention in a hurry, in which case it has more weight.

Next time you walk down the grocery aisles, notice the colors on labels and packaging. Marketing experts use colors that attract buyers' attention. You can use the same colors to give weight to your painting. Just remember to balance them with some calmer colors so the eye has some resting areas too.

Check out Figure 6-3. Yellow and red are both attention-grabbing colors, but the larger area of yellow in this figure is balanced by a smaller area of red.

Grasping intensity

Intensity refers to the brightness of the color. A more intense color carries more weight visually than a less intense or dull color. A dab of chartreuse balances against a big area of drab olive green in Figure 6-4.

Figure 6-3:
Yellow and red balance each other if used in the right proportions.

Figure 6-4:
Balance your painting by pairing different intensities of color.

Talking temperature

In Chapter 5, I tell you how you can divide the color wheel in half to see warm colors — reds, yellows, and oranges — on one side, with cool colors — blues, greens, and purples — on the other. Generally, warms are the color of fire, and cools are the colors of water. To add to the confusion, each color can be biased toward a warm or cool color on the color wheel, which I explain in detail in Chapter 5. Purple, for example, can be more red, so warmer, or more blue, so cooler. The warm or cool feel to a color determines its temperature. When you understand color temperature, you can balance it in your painting. A painting can be dominantly cool with a contrast of warm or vice-versa. If you choose to use only warm colors, the painting may not feel balanced. You can also use temperature in shadows. If an object is warm, it casts a cool shadow. The red apple casts a blue shadow.

The warm red drapes in the painting in Figure 6-5 balance the cooler colors in the rest of the room.

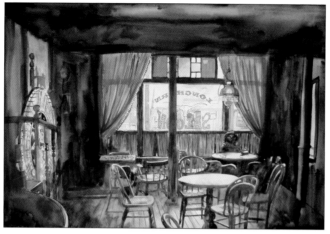

Figure 6-5:
The warm
red
balances
out the cool
blues and
purples
in this
painting.

Balancing temperature is an area that has no set rules that I know of, so feel free to experiment with warm/cool balance. Also, try keeping a dominant temperature, making the painting mostly cool or mostly warm.

Appreciating value

Value, where the color is on the range of light to dark, can be balanced too. Darks and lights can carry weight in a picture — darks more than lights. If all the dark area is on one side of the picture, it may feel heavy on that side. The value of the dark sky balances the value of the dark tree in the foreground in the painting in Figure 6-6.

Notice that nothing is really going on in the sky area, but by adding the darker value, it directs the eye back into the light area of the painting. Value is independent of color. The value can be dark blue or dark green. The eye will see value before it sees color.

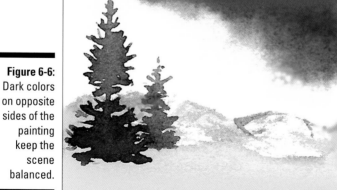

Figure 6-6:
Dark colors
on opposite
sides of the
painting
keep the
scene
balanced.

Change the values often. It's too easy to stick to *middle values* (gray or what falls between light and dark). Lights and darks make the painting sing. The lightest light touching the darkest dark within the painting will be the center of interest. It's an extreme value change (or *contrast,* which is discussed later in this chapter). An entertaining painting displays the entire toolbox of values and uses a value pattern to lead the eye around the painting. And finally, the values need to be balanced. It's a recipe of a pinch of this and pound of that and a little of the middle. You can find out more about value in Chapter 5.

Making Ch-Ch-Ch-Changes

You make many *transitions* or changes in art. Your painting goes from one thing to the other: blue to green, light to dark, big to small, cool to warm, and so on. How you make these changes provides new principles of design. The three main ways of making changes within your art are:

- ✔ **Contrast:** A big or abrupt change
- ✔ **Gradation:** A small, gradual change
- ✔ **Harmony:** A medium change

Comparing contrast

I hope you're having a quiet afternoon to sit back, sip tea, and read this book. If, however, a fire engine screeches to a halt outside your door with a siren blasting, that would be an attention-getting contrast. *Contrast* is putting two strikingly different items close together. An abrupt change is always attention getting.

Figure 6-7 provides an example of contrast in color. This picture is a large area of dark blue with a small, intense yellow butterfly at the bottom. The bright yellow is a surprise against the dark blue; it contrasts with it. The yellow is intense, light, and clean. The blue is dark, heavy, and textured. Surprise! Contrast.

Figure 6-7: A neon yellow butterfly provides contrast on a page of dark blue.

To choose contrasting colors, use your color wheel (check the Cheat Sheet at the front of the book for a sample). Colors that live close beside one another on the wheel are somewhat related and don't contrast with each other. The biggest contrast comes from juxtaposing complementary colors — those opposite each other on the wheel. The yellow of the butterfly is not the complement of the blue (that would be orange), but next to blue's complement, so it's a *split complement*. Split complement schemes make for interesting contrast; the colors vibrate with energy.

Of course, intensity and value also need to be the right recipe. If all the colors are neutralized (toward gray) or darkened or lightened, they may not contrast dramatically.

Because contrast attracts attention, it's a good thing to use in the center of interest. Contrast works with any element. One pointed triangle in a painting of all curvilinear shapes is contrast. A bit of bright white in a low-key (mainly dark) painting is contrast. Abrupt change of any element is contrast.

As in life, contrast must be used sparingly. Too much contrast in your picture creates chaos, just as the siren and hubbub become annoying if they continue.

Grading your changes

The slow, subtle change of gradation can sneak up on you, just as age does. *Gradation* is a subtle, gradual change of light to dark, of warm to cool, of one color to another. It's my favorite type of transition in watercolor. Instead of using one color to shade the side of a building, use a warm orange that slowly becomes a cool blue.

If the changes are smooth and subtle, the audience won't even see a difference, but they'll notice a more interesting scene. They may not even figure out what you did to make it more interesting!

Try making a graded swatch:

1. **Paint a 1-x-4-inch rectangle of watercolor paper with clear water.**

 If you use a 1-inch flat brush, this is one brush stroke. The area should be shiny damp. If the paper absorbs the water and dries immediately, add another stroke of water.

2. **Choose two colors. Paint about 1½ inches of one end of the paper with one color, and paint the opposite end with the other color, leaving about 1 inch of clean paper between them.**

 You can choose any two colors you'd like. You can experiment with primary mixes to see what secondary mix happens in the middle. Or choose opposites to see what neutral results from the complementary colors. In Figure 6-8, I used ultramarine blue and rose madder.

3. **Use your brush to gently blend the two colors together.**

 Pull a little color from each end toward the center. Add more color if needed.

Figure 6-8:
Gradation
exercise
using blue
to red.

You may want to pick up the paper and tip it back and forth to let gravity help in the process.

When you're finished, you should have a slow, smooth transition from one color to the other. You've made a graded wash.

Change colors` often in your paintings — at least every inch. Because of the slow, gentle change in graded washes, you can use as much gradation as you like. Gradation just makes things more intriguing. Use abrupt change like contrast (see the previous section) sparingly.

Check the areas of gradation in Figure 6-9. The house roof has a subtle gradation of warm color on top where the sun hits that gradates to a cool area near the house. The yellow walls of the second story are a gradation of earthy ochre at the top changing to a bright lemon yellow, then changing back again on the ground floor. The trees have numerous gradations of green. The grass is a gradation of yellow-green to a blue-green. The shadows have color gradations. These color changes are much more eye-catching than having only one color, value, or intensity.

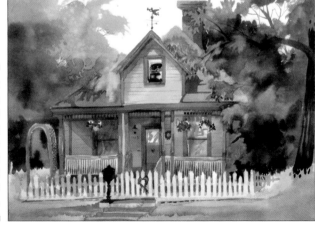

Figure 6-9:
Many areas
of this
painting
take
advantage
of gradation
as a means
of change.

Shadows are more entertaining to the viewer if they combine several colors, and they're perfect candidates for gradation. A shadow using slow gradation of blue to red with purple in the middle is more to look at than just one straight color.

Creating harmony

Often people like each other because they are somewhat alike — they get along, they're harmonious. Creating *harmony* in a painting involves the same principle. You use colors or shapes that get along.

To find colors that make sweet harmony, you just look for colors that lie next to each other on the color wheel (check the color wheel on the Cheat Sheet at the front of the book). And, unlike some human relationships, neighbors on the color wheel all get along. Because the colors are so closely related, they create harmony. Another term for colors directly next to each other is *analogous* color.

You can create harmony by making slight changes and repeating any design element in a slightly altered form. For example, you can repeat round shapes but vary them slightly.

The still life in Figure 6-10 repeats ovals, circles, and round shapes with slight variations to create harmony throughout the painting. Upon a round tray sits an oval silver teapot, round fruits, a curvy creamer, a concave spoon, a sugar bowl with an oval top, a wine glass filled with orange juice, and a tea infuser all in oval shapes. Even the flowers in the background have oval centers and petals.

Paint It Again, Sam: Repeating Yourself

Repetition is another principle of design . . . another principle of design . . . another principle of design.

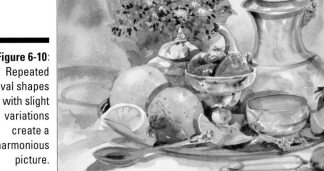

Figure 6-10:
Repeated oval shapes with slight variations create a harmonious picture.

You can repeat any element in paintings: repeat colors in all areas of the painting; repeat values; repeat shapes; repeat lines or textures.

Repetition is visually pleasing, though you need to make use of some tricks to keep repetition from becoming boring. The next sections address variety and alternation, the two principles that work within repetition.

Providing variety

You know the adage "Variety is the spice of life." Variety is the spice in art as well. *Monotony* or sameness can change a potentially good painting into a bedspread pattern and put the viewer to sleep. Of course, there's nothing wrong with pattern. It's just that to make a great painting, you need to add variety to keep the viewer's attention.

Figure 6-11 shows two paintings of trees. Figure 6-11a shows a pattern of some very nice trees. Figure 6-11b takes those nice trees, adds variety, and produces a better painting. Each tree is a different width and a different height, is on a different plane (trees on a plane! Not a good title for a movie, I guess), and is a different distance from its neighbors.

Repeating without variety is an easy mistake to make. Figure 6-12 shows two thumbnail paintings with sky, clouds, mountains, foothills, trees, and foreground. The repeating zigzag in every aspect of Figure 6-12a is too much the same. Variety to the rescue! By zigging where I zagged before, I created a better result in Figure 6-12b, which makes use of repetition *and* variety.

While Figure 6-12 is exaggerated, it's easier than you think to repeat horizon lines, as in the before picture. In the after picture, adding variety lets the horizon lines overlap and go in different directions. Overlapping layers creates depth, so don't be afraid to paint layers over one another. Make a conscious effort to add variety to horizon lines for interest.

Practice variety in a thumbnail sketch (turn to Chapter 7 for more on these itty-bitty paintings). The following are some suggestions to explore variety:

- Make a painting repeating one type of shape (circle, square, whatever). Place a bunch of the same types of shape in your sketch area. Change sizes from very big to very small. You are using repetition of shape with variety of size.

- Make horizontal, diagonal, and vertical lines. Add thickness to some of the lines for variety.

- Use a variety of greens in your landscapes rather than one color. Refer to Chapter 5 for color formulas.

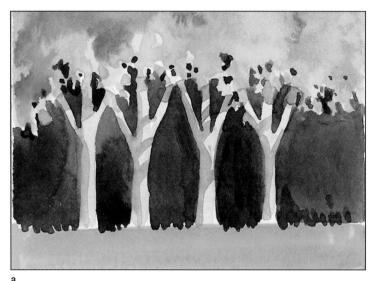

a

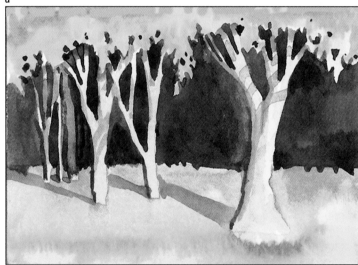

Figure 6-11:
Before and
after variety
is added to
a forest of
aspen trees.

b

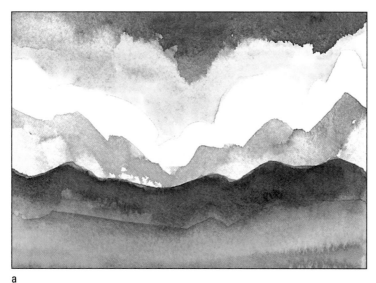

a

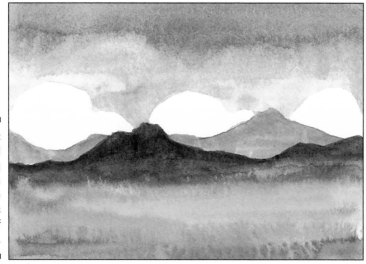

Figure 6-12:
Before and
after adding
variety to a
landscape
that makes
use of
repetition.

b

Making alternations

Alternation — not to be confused with alteration, despite the clever heading — is a type of repetition used mostly in creating patterns. The idea is to take a couple of elements (or more) and create a pattern by alternating between them: long, short, long, short, long, short; or circle, square, circle, square. If you want to shake up the pattern, you can use alternation with variation. Short, long, short, long, long, short, short. Keep 'em guessing!

Alternation can be a handy principle to use in an abstract work. When combined with variety, it can be a handy principle in a realistic work too. For example, imagine a painting of a tall tree, short bush, taller tree, tallest tree, and short bush. This combines alternation with variation, which are both forms of repetition. Figure 6-13 shows a repeated design with alternation of circles, swirls, and lines.

Figure 6-13: Circles, swirls, and lines show alternation in action.

Moving toward Total Dominance

Dominance is the idea of importance. Some object or element in your picture should be dominant — take the lead role — in the painting. Without dominance, your painting may show too many things of equal importance. Choose something to be more important — something to be dominant.

You can establish dominance using any of the elements — color, texture, line, shape, direction, or size of an item. For example, in a painting with all curvilinear lines and round shapes, the curved lines are the dominant element. You can do the same thing with squares. If the squares are all the same size, it might be a fun pattern, but boring as a painting. But if one square is dominant over the already dominant square shapes, you have an interesting painting on your hands. The dominant square may be larger than the others, a different color, a different texture, or even turned a different direction.

In art, there's more than one right answer. Unlike math where two plus two always equals four — and four is the only correct answer — art contains hundreds of right answers. That's good news! So in choosing dominant elements, there are many ways to achieve the correct answer for your painting.

Taking it one painting at a time

You may be a bit overwhelmed by all the principles and rules. But keep in mind that you can't use every element and principle in every painting. The elements and principles are all your *choices*.

Starting to paint with watercolor is like learning to ski: To improve, try one new thing each ski run. One time when you go down the slope, you may concentrate on a pole plant. Next time you may try to improve carving an edge. Do the same thing with your painting: One time concentrate on balance using colors. Next time try repetition of a shape. Choose one element and one principle to concentrate on, and enjoy the process. When you finish the painting, stand back and analyze it. What did you discover? What can you take to the next painting?

Don't set yourself up for thinking you must make the perfect painting. The perfect painting has not been made. After all, when asked what my best painting is, I always say it's my *next* one.

Consider choosing a dominant temperature for your painting. Overall the painting should have one consistent temperature — either cool or warm. (Chapter 5 talks about color temperature.) An easy mistake to make is to evenly mix temperatures. For example, a landscape with a blue sky (cool) and autumn wheat grass (warm) is divided in half by temperature. By making one temperature dominant, you improve the painting. Choose one temperature and follow it throughout the painting. Move the horizon so it doesn't bisect the painting (for more on horizon placement read Chapter 7). If you move the horizon up toward the sky, then the warm grass colors are two-thirds of the painting. Put clouds that have some warm tones in the sky, and now the painting is seven-eighths warm, so the painting is dominantly warm. You now have a dominant temperature, which makes your painting more appealing.

Another area to consider in your painting is the dominant value. The entire painting should be dominated by light or dark. A painting in which all the parts are in a high or light value is said to be a *high-key* painting. Conversely you can keep all the parts in your painting dark to create a *low-key* painting. Choosing a key is key.

Choosing a dominant color may be a good plan. Consider Picasso's Blue Period. All his paintings were dominantly blue. Try using one color as a dominant element in your painting with a little complementary color for contrast. Use different values of the dominant color for variety.

It's not a bad idea to plan the dominance in a painting. You can choose several elements at a time to be dominant: color, value, temperature, shape, size. You can use them all or focus on one at a time. Of course, you don't have to do any of these suggestions. These are just ideas to improve the design of your painting.

Anything can be dominant, but only *one* object should be dominant. Two dominant objects spell trouble, just like in a pack of wolves. If more than one thing attracts attention, the eye is torn between which item to look at. In a painting, it's best to be clear about the main idea you want the viewer to see.

Make a small painting exploring dominance. I'll leave the subject matter up to you for this exercise! Feel free to get creative. My exercise is shown in Figure 6-14.

1. **Choose the size of watercolor paper you want for your painting.**

2. **Choose a color to be dominant.**

3. **Choose a color temperature to be dominant — warm or cool.**

 I chose cool blue.

4. **Choose a value to be dominant: light (high key) or dark (low key).**

 My winter scene is high key.

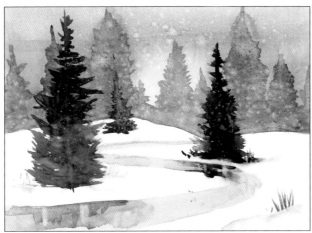

Figure 6-14: This miniature painting shows dominance in color, temperature, and value.

Striving for Unity

A painting that has it all together is said to be a unified painting. *Unity* is defined as being as one or whole. A unified painting is well balanced in all elements and all parts of the painting. Every element is necessary, and if something were taken away, it would be missed.

To determine whether a painting has unity, mentally divide it into quarters by drawing center lines vertically and horizontally. Now imagine separating the quadrants and see whether the four separate pieces look as if they belong together. If the pieces were tossed together with the quarters from three other paintings, would you be able to tell which pieces go together? If you can answer yes, you're looking at a unified painting.

To achieve unity within a painting, you need something from the top to be found in the bottom and something from the bottom should be in the top. If you're working on a landscape, put some of the foreground color in the sky, and put a little sky color in the shadows of the foreground. One element in

only one area is alien. Use repetition. Also look from side to side. If you have a green tree on one side, you need a little green somewhere on the other side.

Figure 6-15 shows a painting with a horizon in the middle. On the top is sky of blue. On the bottom is amber-colored grass with one alien green tree in the lower-left quadrant. If this painting were divided into quarters, you might be able to find the two halves, but nothing from the top relates to the bottom — nothing indicates that the halves belong together. This painting hasn't achieved unity.

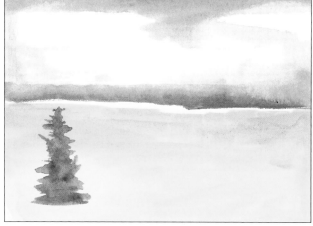

Figure 6-15: An un-unified painting doesn't hang together.

To unify this painting, repeat the color of the grass in the clouds, and introduce some of the sky color into some of the shadows in the grass. Repeat the green in some other area so it's no longer just in one spot. The four quarters of the painting in Figure 6-16 now look like they came from the same painting.

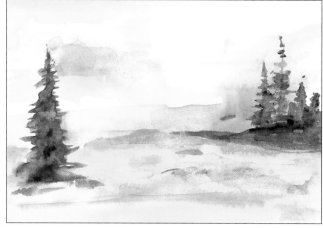

Figure 6-16: A little repetition goes a long way in making a painting unified.

Chapter 7

Composition: Putting
It All Together

I used to think the most inhibiting word in art vocabulary was *composition*. After all, if anything was wrong in a painting it was always blamed on bad composition. But, composition was never well defined to me. It was just this ambiguous but all-encompassing source of blame. I don't fear composition anymore and neither will you because, after reading this chapter, you'll be more familiar with the concepts involved.

Composition encompasses the entire picture and how it is set up. Composition includes the elements and principles of design (covered in Chapters 1, 5, and 6). Composition also takes into account the visual path the viewer's eye takes when looking at the painting.

I liken composition to eating. You eat the same foods over and over. The meals you remember are the ones that combine interesting ingredients and present them exquisitely. In painting as in food, it doesn't matter what's on the menu, it matters how it's prepared and arranged.

By looking at paintings, analyzing the way they are put together, and knowing the vocabulary to discuss paintings, you gain an understanding of composition. Understanding is the way to relieve anxiety and fear about any topic. And understanding composition helps you improve your paintings.

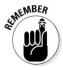

In this chapter, I merely offer guidelines to follow (remember there are no perfect paintings, alas, not even mine). Ten artists discussing most design and composition elements probably would come up with ten different opinions. Analyze the rules and goals yourself, and take with you what you prefer to put into your own paintings.

Setting the Stage

As a painter, you wear many hats, and one of them is the beret of a set designer.

Picture your painting as a set designer does a stage. You're designing space within your painting on a flat sheet of paper. To get some depth and dimension, think of your painting like a stage and include the following:

- ✔ A **foreground** close to the front or bottom of the page. The foreground gets the viewer interested and attracts him to look into the painting.

- ✔ A **middle ground** appropriately in the middle. Often, most of your action takes place here.

- ✔ A **background** farther into space, usually toward the top of the page. The background usually incorporates sky in any outdoor scene and fabric or wall in a still life.

Figure 7-1a shows a cross section of these three areas in a landscape, and Figure 7-1b shows the final painting.

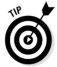

When designing the areas of foreground, middle ground, and background, the three areas are best if made in three different sizes — small, medium, and large. (Chapter 1 has more on using size as an element in your painting.)

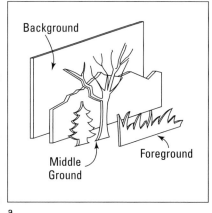
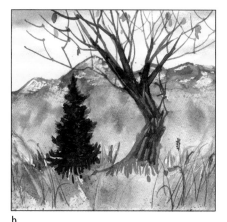

Figure 7-1: Think like a stage designer when composing a painting.

a

b

Studying Values

Relax, I'm not delving into your morals. When talk turns to *values* in the artistic crowd, the conversation is about light and dark in your painting. (Chapter 5 has even more on values.)

One of the most important things to plan, especially in watercolor, is where to put lights and darks in your painting. Because transparent watercolor uses

the white of the paper for the light areas, you need to plan to save the whites and light areas by planning where to put the darks. It's easy to use color and forget value; however, the eye sees value first and color second. A value pattern of lights and darks keeps the viewer entertained and excited when looking at your painting.

Every time you paint, you're composing a symphony. The lights and darks are the high and low notes. Most of the melody is somewhere in between, in the middle range. The lights and darks need to scatter throughout a painting. Too much of the same note is monotonous and boring. Variety saves a song and a painting from this fate. Always look for ways to create variety. (See Chapter 6 for tips on ways to work variety into your painting.)

Exploring different value combinations

When planning what you're going to paint, you need to decide what combination of values you're going to use and where you're going to put them. Figure 7-2 shows several versions of the same basic scene of a sailboat and its reflection in the water with different combinations of light, mid-tone, and dark in the foreground, middle ground, and background. The foreground is the sailboat and its reflection in the water, the middle ground is the surrounding water and the mountains behind the boat, and the background is the sky.

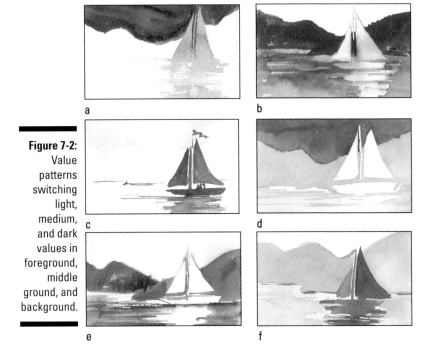

Figure 7-2: Value patterns switching light, medium, and dark values in foreground, middle ground, and background.

The six paintings each have one of each value — light, mid-tone, and dark. Although each study has lights and darks in tiny quantities throughout the painting for definition, the big areas are foreground, middle ground, and

background. I simplified light, mid-tone, and dark to these three areas. By changing the values and areas, I created six different value patterns:

a. This painting uses light in the mid-ground water and mountains, mid-tone for the foreground sailboat and the reflection, and dark value in the sky in the background.

b. This scene uses mid-tone in the foreground sailboat and reflection, dark in the mid-ground water and mountains, and light in the sky in the background.

c. The dark sailboat and reflection in the foreground, mid-tone values in the background, and light in the middle ground give this value study the appearance of a photo negative.

d. This painting has white in the foreground sailboat, with mid-tones filling out the middle ground and the dark values depicting an ominous or a nighttime sky background.

e. A light foreground with the sailboat and reflection is surrounded by dark values in the water and in the mountains in the middle ground, leaving the background sky to recede into the mid-tones.

f. Dark values in the foreground draw attention to the sailboat and its reflection, while the mountains in the mid-ground recede, and the white of the background sky gives the impression of a powerfully sunny day.

Choose your favorite value pattern and translate it into color, retaining the dark, medium, and light values. Figure 7-3 shows my effort from the Figure 7-2e value study.

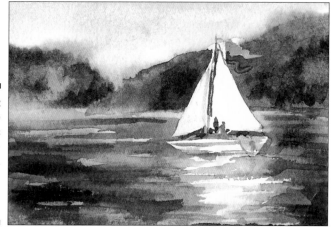

Figure 7-3: Three values separate foreground, middle ground, and background.

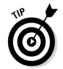

Make a separate sketch, called a *value study,* just considering the values and where they go, then choose which one works best for you to work up in color. ("Starting Small with Thumbnails" later in this chapter talks about preliminary thumbnail sketches.)

Trying out transposition of value

One way to use value effectively is to put a dark item against a light background or vice versa, as in the sailboats in Figure 7-2. Better yet, do both within the same item.

Imagine a fence post in a painting. The fence post is pale gray, nearly white, weathered wood against a field of dark amber wheat stalks. As the fence post reaches the horizon line, it changes to a dark silhouette against the brilliant blue sky, as shown in Figure 7-4. This *transposition of value* is an excellent way to entertain the viewer. Even though the object is all the same color in theory, it changes value depending upon what value it's near.

When you're planning your painting, look for areas that could use transposition of value. Are there areas that can present a light against a dark and transition into a dark against light? This is a good device to attract attention to a center of interest or a significant content issue.

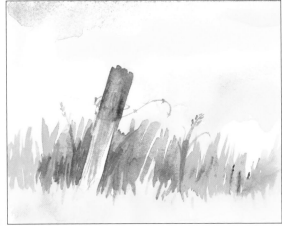

Figure 7-4:
Transposition of value ideas explored in a thumbnail sketch.

Figuring Out Compositional Formats

Choosing the size and shape of your painting is your first big decision. The shape of your paper helps determine the format of your composition.

Staying in shape

A typical watercolor format is with the longest length of the paper horizontal — your desktop printer calls it *landscape* view and so do other artists. But don't forget other formats. You can choose the other view your printer knows, vertical or *portrait,* where the paper is longest vertically. You can break out of these standard views and paint in a square or make your painting any other shape you choose — oval, short and wide, tall and thin, you name it.

Traditionally paintings are rectangles. But because this is art, I would never want to stifle your creativity if you think out of the box. In art, go for it. Try for the award for originality. In the meantime, I'm going back to traditional thinking.

One rectangle may not be enough. Perhaps you need to make a larger statement. You can make several paintings work together to form the overall look of a large painting. Two paintings that go together to make a big painting are called a *diptych* (sounds like *dip*-tick). Three that go together are called a *triptych* (sounds like *trip*-tick). You can frame these separately or together using a mat with several holes. (Chapter 3 has more on presentation and framing.)

Choosing a size

Figuring out what size to make a painting is an important decision to make early. Miniatures cost less to produce, frame, and purchase. Murals are hard to ignore. You may find the answer somewhere in between.

You can get watercolor paper in any size you want, including a roll of watercolor paper as tall as you are and yards and yards long. It's physically challenging to paint, frame, and install a piece that large, but if you want big paintings, there is no limit to the supplies. (Chapter 2 has more info about sizes of watercolor paper.)

When choosing what size to paint, look ahead to the end result. When you finish your painting, you probably want to mat and frame it so it can hang in a major museum — okay, maybe it hangs at home first.

One thing to consider is framing. You can buy standard sizes of premade frames or order a custom frame to fit the size of your painting. Custom framers can make any size frame you need and help you choose the best mat colors and frame molding for your masterpiece.

You can save some money by painting to standard sizes to fit ready-made mats and frames. Some ready-made frame sizes are 8 x 10 inches, 9 x 12 inches, 11 x 14 inches, 16 x 20 inches, 18 x 24 inches, and 20 x 24 inches. A quarter sheet of watercolor paper is 11 x 15 inches. Adding a 2½-inch mat on all sides fits into a standard 16-x-20-inch frame. If you're on a budget — and what artist isn't — using a standard frame saves you a pile of bucks. Turn to Chapter 3 for more on matting and framing.

Directing Placement

How do you decide where to put things in your painting? Be careful how you answer because placing items in your painting is one of the biggest elements of composition.

Guiding the viewer's eye

You're composing, arranging, and organizing a scene. You need to group items to draw the viewer in and create interest. You provide the path for the viewer's eye to travel within your painting. You also need to leave some areas where not much is happening to give the viewer's eye a resting place. The items in the painting are connected by value or color or line or whatever you decide to use to take your viewer on this path to look at everything you want them to see.

Without organizational formats to place the important elements in a painting, the result is chaos. Your job as an artist is to create order, not chaos.

Using the alphabet as your guide

The alphabet is a great source as a guide to overall placement plans in a painting. Use the shape of the letter as a guide to placing the good stuff, as well as the path the viewer's eye travels when looking at the painting. An "S" becomes a winding river or road leading up to a little barn and silo. For lefties, the letter "Z" does the same thing. Other favorite letters to follow for compositional sources are "L," "C," "H," "N," and "Q." Okay, I just made up "Q" to see if you could see it. Actually, it may work. The idea is that you have an organizational plan. Figure 7-5 shows some alphabetical placement patterns.

Figure 7-5: Guiding the viewer's eye with letters.

Using lines and shapes

Vertical and horizontal lines act as eye-stoppers to contain the viewer within the painting. Hopefully the viewer finds enough in the painting to be entertained and keep looking for a while — maybe long enough to get out the credit card and take it home.

You can use other shapes to organize space as well. Figure 7-6 shows a horizontal format, vertical format, diagonal format, and *cruciform* format (sometimes called a cross), each of which works well for composition placement.

Eventually the viewer must exit the painting, but make sure you don't drive him out by making distinct diagonal lines to the corners.

Centering the viewer's interest

As the director and producer of your painting, you need to choose a star of the show, known as the center of interest. The *center of interest* is the focal point of the painting, the main object or area that you want viewers to see. Everything else should be supporting players in your stage show. If you give equal importance or attention to more than one item, you confuse the viewer, distract her attention, and make her eye leave the painting in search of something she understands more easily. You may even bore her, and you want to entertain her. So you need to decide what you want your audience to see in your painting. What struck you when you were moved to make this painting? What inspired you to paint this scene, this group of objects, this creature? The answer to those questions is what you want in your center of interest.

How do you make your item or area the center of interest? You tell your audience that it is the focal point of the painting by making it more detailed, brighter, bigger, sharper in contrast, or the lightest light against the darkest dark area.

In contrast to its name, you do *not* want to put the center of interest in the center of your painting. If you draw an X that reaches the four corners of your paper, the intersection of the lines is the exact center of the page. Nothing of importance should go there.

Instead, take a lesson from the Greeks and Romans, who invented the *rule of thirds.* Actually, they called it something a lot more complex — you know those Greeks and Romans. They made some very complicated formulas you can follow to find the perfect point of placement, but they liked math more than I do. An easy way to get to the same spot is to imagine a big tic-tac-toe board on your paper, which divides your paper into thirds both horizontally and vertically. The intersections of the lines are the choice spots to set your center of interest. Choose one.

The center of interest doesn't have to be just one item; you can have an area of interest, rather than one center of interest. If you are painting a grouping of flowers, you can make one area more defined and interesting, thus making it an area of interest.

Sidestepping Composition Blunders

When it comes to day-to-day living, avoid these things: walking down dark alleys late at night, consuming too much alcohol, eating too much fried food, getting too much sun. In painting, you also want to avoid certain things, such as placing important elements at the center or corners, to make your compositions better.

Steering clear of the center

Just as the center of interest doesn't belong in the center of the page, don't place other elements there either. A horizon cuts the painting in two if placed in the center. You do better to shift it up or down for a more interesting painting.

Avoid dividing the paper vertically too. Don't have a tree, a flower, a sailboat mast, or anything else split the paper into two equal sides.

Equality has no place in art. Make variety your new motto. Vary the sizes of the spaces, the colors, the directions — everything should have variety. (Chapter 6 goes into more detail about variety.)

Staying out of the corners

A line leading to any corner of the paper is an invitation to the viewer to follow that line right out of the painting and on to the next one. If you have a road or a river leading into the picture, make sure the continuation of the line, even if it isn't visible or painted in the picture, leads the viewer's eye above or below the corner and not directly to it.

Kissing tangents goodbye

Tangents are items or lines that touch or just kiss. Kissing is good for people but bad for paintings. Tangent areas make it difficult for the viewer to figure out what's going on in the painting. A much better solution is to overlap shapes and lines so the viewer knows what's in front and what's behind. This also creates a deeper sense of space. Creating a sense of deep three-dimensional space on a two-dimensional surface like flat paper is difficult enough, so use all the tricks possible to make it believable.

"That's the way it is in my photograph" is no excuse for poor composition. I once painted a landscape with a tree that had half its foliage missing. I think I put it in the center of the page too. It looked silly. But that was the way it was. So what? This is art. Are you recording a scene like a camera? Or are you composing a fabulous work of fine art? Your choice.

Pushing background back

A beginner's *faux pas* (goof) is to timidly put a little vase of flowers in the center of the paper and leave a whole lot of background with nothing going on. Fill your space. Make the subject go completely out of the picture plane. Crop the photo you're working from for interest.

Make every shape in your painting interesting, and that includes the background shapes. Perfect geometric circles, squares, and equilateral triangles aren't interesting. They are predictable and straight. Make shapes with different lengths and widths and unexpected edges. When painting trees, remember that the area between the trees also needs to be designed as a shape. No two trees should be the same height or width, and so it is with the area between the trees.

Starting Small with Thumbnails

Put away the polish and nail file; you aren't getting a manicure. A *thumbnail* is a mini-size sketch you draw to work out the kinks before you spend all that time, effort, and money on the full-size painting. These sketches serve as little road maps so you know where you're going to end up in your painting. After all, without a road map you may get lost.

Few things improve your painting more than planning your painting by using a thumbnail. As Ben Franklin said, "Failing to plan is planning to fail."

Artists call these little sketch plans thumbnails, but usually the sketches are a bit larger than an actual thumbnail. I make them about 1½ x 3 inches, but there are no rules. In fact, the only person who sees these sketches is you, so you call the shots.

Figures 7-7a and 7-7b show thumbnails for the fence post painting in Figure 7-4 and for the iris project coming up next.

Figure 7-7:
A couple of thumbnails.

a b

When you're ready to start a painting, think through the composition visually by following these steps to create a thumbnail sketch:

1. **Draw a small shape that represents your painting.**

 It doesn't have to be to scale; you just want to duplicate the general shape.

2. **Sketch your idea with a pencil or paint in watercolor.**

 Usually you don't want to wait for watercolor to dry for these quick sketches. I usually just draw a rough idea in pencil unless I need to decide color choices.

3. **Sketch another version of your idea.**

 Always make several thumbnails to work out an idea. You then can choose the best one. It may be your first one. It may be your last one. Unless you make several sketches, you may not know if the one you've done is the best one.

4. **Choose the sketch you want to paint, enlarge it, and transfer it to your watercolor paper.**

 Chapter 8 has instructions on how to enlarge and transfer your thumbnails.

You can keep a sketchbook with all your ideas, journaling, and organization, or you can just doodle a thumbnail on scratch paper and toss it in a box for later. (And, no, you can't toss it in the round file. How will you measure your progress?) Choose either method of saving your sketches to fit your needs.

Sketchbooks are great to collect ideas and recall them at a later time. Sometimes you feel creative; that's the time to jot down all the different ways to make a painting. Another time, the ideas may not be flowing as fast, and you can get out the sketchbook full of thumbnails from more fruitful days.

Take your sketchbook everywhere. Keep one in the car, and if you're waiting on something, you can always sketch. If you sketch with watercolor pencils, you can solve color issues too. Put dates on the pages, and you have a record of your ideas and when you had them.

Make a cool tool that helps you focus in on your subject and doesn't cost a cent: Get an old overexposed 35mm slide, take out the lousy film, and leave just the slide frame with an open hole. Look through the frame to help you see your subject. Use it like a viewfinder in a camera. Close one eye and look through the frame. As you move the frame closer to your eye, the view is wider. As you move the frame farther away, you crop the view.

Project: Finding a Natural Setting for Flowers

I live near an iris farm, which sometimes makes up for the dairy farm that moved in next door. I took the picture for this painting where the flowers are breathtaking and meticulously labeled. I sometimes like to think of the title of a painting before making it. This flower is called Color Me Blue, which seems the perfect title.

When painting flowers in a natural setting, you don't need to worry about copying them exactly. Each frill on a petal can wriggle in a different way. Each leaf can be different. Start with the outline drawing, but don't stress over making an exact copy because it doesn't matter.

The composition you're copying is a backwards letter "C." The center of interest is in the lower left-hand third.

1. **Decide what size you want your painting and transfer the drawing in Figure 7-8 to your paper.**

 I chose a vertical format for the upright iris on 8-x-10-inch paper, but you can copy the image any way you want.

 See Chapter 8 for help on transferring the drawing pattern to your paper.

Figure 7-8:
An iris drawing to trace, enlarge, and transfer to watercolor paper.

2. **Activate your paints.**

 I used lilac and cobalt blue in the flowers and a variety of yellow (including yellow ochre), green, and blue in the leaves and the background. A small bit of cadmium orange and burnt sienna accents the flowers and their stems.

3. **Start by applying a transparent wash of lilac in the flowers using a round brush.**

 I used the same #10 round brush for the entire painting out of laziness. Yes, even the tiny letters were done with the tiny point that can do itty-bitty detail. When pushed down, the bristles splay into a big wash fan for large areas, such as making the grassy areas in the foreground.

 Lay the brush down nearly on its side to sweep in a lilac wash quickly over the flowers. Put the point of the brush toward the edge of the flowers and wriggle in the edge quickly. Don't worry about a very smooth wash; the variety in light and dark looks like shadows. See Figure 7-9.

Figure 7-9:
The beginning under-painting layer of the flowers.

4. **Let the flowers dry completely.**

5. **Paint in the background using the wet-in-wet technique (for more on this, see Chapter 3).**

 A. First wet the entire area around the flowers with clear water so the paper remains damp.

To keep the paper from buckling and to give you extra time with the background, dampen the back of the paper with a wet sponge.

B. Quickly cover the background area with a variety of greens, yellow ochre, and some drops of lilac. Keep it damp, transparent, and loose.

C. Flick some drops of clear water in the background green with your fingers. This will make little backwash blooms for texture. If water hits dry paper, like the petal, just leave it to dry.

See Figure 7-10. When you're happy with the background, let it dry.

Figure 7-10:
Add the
background.

6. **When the background is dry, paint the details. See Figure 7-11.**

A. Use a darker green and paint the dark spaces between the leaves. The leaves appear by negative painting around them with darker background colors. (You can find more on negative painting in Chapter 3.) You can follow the drawing or just put leaves wherever you see the need.

Remember your composition. Use variety. Make different heights, widths, space widths, and colors in the leaves.

B. Detail the flowers with some darker blue and lilac. The most detail is on the lowest flower, and the darkest darks are placed near it, making this flower the center of interest.

The words "Color Me Blue" on the tag next to the bottom flower are an irresistible draw of attention painted using burnt sienna. If this isn't enough to make the center of interest, hammer it home by adding the warm cadmium orange touches, with the cleanest application at the lowest flower.

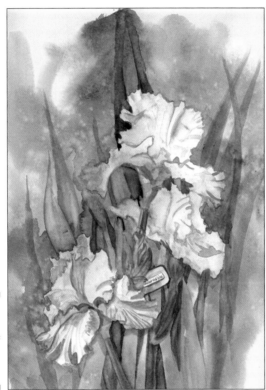

Figure 7-11:
The final details of *Color Me Blue.*

Chapter 8

Draw, Drawing, Drawn to Watercolor

Drawing is the basic essential to all art. Drawing is important in watercolor because you need to plan in order to save the precious white areas in your painting. With a good plan and a basic outline in place, your paintings will be more successful. The drawing methods in this chapter relate to drawing needed for watercolor paintings. You need to draw shapes accurately and understand how shadows and perspective work to make your paintings believable.

Watercolor requires a drawing unless you are working experimentally and looking for an abstract result. If you are working *representationally,* meaning that the painting is supposed to represent or look like something of the real world, you need a drawing.

When drawing in preparation for your watercolor, you are collecting information for your painting. Because you'll be painting the image, you need only the *cartoon,* or outline of the areas and shapes. You don't need to do shadows and shading; you paint those aspects. You may want to outline the shadow area to remind you where to paint the darks and lights, but the drawing is for your use only. You determine how much detail you need to include to accomplish the painting.

Drawing takes time and practice, but after you acquire the skill, drawing can fill your life with something to do forever. In our society of immediate gratification, it's hard to wait for a lifetime of practice before you get started. Good news. This chapter offers a number of quick ideas to make drawing easy and painless. (If this chapter really sparks your interest in drawing or you want more in-depth instruction, grab a copy of *Drawing For Dummies* by Brenda Hoddinott [Wiley].)

Drawing Geometric Shapes and Adding Dimension with Shadows

One of the best methods to use when you're new to drawing is to see things as simple geometric shapes. Almost everything can be broken down, or *abstracted,* into circles, squares, and triangles. When these flat shapes get three-dimensional form, they become spheres and cylinders, cubes, and pyramids.

When I start talking about drawing, everyone immediately says, "I can't draw a straight line." Who cares? Straight is boring. There aren't any straight lines in any of my paintings. Another stereotype I hear is, "I can only draw a stick figure." To which I reply, "Good!" That's exactly the right attitude for this exercise.

Draw a bunch of items, but reduce them into circles, lines, squares, triangles, and simplified shapes — much like a stick figure. See the shapes first. The details are just icing on the cake. See Figure 8-1 as an example.

Check perfection at the door for this part. Think loose and free, and scribble for this type of drawing. No erasers allowed.

Simplifying a complex shape into familiar geometric shapes makes it easier to see and therefore easier to duplicate with a drawing. Figure 8-1 shows two prairie dog drawings that begin with geometric shapes.

Figure 8-1:
Inanimate geometric shapes become lively prairie dogs.

Seeing light and shadow

Lines create shapes: circles, squares, and triangles. When you add values in the correct places in the form of shadows and highlights, the geometric shapes take on the illusion of three dimensions. The thing that separates a flat circle from a round sphere is light and shadow. The key to adding dimension is understanding shadows.

The light that creates shadows and highlights comes from something: the sun, artificial light, a candle. The source of the light is called — surprise! — the *light source*. Pay attention to the light source when you're drawing, especially when you're indicating shadows. Multiple light sources are possible, but single light sources make for a more dramatic painting.

The highlights and shadows depend on whether the surface is shiny or dull — its *reflectivity* — the intensity of the light source, and the shape of the surface itself. The shadows and highlights on a flat surface, like a cube, are different than those on a curved surface, like a sphere or cylinder. But flat and curved surfaces are mostly light and shadow, and have few, if any, parts unaffected by the light source. The size of a shadow depends on the object and the light source.

All objects have some combination of highlights, reflected light, core shadows, cast shadows, and crevice dark:

- ✔ **Highlight:** This is the area of lightest shadow. It's where the light first strikes the shape and the closest point to the light source.

 The highlight follows the shape of the object. In the drawings in the following sections, notice the highlight is round on the sphere, a whole side plane on the cube and pyramid, and runs the length of the tube on the cylinder.

- ✔ **Reflected light:** Light can bounce off other sources and land back on an object. If it bounces back or is reflected, the light is slightly dimmer than the original light.

- ✔ **Cast shadow:** The object blocks light and casts a shadow where light is prevented from illuminating the surface upon which the object sits. The cast shadow changes shape with the angle of the light source and its distance from the object.

 Experiment with a flashlight and a baseball to see the variety of oval cast shadows you can create. The cast shadow mirrors the object's shape and follows the surface's contours, if there are any (wrinkles in fabric or hills in snow).

 The light source's height and angle above the object determines how long the cast shadow is. If you're outdoors, the sun is your light source, and the cast shadow will change by time of day. Shadows created by the sun are longer in the morning and evening, so a low angle of light elongates the shadows.

- ✔ **Core shadow:** The darkest area of shadow is the place farthest from the light but without any reflected light bounced into it. The core shadow follows the contour of the shape. A sphere's core shadow is crescent shaped, and a cylinder's is a vertical flat strip along the tube.

 Flat surfaces may not have a core shadow. Instead they may have a different value to each plane or side.

- ✔ **Crevice dark:** The object sits on a surface, and where the object meets the surface is a line of deep dark shadow that I call the crevice dark, because a crevice is a deep narrow edge or opening that light can't reach.

Choosing your drawing utensil

When you're ready to start drawing, I say use a pencil. You've been using a pencil since before kindergarten, and you probably feel pretty comfortable with one.

Drawing pencils come in different values from H to B: Think of H as hard; think of B as black. The pencils are numbered from 2 to 8. The higher the number, the more the pencil relates to the quality of hardness or blackness. An 8B pencil draws very black. An HB pencil (no numbers) is right in the middle and is similar to the No. 2 pencil you used to take tests in school. As the pencils get toward higher B numbers, the lead gets softer and larger around. Conversely the larger the number of H pencil, the harder the lead; therefore, the

lighter the drawn line and the smaller around the diameter.

It's just a habit to use pencil when talking about drawing. You can also use watercolor paint to make your drawings, though using a brush may be a little more foreign. Or you can go middle of the road and use a watercolor pencil. Watercolor pencils combine the best of both worlds. Watercolor pencils come in a rainbow of colors, and you use them as you do colored pencils, but they have an added bonus: You can blend with a brush and water. You can soften lines by applying water. You can even erase lines if you add enough water and rub with a brush until the line disappears.

By understanding the theory of shadow, you can use it to suggest volume on a flat paper surface.

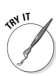

From circles to spheres

Start with a loosening-up exercise:

1. **Draw a circle.**

 It doesn't matter if the circle is neat. It can be a loop with incomplete starts and stops. Scribble till you get a circle from many circular lines defining the shape.

 To loosen up, try drawing circles from each joint: wrist, elbow, shoulder. You may have to stand to get far enough away from the paper to use your shoulder.

2. **After you have a circle you like (Figure 8-2a), add the correct shadows, as shown in Figure 8-2b.**

 Start with the lightest touch and make the light shadow surrounding the highlight. As you move down toward the core shadow, put more pressure on your pencil for a darker mark. You can also lay the pencil on its side to use the widest area for faster coverage. Ease up on the value as you reach the reflected light area. There is a crevice dark where the object touches the surface. The cast shadow has a reflected light bouncing back from the sphere, so even it has some variation in value.

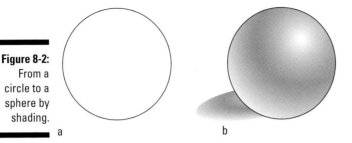

Figure 8-2:
From a
circle to a
sphere by
shading.

a b

From a square to a cube

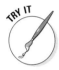

Okay, maybe you need a straight line every once in a while. If you want really straight lines, there's nothing wrong with using a ruler. For now, you don't need anything so precise. Just make a square — and in case you've forgotten, all four sides of a square are the same length — and follow these steps to transform a square into a cube:

1. **Draw a square, then draw a second square about the same size that overlaps the first about half the width beside and half the length above (see Figure 8-3a).**

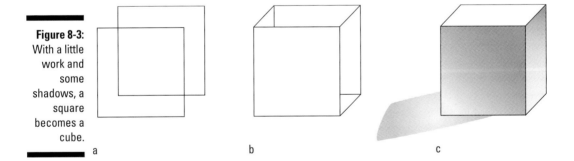

Figure 8-3:
With a little
work and
some
shadows, a
square
becomes a
cube.

a b c

2. **Connect the four corners of the two squares by drawing straight lines between them (refer to Figure 8-3b).**

 You now have a cube.

3. **Start shadowing the cube, making a light, medium, and dark side (refer to Figure 8-3c).**

 Because you don't see the back of the cube, you have only three sides to worry about.

 The secret to shadowing a cube is to keep in mind that each side is a different value. For the one in Figure 8-3c, rather than erasing the part of the square behind the first square, just make that side the darkest and shade it in dark. Pick the right side for a medium value and leave the top white or light. All you need now is a cast shadow. Because the light is on top and the medium side is to the right, that dictates that the light source is coming from the top and a little right, so the cast shadow is to the left.

The angle of the light and where it originates from dictate where the cast shadow falls. I shined a light on a box. By moving the light, the cast shadow changes shape. In Figure 8-3c, most of the shadow's edges are parallel to the object's edges, but some are different. The light sneaks around the edge and makes a new angle at the bottom left corner. The cast shadow contains some light that bounces off the object, so make a graded value from light near the object to darker as the shadow gets farther away from the object. Set up a similar box-and-light experiment to observe light and shadow.

From a triangle to a pyramid

A pyramid is essentially half a cube. It has a square base and a pointed top. It's easier to draw than a cube because it has fewer sides. To make the transformation:

1. **Draw a triangle (see Figure 8-4a).**

2. **Make another triangle, using one of the legs of the first triangle as the longest leg of the second triangle (see Figure 8-4b).**

 From the top of the first triangle draw a line that angles out a bit to one side and ends higher than the base of the first triangle. Connect that line to the bottom corner of the first triangle with a straight line.

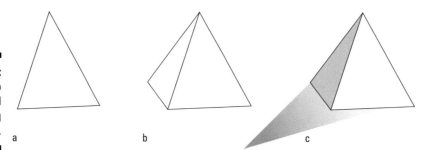

Figure 8-4:
Triangle to pyramid using shadow.

a b c

3. **Add your shadowing (see Figure 8-4c).**

 Only two sides show in a pyramid — a light side and a dark side — as shown in Figure 8-4c. The cast shadow slants away from the dark side.

From circle to cylinder

Another important shape is the cylinder or tube. Cylinder shapes make arms and legs, tree trunks, watering can spouts, chimneys, and oodles of objects you'll encounter on your painting journey.

To make a cylinder:

1. **Draw two ovals, as shown in Figure 8-5a.**

 Circles work as well; use whichever one you prefer.

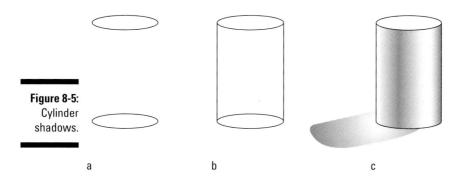

Figure 8-5: Cylinder shadows.

a b c

2. **Connect the ovals with straight lines (see Figure 8-5b).**
3. **Add shadows (see Figure 8-5c).**

 The shadows become lines the length of the tube rather than spots like on the sphere.

Maintaining Perspective

In the preceding section you make one view of each of four geometric shapes. One perspective. How do you make more? The rules of *perspective* help you make shapes look correct in space and in relation to each other.

Perspective uses horizon lines and vanishing points. These items are created by you, the artist. The *horizon* is where the sky meets the earth. The *vanishing point* is located on the horizon line and is the point where all horizontal lines *converge*. If you extend the horizontal lines of an object, they meet at one spot on the horizon.

The number of vanishing points corresponds to the number of perspectives. In *one-point perspective,* you have one vanishing point. *Two-point* has two vanishing points, and *three-point* has three vanishing points. One- and two-point perspectives are used most often in art, but I throw in three-point for free just so you know it exists. You may even see a creative application where it will come in handy. I discuss all these points in the next sections.

Vanishing points and their theory can be applied to landscapes as well as still lifes. Even people and wildlife are influenced by perspective. Understanding and being able to use vanishing points makes your drawing in your paintings more believable and realistic. Paper has length and width — two dimensions. You're trying to get your audience to believe that there is depth or a third dimension — which is always an illusion. You need every trick you can to make this magic happen.

To help you think three-dimensionally even though you're working on a two-dimensional surface, picture everything you paint as fitting into a cube.

Looking from a one-point perspective

One-point perspective has all converging lines leading to one location. In Leonardo da Vinci's *The Last Supper,* all lines lead to the center of the picture or the leading character, Christ. When you look down a road, the sides of the street seem to converge toward each other. Both of these are examples of one-point perspective.

One-point perspective is useful in simple situations. Flat buildings, straight roads, railroad tracks, and telephone lines and poles all follow one-point perspective nicely.

See Figure 8-6 for a visual of one-point perspective.

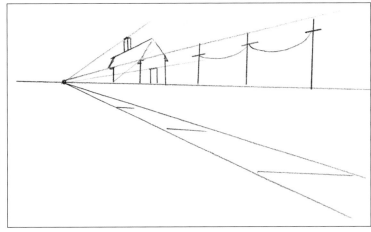

Figure 8-6:
This rural scene is drawn in one-point perspective.

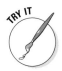

Draw another cube, but this time use one-point perspective. Just follow these steps and refer to Figure 8-7:

1. **Draw a 1-inch square on drawing paper.**

2. **Draw a horizon line above the square.**

3. **Make a mark on the horizon line behind the square to serve as the vanishing point.**

 You can also put the vanishing point to the right or left of the square on the horizon line.

4. **Using a ruler, draw a line from each of the square's top corners to the vanishing point on the horizon.**

 If you put your vanishing point to the side of the box, draw a third line to the vanishing point from the bottom corner of the square that is closest to the vanishing point.

5. **Draw a line parallel to the top of the square between the two lines that go to the vanishing point to indicate the top edge of a cube.**

 You now have two sides of a cube.

 If you drew a vanishing point to the left or right of the square, complete the cube's third side. (The top is side two.) From the corner of the top, draw a line parallel to the original square down to the vanishing line.

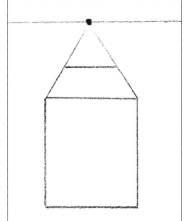

Figure 8-7:
A cube from one-point perspective.

For a different one-point perspective, do the exercise again but this time move the horizon line behind the square and draw the lines to the vanishing point from the top and bottom corners on one side of the square (see Figure 8-8).

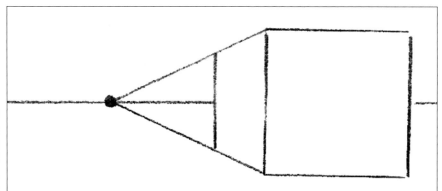

Figure 8-8:
A different one-point perspective.

Seeing two-point perspective

Two-point perspective uses two vanishing points on the horizon line where all the horizontal lines converge. A three-quarter view of a building where one corner is closest to the viewer and the two visible sides recede back into space uses this perspective. Figure 8-9 could be the beginnings of such a view.

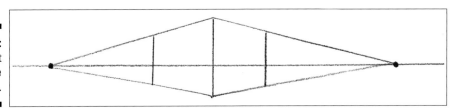

Figure 8-9:
Two-point
perspective
example.

Two-point is the most useful of the three types of perspective. Most land-scapes are drawn or painted in two-point perspective. You can also use two-point perspective in a still life. This type of perspective helps your drawings look believable, so your paintings will be more realistic.

In this exercise, you draw a cube in two-point perspective.

1. **Draw a horizon line.**

2. **Make a 1-inch vertical line that crosses the horizon line.**

3. **Make two dots on the horizon line about 3 inches away from the vertical line on either side.**

4. **Draw lines from the top of the vertical line to the dots, or vanishing points, on the horizon line on both sides.**

5. **Repeat Step 4 from the bottom of the vertical line.**

6. **Draw a vertical line on each side of the central vertical line between the lines drawn in Steps 4 and 5.**

 You should have something resembling Figure 8-9.

This box is the basic shape to most buildings. It could also be a basket in a still life. It could even be the body of a cow. By moving the vanishing points and proportions, you can make any cube-like shape accurately.

Try drawing the box again. This time move the horizon line and vanishing points to resemble Figure 8-10. Your first vertical line can be above, below, or not even touching the horizon line.

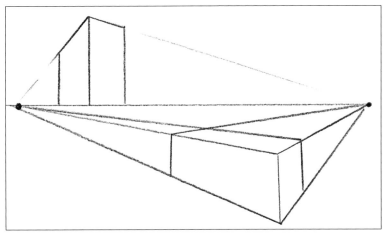

Figure 8-10:
A different
two-point
perspective.

When experimenting with two-point perspective, remember that all the vertical sides stay vertical. Only the top and bottom change and recede to the vanishing point.

Viewing three-point perspective

Three-point perspective is sometimes called *worm's-eye* or *bird's-eye view.* If you can imagine what a worm or bird might see from their lowly or lofty positions in the world, you can understand three-point perspective. Look at the cube as it becomes a product of three-point perspective in Figure 8-11. The sides are no longer parallel. They too follow a vanishing point toward the horizon which leaves the cube floating in space.

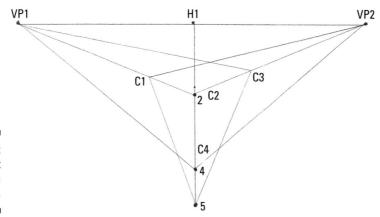

Figure 8-11:
Three-point perspective example.

Draw a cube again, using three-point perspective this time:

1. **Draw a horizon line across the long side of a piece of 8½-x-11-inch paper.**

 Make it fairly high on the paper because you go down 5 inches in Step 3.

2. **Lay a ruler on the horizon line and place a point on the horizon line at 0 inches, 5 inches, and 10 inches.**

 The point at 0 inches is vanishing point #1 (VP1). The point at 10 inches is vanishing point #2 (VP2). Mark the 5-inch point as the center of the horizon line (H1). Label them as such, following Figure 8-12 for guidance.

3. **Draw a 5-inch line down from the center (H1), perpendicular to the horizon line, so this line forms a right angle with the horizon line.**

 Mark the bottom of the 5-inch line as vanishing point #3 (VP3). Figure 8-12 shows the two lines.

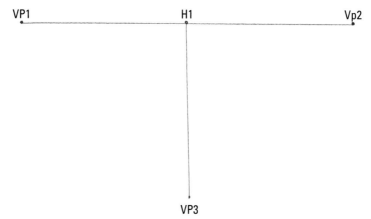

Figure 8-12:
Laying the foundation for a three-point perspective cube.

4. **Mark the 2-inch point and the 4-inch point on the line extending from H1 to VP3 (see Figure 8-13).**

 These are corner 2 (C2) and corner 4 (C4), respectively.

5. **Use a ruler to draw two lines from the two outside vanishing points, VP1 and VP2, to connect with C4 (see Figure 8-13).**

 This is the bottom of the cube.

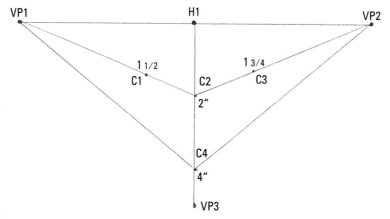

Figure 8-13:
Starting out with the top and the bottom.

6. **Use a ruler to draw lines from VP1 and VP2 to C2 (see Figure 8-13).**

 These form the top of the cube.

7. **Measure 1½ inches from the center line along the line from VP1 to C2 and make a mark (see Figure 8-13).**

 This point is corner 1 (C1).

8. **Mirror Step 7 by marking 1¾ inches from the center line along the line from VP2 to C2 (see Figure 8-13).**

 This point is corner 3 (C3).

9. **Draw a line from C1 to VP3. Then draw a line from C3 to VP3 (see Figure 8-14).**

 These are the sides of the cube.

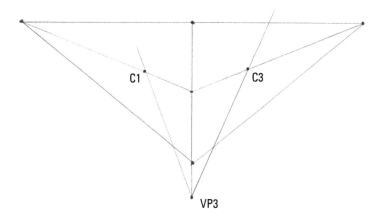

Figure 8-14:
Setting up
the sides.

10. **Finish the cube by drawing a line from C1 to VP2. Mirror this line by drawing a line from C3 to VP1.**

 You now have Figure 8-11.

Adjusting to aerial and atmospheric perspectives

A few more rules of perspective. *Aerial perspective* is about creating the illusion of depth of space with some tricks to make things appear to recede into space. You're using a flat piece of paper after all, so how in the world do you make something look a hundred miles away? Well, you remember these rules about perspective. As things get farther away, they:

✔ **Get smaller:** In the one-point perspective example in Figure 8-6, notice that things get smaller the farther away they get.

 Keep in mind that objects get smaller in proportion to vanishing points and distance.

✔ **Have less detail:** Keep the details in the foreground to bring an item closer. As an object goes back into space, it has less detail until no details at all are visible.

> ✔ **Are less intense in color; they're grayer:** Colors are more vibrant or intense the closer they are to the viewer. Layers of atmosphere obstruct the view, and the colors appear grayer in the distance.
>
> ✔ **Appear cooler:** A blue tint helps the background appear to recede into space. As things come closer they're warmer. A meadow landscape is already set up for this, having hay-colored grasses in the foreground and a blue sky for background. Why fight nature?

Atmospheric perspective refers to layers of atmosphere getting in the way of space to create the illusion of distance. Think of old European paintings that show fog in the air and objects in the distance getting smokier or hazier as they get farther away. To achieve a foggy look, make colors grayer and edges softer. Also simplify details to indicate fog and distance. The term *sfumato,* which means smoky in Italian, is used to describe the look. Many of da Vinci's paintings incorporate this technique.

Tools to Help You Get a Better Drawing

Up to now, I've been discussing tips and techniques for drawing images *freehand.* The public seems to prize drawing freehand. "Did you do that freehand? Wow!" Somehow using tools and aids is regarded as "cheating." I'm here to tell you that it's okay to cheat sometimes. In fact, in this section, I'm going to tell you how to cheat. And I'm not going to use the word *cheat* anymore; after all, it's just using tools.

As you start drawing, you develop more skill and a better eye. But because we have cool tools, why not use them to grow in drawing? Let's face it; this is the age of technology. If Michelangelo and da Vinci were alive today, they would be all over computers and optics. They made the most of what they had back in their day. This section offers some tools that are available today for a variety of budgets.

Copyright caution

Just a word of caution about the reference material you use. If you're working from an educational book, like this one, you can re-create the exercises. After all, that's what it's all about. But understand that your paintings won't be original material and should never be sold or exhibited in a show as your own. It's not a bad idea to make a note on the back that includes "after Colette Pitcher," the title of the work you're copying, and your name and date.

What about other stuff? There are fabulous calendars, Internet images, and magazines that just call you to paint from them. Caution: These are all copyrighted materials. You can use them to practice painting and techniques in the privacy of your own home, but they aren't original images by you, and you can't exhibit them.

The easy solution is to get your own camera. Take your own shots. You are in total control of your images now. You took the photograph reference material, so it's an original image. Practice with anything, but aim at working up to using your own originals.

The technology tools I mention in the next sections are great. Do they replace the artist's eye and skill? Absolutely not. Projectors and cameras distort images. When pictures are enlarged, the distortion only becomes more pronounced. All these machines and aids still require the artist to hone the images, place them correctly, choreograph the outcome, and add the content and emotional impact that a machine never can. You, the artist, must constantly correct and refine what the tools help you achieve.

Tracing your image

Designers use tracing paper to speed up drawing. *Tracing paper* is paper thin enough to see through, though it has a slightly frosted surface. You can lay tracing paper over a photograph, a magazine page, or any other flat image and see enough to trace the outline of the image underneath.

Acetate is a plastic-like sheet that's completely clear and lets you see all the details without the frosted surface of tracing paper obscuring anything. A water-media acetate accepts watercolor so that the paint doesn't bead up when you apply it to the surface. The acetate, however, is heavier and costs more than good, old tracing paper.

Tracing paper is cheap, so you can use it abundantly. Scribble out your drawing. Then take another piece of tracing paper and lay it on top. Trace the lines you like and refine the drawing. Instead of erasing, lay on more tracing paper and refine the drawing again.

Make sure to remove earlier drawings from underneath. You don't want to be confused by multiple images under your fresh sheet.

When you finish refining your image, place the final tracing paper over your watercolor paper. You can see through the paper to see the watercolor paper's edges. Move the drawing around until you like the placement, then transfer the image, using the steps in the "Transferring your drawing to your watercolor paper" section later in this chapter.

Shining a light on projectors

A *projector* uses light and mirrors to re-create and enlarge an image. An artist can project the picture onto a wall and focus to the size required. You can attach paper to the wall, project the image onto the paper, and transfer the image that way.

Projectors are especially handy for muralists, who can paint directly from the image thrown on the wall. The artist just redraws the lines where he sees the projected image.

There are many kinds and qualities of projectors. Some have more options and cost more and do a better job. Some are a waste of money and barely deliver results. Before buying, ask for a demonstration.

You may be familiar with a *slide projector.* They project 35mm slides onto a wall or screen. Although they are getting scarce, they make a good image projector too, but only for slides. *Digital projectors* are replacing this technology rapidly. Digital projectors work with computers and digital cameras to project images. The good news for artists is that the new projectors give you more options, but any projector can get your image where you want it to go.

Tapping into computers

Computers are amazing tools. Some artists are going completely digital by using photo manipulation programs and technologies. Many fine art shows are wary of this and don't allow digitally enhanced images. Still, computers can be a great tool to aid in preparing your reference materials. When you work from your own photographs, you can import them to the computer and use software to crop the image and manipulate the contrast, values, and colors. You even can reduce the photo to the image's outlines and edges, getting you very close to having your drawing done by a computer. Of course, reducing and enlarging your images are easy too. Magic.

Trying Out Thumbnails and Transfers

Starting a drawing is easier if you have a plan. A good way to make a plan is by creating *thumbnail sketches.* These mini-sketches allow you to quickly plan what you may want to make big.

Then you enlarge the drawing you like onto drawing paper or tracing paper, where you can erase and scribble and further refine it. And finally, you transfer the drawing you're happy with onto your good watercolor paper.

Starting small and sketching a plan

Thumbnail sketches are miniature plans that help you decide where shapes and values go for the best composition. Chapter 7 is devoted entirely to composition, and thumbnails are discussed at length there.

Make a plan sketch to determine where you need to save whites, how to arrange the value pattern to guide the viewer's eye, where to place the center of interest, and how to break up space. Any type of paper will work: copy paper, a nice sketchbook, or the back of a discarded envelope.

You save so much paper by making small sketches first to see which are the best ideas to enlarge.

After planning the placement of the elements in the thumbnail study, redraw it to the correct size on a piece of drawing or tracing paper. Work like a designer if you need to. A designer would take scissors and cut out shapes and move them around until she had the correct placement. You can experiment with spreading objects out or overlapping them. Then you can redraw the scene using more tracing paper, or transfer the drawing to your watercolor paper if the placement is what you want. This tracing paper drawing is a tool and likely will be discarded, so spending a lot of time on it makes no sense. You want to get to the painting!

Transferring your drawing to your watercolor paper

You usually *transfer* your drawing to watercolor paper instead of drawing directly on the watercolor paper. Remember that you want to respect the paper as much as possible. Erasing is not respecting. So make your drawing on a piece of drawing paper the size you want your painting to be. That way you can smudge it, set your coffee cup on it, erase it, and do all the things you're not allowed to do on your final painting.

After you've drawn your image on drawing paper, or if you're working from photographs or copying the art in this book, you need a system to transfer the original image to your watercolor paper. For that, you need a red ballpoint pen, a waterproof pen (or a pencil if a pen is too permanent for you), white artist's tape, tracing paper (which is available at most drug stores and office supply stores as well as art supply stores), and some *graphite paper,* which is like carbon paper (if you're old enough to know what that is). Graphite paper is coated on one side with graphite, oddly enough, which transfers to whatever you press it onto.

You can make your own graphite paper by rubbing pencil on a sheet of paper or on the backside of the drawing. If you want a mirror image, try turning the drawing over and matching the lines or rubbing the back so the pencil transfers onto the watercolor paper.

To transfer an image, follow these steps:

1. **Tape the image to your watercolor paper using white artist's tape on one side.**

2. **Slide a piece of graphite paper under the drawing and on top of the watercolor paper, making sure the coated side of the graphite paper is on the watercolor paper.**

3. **Retrace the lines using a red ballpoint pen.**

The red ink lets you know where you've been and what's left to transfer. The more detailed the drawing, the more helpful this tip becomes. Peek beneath the graphite paper before removing it to check for any forgotten lines. Also peek when you first start tracing to make sure the correct side of the graphite paper is down and working correctly.

The image transfers to the watercolor paper.

4. **Remove the transferred drawing and draw over the graphite lines on the watercolor paper using a waterproof pen or a pencil.**

I generally use a black pen, but you can use another color if you like. Using a waterproof pen is like making your own coloring book page. Add as much or as little detail as you want, and start painting within the lines (or outside the lines if you like — you're the artist!).

You can also use diluted paint to sketch first. When that dries, get a little bolder with the value of the paint by making it darker.

The drawing is only a guide, and you may deviate or follow it as you like.

Figures 8-15a and 8-15b show a tracing and the finished product.

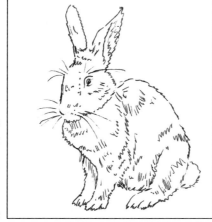
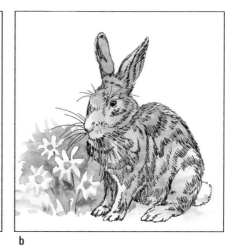

Figure 8-15:
Bunny, from tracing to final painting.

a b

Be careful not to press too hard when rubbing or using ballpoint pens to transfer your image. It's possible to carve a line into the watercolor paper that may show up later where you don't want it to be seen. Transferring the line requires a bit of pressure because you're going through several layers of paper. Test on a scrap to see how much pressure you need to transfer the line but not make an indentation in the paper.

Project: Building a Barn

Okay, after all this drawing, how about a little painting? (This is, after all, a book about painting.) This project allows you to practice your drawing and shading skills as well as work with perspective. Then you get to give your paintbrush a workout as well.

The farm scene in this project is a collection of cubes (buildings), pyramids (roofs), and cylinders (silos). The scene uses two-point perspective. Should you need to draw your own two-point perspective, measure the roof line and the ground line and see where they would converge. All horizontal lines also travel to this point: the windows, doors, siding slats, vents, bricks, and shingles.

1. **Trace and transfer the outline in Figure 8-16 onto an 8-x-11-inch piece of watercolor paper.**

 See the steps in the "Transferring your drawing to your watercolor paper" if you need a refresher on how to get the image out of the book and onto your paper.

2. **Activate your paints.**

 Make a puddle of ultramarine blue, one of burnt sienna, and a mix of both.

3. **Paint the sides of the buildings that are all on the same plane (see Figure 8-17).**

 Instead of painting the sides one color, make them more interesting by making a graded wash — a transition of cool to warm (see Chapter 6 for more on painting gradations). A ½-inch flat brush makes painting rectangles, like the barn, quick and easy. Cool is blue, and the warm is the burnt sienna. They create gray when mixed equally.

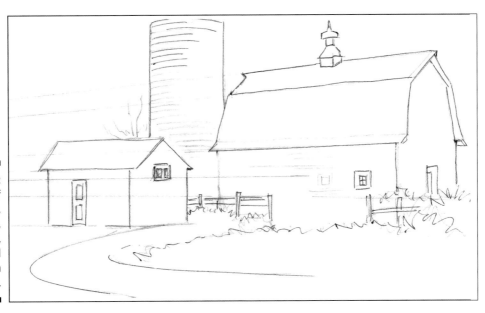

Figure 8-16: An outline of cubes, pyramids, cylinders, and shadows in perspective.

Use a pointed round brush to paint around the fence posts, windows, and doors (negative painting — see Chapter 4) to leave them white.

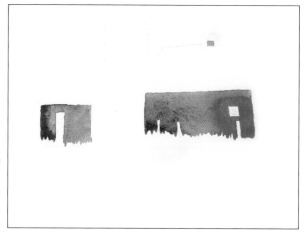

Figure 8-17:
Build some barn siding.

4. **Paint the silo (see Figure 8-18).**

 This cylinder shape uses burnt sienna for the reflected light and ultramarine blue for the core shadow. Keep the edges wet and soft.

5. **Paint the eave under the leading edge of the barn roof (see Figure 8-18).**

 Make a graduated stripe of ultramarine blue at the top to burnt sienna.

6. **Paint the cupola (see Figure 8-18).**

 The *cupola* is the ornamental top on the barn roof. It's a collection of cylinders and cubes. Paint in blue and brown as you did with the silo and barn.

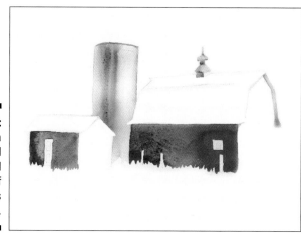

Figure 8-18:
Add a cylindrical silo and fill in some of the barn's features.

7. **Paint the roofs (see Figure 8-19).**

 Paint the roof of the barn and the smaller building with a diluted burnt sienna. Pay particular attention to the edges so they can be seen. Look to use blue next to brown (burnt sienna) or vice versa so there's a contrast between edges.

8. **Paint the front of the barn and the details (see Figure 8-19).**

 Use burnt sienna with a lot of water to paint the front of the barn. This will define the right-hand side. Use diluted ultramarine blue for windows and shadows under roof overhangs. Lift out the fence by painting clear water over the rails and blotting with a towel.

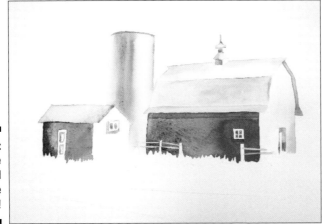

Figure 8-19: Raise the roof and color in the details!

9. **Paint the foreground (see Figure 8-20).**

 Paint a road using dry, rough texture. Notice the perspective in the road. It's larger where it's closer in the foreground. The severe curve also gives the illusion of depth. Paint some yellows, oranges, and greens loosely for grass around the road. I added a green tree to define the silo and house-like building.

 I used a dark mixture of blue and burnt sienna to paint some of the fence dark. The cupola casts a shadow of diluted ultramarine blue.

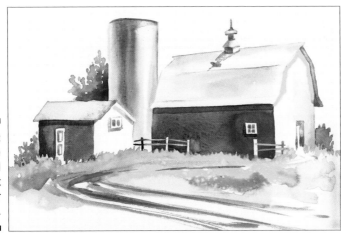

Figure 8-20: Add the foreground to finish out your painting.

Part III
Painting Projects Aplenty

The 5th Wave — By Rich Tennant

"Oh, those? I thought painting might help relieve the tension around here a little. I did these while you were napping. I'm particularly fond of the Red Cross ship. What do you think?"

In this part . . .

These chapters give you tips and instructions on painting inanimate objects, lifelike animals, more than one landscape, more than two seascapes, and just a whole lot of painting projects.

Animal, vegetable, or mineral — whatever you long to paint, these chapters show you how.

Chapter 9

Giving Life to Still Life

A group of preschool children came into the gallery for an art tour the other day. It was raining, and the kids hadn't been able to go out for recess. Needless to say, the group was full of energy. "Who likes to do art?" I asked to get their attention. Immediately, 20 little hands shot up into the air. "Who knows about different types of paintings? Everyone show me, if you were a still life, what would you look like?" Every hand went to their sides, and the children stood at rigid attention. *Brilliant,* I thought, *I'll use that one again!*

Like the kids, you know that *still life* is a category of painting that involves subjects that do not move and never will move. Everyday items you find around the house can be arranged and painted as a still life. The subjects won't talk back, won't fidget, and usually can be eaten for dinner. What more can an artist ask for?

Items you can use to create a still life are: food (fruit is a popular choice), kitchen items, fabric, hobby items, sports gear, flowers, and antiques and collectibles. You can choose from an unending variety of items and combinations of those items. As you explore the still-life genre, you can choose pieces that symbolize deeper meanings and let the viewer see into your personality.

In this chapter, you make still-life arrangements. You'll think about backgrounds and surfaces, and consider specific elements like flowers, fabric folds, patterns, and more.

Finding and Arranging the Items in Your Painting

The first thing you need to do to paint a still life is to find some items you want to look at long enough to create a painting. I love dishes and all the paraphernalia you find in the kitchen and dining room. You may like some type of collectible. Anything that will sit still is fair game. It's a great excuse to get the toys out and play.

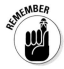

And, speaking of playing, *play* is a good term. You're trying out compositions by arranging and playing with the items. Move the parts around until the composition feels right. (Chapter 7 tells you all you need to know about composition.)

Use these steps to get started with your arrangement for a still life:

1. **Choose the surface you want to set up on.**

 Traditionally, items are arranged on a table. Now, on top of the table do you want to arrange some fabric or place a doily or go for the bare look? The upcoming "Setting the Scene: Surfaces and Backgrounds" section talks about surfaces.

2. **Consider the background.**

 Look at the color behind your surface. Decide whether you want to change it by draping fabric behind as a backdrop. Maybe you want something behind the still-life grouping to balance it — a window or more art?

3. **Find the elements you want to paint and arrange them on the surface in various ways until you find an arrangement you like.**

 Take into account what you like to paint. Decide whether the items you've chosen go together and whether they need to relate to each other.

 Moving the items around is like making a drawing, but much easier because you don't have to erase! Set items in front of other items to create interesting compound shapes. Look for negative areas between the shapes. Balance horizontal items with a vertical item.

 Set up an arrangement that pleases you. Play.

4. **Experiment with light.**

 You can set up a light to create dramatic light and shadows.

 Some artists go so far as to set up a still life inside a box with just one open end in order to control the light. You can easily pin fabric to the cardboard back as a backdrop. Then clamp a light source to the top. This way the light on the still life isn't influenced by overhead lighting or other lights you may need to paint with.

Playtime is over and it's time to get to work on the painting. But that's no problem because this work is enjoyable.

Setting the Scene: Surfaces and Backgrounds

You probably have an infinite number of choices when it comes to the surface on which you set your still life. You can set up on a piece of furniture or a countertop. You can elevate it by setting it up on a box and draping fabric over the box.

Likewise, you can choose all sorts of backgrounds to frame your items. You can use draped fabric, a wall, a wall with another piece of art on it, or nothing at all — just some colors swirled behind.

Think about the contrast of values and colors with the items you are placing on your surface and in front of your background. Do you want to have items fade into the background? Then choose a background with a similar value to the item. Do you want the item to jump out dramatically? Then choose high contrast values: a light object against a dark background, for example. Colors can be placed next to each other to be a bit dramatic as well. When you place a complement or a near-complement (opposites on the color wheel) next to a color, it almost vibrates with energy. Or maybe you want to explore subtle colors and use *analogous colors* (neighbors on the color wheel). The possibilities are limitless. (Chapter 5 has more information on color.)

In this section, I address some of the more common surfaces and challenge you to find uncommon ways to use them.

Grounding your still life on a simple surface

Often I don't want anything to distract from the still life itself. Because the items can be busy and have lots of texture, a simple surface gives the eye a resting place.

Sometimes the objects in a still life look like they're floating in space. The solution is to ground them with shadows, surface edges, and crevice darks where the items touch the tabletop. You can also use the division between tabletop and background wall, which is sometimes called a *horizon line* (turn to Chapter 8 for more on horizon lines and perspective). Making a horizon line stops the foreground surface and solves the problem of the items *floating*. Defining the horizon by a line with a graded wash that fades as it comes forward gives your painting depth without making it fussy or distracting. You may think of other ways to make a gradation separate the surface or background. The background could be dark at the horizon line and fade as it ascends. You can use all sorts of combinations to define the background from the foreground.

Cast shadows can be an interesting line to lead the eye into the painting without making an area too busy. See what I mean in Figure 9-1. The cast shadows are so interesting that a patterned cloth or fabric would be inappropriate and distracting.

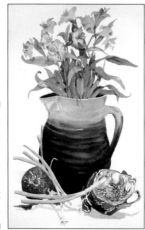

Figure 9-1:
Simple foreground with a horizon and cast shadows.

Whittling the choice down to wood

Wood is easy to paint in watercolor. Careful observation can help you reproduce any type of wood color and grain.

Getting the right color

The beauty of wood is the range of colors it comes in. When you're mixing colors for wood, follow these suggestions:

- ✔ For light woods, such as oak, pine, ash, and poplar, start with a light yellow such as yellow ochre.
- ✔ For darker woods, such as maple, fruitwood, cherry, mahogany, dark oak, and walnut, start with a burnt sienna. You can mix it with a little alizarin crimson for the darker woods.

To make your brown even darker, add ultramarine blue. Sounds weird, but it works great.

Look for contrasts in value. If your subjects are dark, perhaps they look best against a light wood. Light and pale subjects would pop against a dark wood. Some woods are very reflective and can offer all kinds of challenges.

Getting a good grain

Adding grain details to your surface makes the wood look more realistic. Follow these steps to paint a wood surface. The example I use is oak.

1. **Start with a *wash* (lots of water with a little pigment) across the whole wood surface.**

 In Figure 9-2, I applied yellow ochre with a ½-inch flat brush to replicate the color of oak.

Figure 9-2:
The first
layer
for oak.

You can make more wood grain texture by *dry brushing* (using paint with not much water) with a fan brush over the top of this initial background wash.

2. **Let it dry.**

3. **Use a liner brush to paint the lines representing the grain.**

 I used burnt sienna that was a little less diluted for the oak grain, as you can see in Figure 9-3. If you need a darker brown, add ultramarine blue to your burnt sienna.

 If you want any lighter spots, lift them out with a damp brush and blot with your tissue. (Chapter 3 tells you how to lift paint.)

Figure 9-3:
Detail lines
define a
wood grain.

To make the wood look like it's receding into space, incorporate some perspective ideas: Make your wash darker in the back and lighten it toward the front. You can also have the grain lines in Step 3 get closer together as they go farther away.

Draping fabric

Most still-life surfaces are covered by a piece of fabric. Fabrics are a great way to create interest with color, patterns, and folds.

Often folds and creases in the fabric are exaggerated to allow opportunity for shadows, lines, balance, directional pull, and tension. Or maybe it's just that artists don't like to iron.

Creating innies, outies, creases, and folds

Fabric is a kind of landscape all by itself. Material makes hills, valleys, and lines.

I made up the terms *innie* and *outie* as they apply to painting. If you use these terms while talking to an art snob, they'll think you're discussing bellybuttons and wonder why you're talking anatomy instead of art!

Figure 9-4 shows various folds in fabric:

- ✔ (A) is an example of a **valley** or an innie. Make this fold look *concave* (curved inward) by giving it a dark center that becomes a soft edge as the light hits the area that comes forward toward the viewer.

- ✔ (B) is an outie or a **hill** that comes toward the viewer. It's the opposite of the valley fold. The light area is in the center or highest point, while the side of the fold fades into soft, darker edges.

- ✔ (C) is a **wrinkle** or a **crease.** The trick to making a wrinkle or crease is to make hard edges on the fold side. The fold may even have a deep, dark line to define it. The dark gradually gets lighter as it catches more light.

Figure 9-4:
Fabric
makes a
landscape
unto itself
with valleys,
hills,
creases,
and
wrinkles.

B A C

The secret to getting fabric to look real in watercolor is to use soft and hard edges in the shadows. (For more on soft and hard edges see Chapter 3.) The shadows describe the contours, so paint them first. Hard edges look like folds and creases. Soft edges fade away.

Even if your fabric has an ornate pattern, start painting the shadows as if no pattern exists.

Do use the colors you see to paint the shadows, but often a good color to paint with is ultramarine blue. Sometimes I neutralize the blue with a bit of burnt sienna. And dropping in some *analogous colors* (colors that live beside each other on the color wheel) like purple is fun.

Blue used as a *glaze* (a little pigment in a lot of water; see Chapter 3 for details) darkens whatever it's painted over, thus looking like a realistic shadow. Keep the paint transparent enough so that the detail underneath shows through the shadow — it's just what happens with real shadows.

Adding stars and stripes, plaids and patterns

After you get all the shadows painted and not before, you may add any pattern in the fabric that you choose. If you're painting something with stripes, the lines describe the contours and shapes of the fabric. The lines disappear into folds (see Figure 9-5).

You paint the pattern all in the same color (because it's all the same color in the fabric), but the shadows you've already painted give the illusion of depth and color change. It just appears to the viewer that you carefully used a number of values and colors to paint the pattern on the fabric.

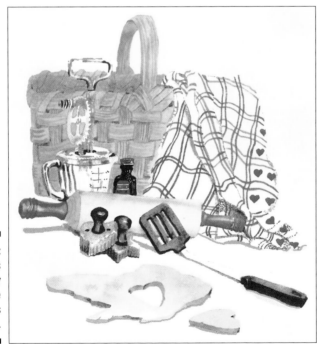

Figure 9-5:
Patterns emerge only after the shadows are shown.

Look at some other fabric patterns and notice how the pattern defines the hills and valleys of the fabric. Plaids are complex stripe patterns with the stripes going vertically and horizontally. Other patterns that have shapes, like polka dots and paisleys, have only half the shapes show on folds and edges.

Look through your closets and pull out some interesting fabrics to observe. Puddle the fabric on a table and place a light above it to cast some interesting shadows. What does the pattern do to define the landscape of the fabric?

Painting lace, cutwork, or eyelet

Lace is a very popular surface in watercolor still lifes lately. Viewers praise the delicate, intricate patterns. And, duplicating patterns is a fun exercise in negative painting — start with white paper and you're finished with the lace immediately. It's all that tedious background that takes time!

Negative painting, painting around the area you want to leave white, needs what I call crossword puzzle mentality. It exercises the brain and makes you think. Negative painting can also be quite meditative and Zen-like. But if you're not a patient person, you may not like painting lace at all.

Lace, cutwork, and eyelet are similar in that they all have holes that allow the background to show through. Like any fabric, paint the shadows first, ignoring the holes and other detail. After the shadows are dry, paint the holes by negative painting around the lace strings.

Cutwork is a little less intricate than lace with just the holes needing to be painted, though the stitches are the details that make it lovely (Figure 9-27 at the end of the chapter shows cutwork). Eyelet has even fewer holes to paint through. Pay attention to the details for realism. Simplify the details for a more impressionistic look.

Figure 9-6 shows a lace doily under a vase holding a single rose. The following steps help you paint a lace doily, both negatively and positively, like the one in this figure. (I get into roses in the upcoming "Going for classic and more complicated with roses" section.)

1. **Use any size watercolor paper you want and a round brush with a sharp point. Activate your paints.**

 You'll need ultramarine blue, a puddle of blue-gray mixed from ultramarine blue and burnt sienna, a color for the surface (I used ultramarine blue and burnt sienna again), green, and some alizarin crimson and violet, if you like.

2. **Lay a piece of lace or a doily on a dark surface for your model.**

 If you don't have a lace subject to use, try painting the lace in Figure 9-6. Find something simple to take less time, or stimulate your brain cells by

creating something complex. Elaborate lace takes a lot of time, but might be fun. The lace in Figure 9-6 is painted very loose and simplified.

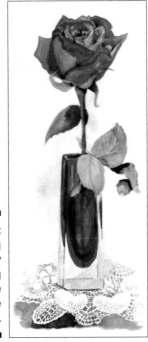

Figure 9-6:
Creating lace by painting negative and positive shapes.

3. **Draw the lace shape on your watercolor paper with a pencil, or just start painting.**

You want to paint in the details, but if you need to first plan the details, you can draw them to remember where they fit. Sometimes I like to paint without drawing everything first. Try both ways to figure out what you like.

4. **Paint any shadows in the folds using ultramarine blue in plenty of water (see Figure 9-7 to get an idea of how this is done).**

Observe your lace to see if you have any wrinkles, hills, and valleys in it. There are few in Figure 9-6.

Shadows are a graded wash of dark near a fold moving away to a lighter area. For a blue-gray shadow color, add a bit of burnt sienna to the ultramarine blue diluted with plenty of water.

Drop in a little variety of color to the shadow. I dropped a watered down alizarin crimson and violet into the ultramarine while it was still wet.

5. **Paint the shadows the lace casts in the same manner as you did in Step 4 (see Figure 9-8 for guidance).**

The *cast shadow* is the shadow under the cloth. These shadows fall onto the table usually.

Figure 9-7:
Shadows
define the
surface
terrain of
hills and
valleys.

Figure 9-8:
A cast
shadow
defines the
edges of
lace and
vase.

6. **Let everything dry.**

7. **Paint the holes in the lace (negative painting), leaving the white of the paper as the lace (see Figure 9-9).**

 Use a paint that is the color of the surface the lace rests on. Use burnt sienna and ultramarine blue for a dark surface. Let it be more blue and darker by adding less water and using more pigment.

Figure 9-9: By painting the holes, the lace appears.

8. **Paint the positive lace (see Figure 9-10).**

 At a certain imaginary horizon — about where the vase sits — the lace becomes positive instead of negative (this is all arbitrary). Instead of painting around the lace, you paint the actual lace itself.

 Use the same shadow color of ultramarine blue and burnt sienna to gray it out. This is all just an effect to entertain the viewer.

Notice what fun I had playing with the viewer's head as the lace uses negative painting in the foreground and reverses to positive painting behind the glass vase. You can even see the lace through the glass in Figure 9-6. I used more-diluted paint to make the lace look like it's being seen through the vase.

Figure 9-10:
The top lace
is painted as
positive blue
lines.

Braving backgrounds

I haven't met a beginner yet who wasn't scared of backgrounds. (I think they're the most fun, though.) Perhaps it's the ambiguity or perhaps it's the control issue that is inhibiting. Whatever the problem, it really is no problem. Most of the time, I like to just make a soft, out-of-focus blur of colors. Watercolor makes this pretty easy.

Use this sequence when you're ready to add a background to any still-life items that you have already painted.

1. **Choose the colors that you want in the background and activate your paints.**

 Don't know what colors to choose? Try three *analogous colors* (neighbors on the color wheel).

 You may develop a style of choosing colors. You may always choose colors that are repeated in objects within the still life, or you may choose colors that are quite different. Look at other paintings to determine which color patterns you prefer.

 Mix large enough puddles on your palette so you won't have to stop and mix more color during your wash.

2. **Wet the background area thoroughly with clear water. Make it evenly damp.**

 If the paper starts to dry, rewet it. When you apply the color, you won't form hard edges as long as the paper stays damp.

3. **Drop in colors and sweep them with your brush next to the subject and allow the color to softly dissipate into the wet area.**

 Go close to the subject, but don't take so long that you allow the background area to dry. Mix colors on the paper as little as possible. Let the water move the paint around and do the mixing work. If you use your brush to stir the paint around too much, you'll make mud. Instead, pick up the paper and tilt it until the colors blend nicely. Flip ahead to Figure 9-11 to see an example of this type of background.

Do you always have to paint the background after you finish the main image in the still life? Of course not. There really are no rules. At some point you just need to make a plan (even if it's just in your head). Sometimes the background is easier to paint first because a light background can be covered later by a darker subject. Sometimes you want to surround the subject after you have painted it on clean white paper. You can even work the background and foreground up together if you have a plan. Or you may not want a background at all, and therefore, white is alright.

Lines or hard edges in backgrounds are caused by uneven wetness. The color travels to the edges of wet, gets stopped by a dry area, and creates a hard edge. Don't allow a spot to dry if you want the color to keep traveling. Of course, if you go back in and introduce a lot of water, you have uneven wetness again, only this time with too much water rather than a dry spot. More water in a damp area causes a blossom. Practice keeping your paper evenly wet. Get the dampness consistent before adding color. Blot too much water with a paper towel, or soak it up with a dry brush. Better yet, spread it around. The paper will absorb the water quickly. If you have too much wetness, wait. Watercolor will teach you patience.

Directing the Stars of the Show

Deciding what items to put in your still life is where you show your personality. Choose items you like. Tell a story. The story doesn't need to be elaborate. If you're making lemonade, your still life would feature a pitcher filled with ice, amber liquid, and floating slices of lemon. On the countertop would be some whole fresh lemons, perhaps one cut open, a knife, and a little drip of tart lemon juice puddled in an interesting shape. Did your mouth water? That's the effect you want to create.

I like to put things together that relate to each other. In art school, we had to paint still lifes of anything left in the art department. I still have paintings of skulls with tennis shoes and weeds (mainly because no one would buy them). If selling is your motive, you need to hit a responsive chord with art patrons. But if you just want practice, you can paint anything. A crushed paper bag is a popular art school subject because it allows budding artists to practice light and shadow, and creases and folds by manipulating a light, medium, and dark value.

Think of all the stories you can tell with a still life. Add a photograph of a person to mementos to recall a personal history. Explain a hobby, play a

game, grow a garden, show holiday treasures, celebrate a sport, cook a meal, explore a nostalgic past, make a science lab of the future, see color in a scattered pile of crayons or toys. There's no end of stories to be told through still-life arrangements.

Artists and wannabe artists should also cultivate areas other than art as interests. Then you'll have endless subjects to paint. I often get the comment, "You do so many subjects!" True. I like a lot of stuff. Some artists specialize in one topic and that works very well too. My favorite topics are western, water, animals, cars, rural, fish, spiritual, mountains, ocean, birds, flowers, people, gardening, travel . . . hmm . . . perhaps focus has some merit.

As always, you may just enjoy the simple beauty of the objects. Light and shadow inspires me to paint. What can you place in a still life? What can't you?!

Perhaps you don't have a cupboard filled with priceless collectibles or a greenhouse with oodles of plants to serve as still-life subjects. Do what I do with some of my artist buddies. Ask the local antique dealer or greenhouse owner if you can sit in his store for a day and paint. The owner usually loves the idea — you entertain the customers. If painting in front of the public is a bit inhibiting, ask if you can take photographs. Tell the owner what you're up to, compliment his inventory, and promise that if your painting turns out, you'll return and show him. Use your art to make friends.

Going bananas for fruit and veggies

Why are fruits and vegetables so popular in a still life? Besides being beautiful and a snack for later on, fruit with shiny skin like apples, oranges, and pears reflect color, as does that fruity vegetable, the tomato, and squashes and gourds and all sorts of things. When they're placed beside one another, a little color from one will bounce off and reflect onto the other. For example, when a yellow pepper and a red pepper sit beside one another in a still-life setup, a little red reflects on the yellow pepper and a little yellow reflects onto the red pepper. It's color heaven!

Going to the grocery store now becomes a search for art supplies. All produce is fair game: onions, berries, carrots, eggplants, and pineapples. Look for items that reflect light. Put them against ones that aren't shiny. Make groupings of like colors. Make groupings of vibrating colors. You think that everything has been done? Not until you do it too. You'll make your own unique still life.

Even, whole, neat circles are boring. So break them up by overlapping other shapes.

Figure 9-11 shows a still life using fruit. Notice how all the circles are broken up by having something else overlap in front of them. Overlapping creates the illusion of depth of space and solves the boring-circle dilemma. The viewer completes the circle in her brain. I like to get the viewer involved by not showing everything. Even the foreground fabric gets in the way and helps break up the shape of the front grapefruit. It's a good idea to make round shapes more interesting and less predictable.

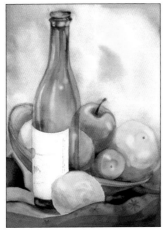

Figure 9-11: Fruit provides color and reflection in still lifes.

The bottle creates a striking vertical counterbalance to the horizontal fruits. It's a good idea to have verticals and horizontals to fill space. This makes a triangular composition and gives the viewer's eye a path to follow. (For more on composition and eye path check out Chapter 7.)

Shining through glass

The bottle in Figure 9-11 provides a challenge in that it is transparent glass. How do you give viewers the impression that they're seeing something through glass?

Well, you start by observing glass. People will think you're crazy now that you're an artist because you stop to observe everything. By really taking the time to look, you'll also learn to see. Before you started painting, you may never have noticed the subtleties of a highlight or the bounce-back of fruit colors. I contend that you'll live longer by enjoying these visual treats.

Glass is complex, but knowing a couple of easy-to-follow rules will make it believable in your painting:

- ✔ **Glass distorts.** Things tend to distort when seen through glass. If something starts on one side of the glass and goes behind it, at the point of touching the glass, the object bends a little. The distortion is greater if the glass container is filled with water. This is useful information if you have a glass vase with water holding a flower in your still life. Straight lines wiggle a little behind water and glass.

- ✔ **Glass makes things grayer.** When seen behind glass, items are a little grayer and less defined. The color of the glass also influences the color of whatever is behind it.

In painting the bottle in Figure 9-11, I painted the entire bottle green first and lifted highlights out of the damp paint using a dry brush. I lifted the circular highlights after the bottle was dry. After the green of the bottle was dry, I painted the items that appear behind it. I added a little more water to the

paint to do the sections of fruit behind the glass to make them a little lighter than the pieces not obscured. To achieve the bright white edges on the bottle, I used a razor blade to scrape off the paint. You can also save this white edge using masking fluid.

You can use many methods to achieve the same look, and one technique you can use when painting glass is *glazing*. You paint everything behind the glass, like a stem or leaves or a tabletop. Use clean hard edges. Let it dry. Then *glaze* (a little pigment in a lot of water layered over other layers) a color of your choice over the glass area. (Chapter 3 tells you about this technique in depth.) Depending on the paper, this softens edges and looks like glass in front of your items. Ironically, when framing a picture, the glass used is called *glazing*.

Saying it with flowers

Flowers are the inspiration for many still-life paintings. They also provide a vertical counterbalance to horizontal lines.

Flowers also can symbolize meanings and set the mood for the painting. For example, sunflowers indicate a casual painting with a touch of country atmosphere. Roses, however, set a formal mood.

Shaping up your flowers

Flowers are mostly circular and oval, but look at the general shape of the flower before you begin sketching the simplified shape. (See more on drawing in Chapter 8.) Reduce the complexity of the flower to simple geometric forms. For example, trumpet flowers are a circle attached to a cone or triangle shape. When you have all the general shapes in, then you can go back and refine the details.

If you have a bouquet of flowers, you may want to first sketch the entire shape of the bouquet as a circular shape. Then, within the big circle, sketch the individual shapes representing the individual blooms.

Sketch on tracing paper. Start loose. Put another piece of tracing paper over the first rough sketch and draw a little more carefully. Forget the eraser. Put each refined stage of the drawing on a new piece of tracing paper. You can look through the tracing paper to see the sketch below. When you get the drawing the way you like it, take the top tracing paper sheet and place it over the watercolor paper. You can now move it around until it's in just the right location relative to the sides of the watercolor paper. This allows you to crop some parts of the drawing if it adds interest. Try to avoid the "lollipop" look in the center of the page. Read Chapter 7 for ideas on better composition and Chapter 8 for info on how to transfer your drawing to watercolor paper.

Avoid the every-flower-looking-forward-and-perfect syndrome. Have some facing sideways and backwards. Have some buds. Have some flowers past their prime. If you do this, you have created a whole life cycle and now have the symbolic circle of life in your painting. The painting now has more content. It will interest the viewer longer too.

Staying simple

When painting flowers, start simple. At first choose flowers with fewer petals. Daisies, pansies, and tulips are great flowers to start exploring. (Chapter 4 has a painting of daisies.)

You don't need to paint every detail between each petal. The viewer's brain lets him see the separations between the petals. If you explain too much — paint every hair on the dog or every petal on the flower — your painting is less interesting than a simpler rendition that involves the viewer. In this case, less is more.

Paint a simple pansy with five petals.

1. **Trace Figure 9-12 and transfer it to your watercolor paper. (Chapter 8 tells you how to transfer.)**

 Notice the petal numbering in my tracing. I refer to the petals by their numbers throughout the steps.

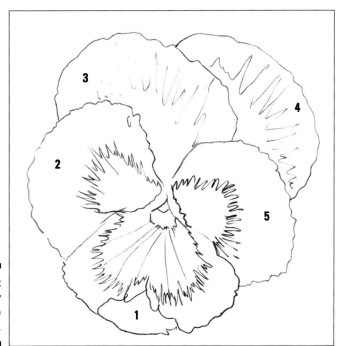

Figure 9-12:
Pansy drawing to trace.

2. **Choose a 4-x-6-inch piece of watercolor paper and mix four puddles of color on your palette.**

 • Make one puddle of lemon yellow.

 • Make a puddle of red-purple. I used quinacrodone violet, but you can mix permanent rose with cobalt blue.

- Make a puddle of dark blue-purple (you can mix ultramarine blue with alizarin crimson to make a blue-purple). The dark purple I used is a mixture of dioxazine violet, burnt sienna, and Payne's gray.

- Mix one more puddle of blue-gray (ultramarine blue and burnt sienna).

3. **Start with the lightest color, yellow. Using a pointed round brush, paint the center of the pansy, as shown in Figure 9-13a.**

 If the yellow is too light, you can add more pigment or another layer of paint after this one dries.

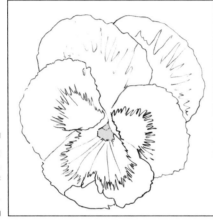

Figure 9-13: The beginning of a pansy.

a b

4. **Paint petals 3 and 4 with the red-purple (see Figure 9-13b). Avoid the yellow center so the dark color doesn't flow into anything wet.**

 Make the purple even; you add the dark layer later.

5. **Make sure the puddle of blue-gray is pretty liquid and use it to paint the light blue-gray shadow areas that pucker petals 1, 2, and 5, as well as the shadows in the white areas (shown in Figure 9-14).**

 There's a shadow under petal 1 falling on petal 2. Paint the blue-gray above the yellow center where petals 2 and 5 touch.

6. **Paint the center patch of red-purple on petals 2 and 5. While the paint is damp, drop in some of the dark blue-purple so the water mixes the two paints, but not totally. See Figure 9-15a.**

7. **Paint the red-purple center of petal 1 only if the yellow center is dry (as shown in Figure 9-15b).**

8. **Let all the petals dry.**

9. **Paint the dark areas of petals 3 and 4 as a layer over the red-purple (see Figure 9-16a). Add the dark area at the tip of petal 1.**

 Be selective and paint the dark blue-purple to describe the veins and shadows of each petal.

Figure 9-14:
The top petals are painted purple, and the lower petals have shadows.

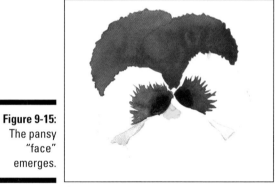

Figure 9-15:
The pansy "face" emerges.

a

b

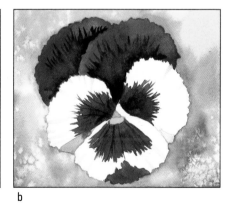

Figure 9-16:
The last petal detail on the pansy is painted.

a

b

10. **If you choose to add a background, such as the one shown in Figure 9-16b), prepare some puddles of color you want, then wet the entire background with clear water, drop in colors, and let the water mix the colors.**

I used several values of green, purple, and yellow, and sprinkled in a small pinch of salt for the texture. (See Chapter 4 to find out more about using salt to add texture.)

Going for classic and more complicated with roses

The more petals a flower has, the more complicated it is to paint. The way to approach a flower with many petals is to paint each petal individually. Look for the subtle lights and darks at the edges of the petals. Why do you see one petal against another? The answer is usually value. One petal has to be darker. The color is most often the same, but the values are different.

To get lighter value, add water to your pigment. You can also layer the paint to make the value darker. If at first the color isn't dark enough, add another layer. Layers of transparent pigment produce glowing depth.

You can get lost in the intricacy of roses, but isn't that part of the fun? In this exercise, you paint a rose with many petals.

1. **Choose a 4-x-6-inch piece of watercolor paper.**

 Grab some tracing paper and graphite paper as well.

2. **Trace the rose in Figure 9-17 and transfer it onto your watercolor paper — Chapter 8 tells you how.**

 Notice that the drawing is generally an oval shape. Then the edges are made more interesting with dips and divots, converting the boring oval into an eye-catching shape.

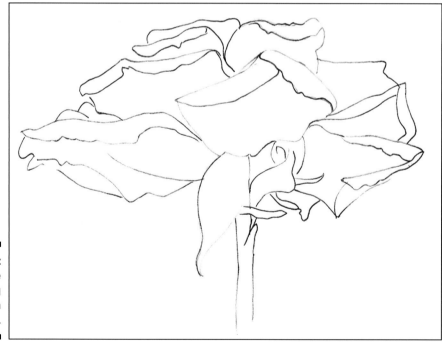

Figure 9-17:
Your rose is taking shape with this outline.

3. Choose the color of rose you want to paint and activate your paints.

Roses come in many colors, and you may want to paint your own color choice. I used brilliant pink for the light areas and alizarin crimson for the darks (refer to Figure 9-21 to see the final painting). Where it's really dark, I mixed in some purple with the alizarin crimson to create a shadow. I used green and a yellow-green for the stem and leaf.

4. Using a pointed round brush, wet the entire paper with clear water and cover it with a light wash (see Figure 9-18).

I used lemon yellow and brilliant pink and opera (a bright pink) all at once while the paper was still wet. If you're using your own color scheme, choose the lightest colors that you want to peek through the other layers.

5. Pick up the paper and tilt it so the colors blend and no hard edges form. Spray water on the paper if it gets too bright or dry.

This layer is the *underpainting.* It unifies the painting. It's so transparent that another layer covers it easily.

6. Let the first layer of color dry completely.

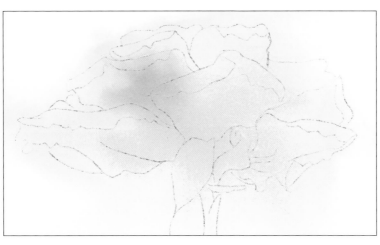

Figure 9-18:
The rose is painted with a wild wash that doesn't have to stay between the lines.

7. Start on one side of the flower and paint a petal using a graded wash of dark to light (see Figure 9-19).

Follow the drawing to determine where to put color and where to soften or lighten the color.

I left the curled-over petals the color of the yellow wash. I painted the undersides of the petals a gradation of light pink to dark. The lightest area was brilliant pink, then opera, then permanent alizarin crimson with a tiny touch of ultramarine blue at the darkest point.

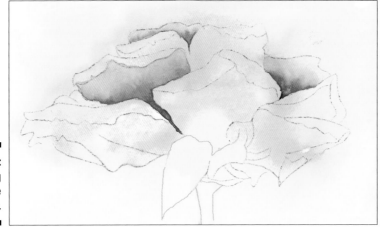

Figure 9-19:
Adding
depth to the
inner petals.

8. **Find a petal that doesn't touch a wet area and paint a graded wash of dark to light.**

9. **Repeat Steps 7 and 8 until all the petals are painted.**

 Paint a petal from dark to light. While that petal dries, go paint another petal that doesn't touch a wet one. Work on the left and then the right side of the rose. The petals will probably have enough time to dry while you work on the opposite side. If not, pull out the blow-dryer to speed up the drying time.

10. **Paint the stem and leaf light yellow-green, and add the dark green shadow to the stem when the paper is dry enough to hold an edge. Drop a dark bit of green into damp yellow-green at the base of the leaf. See Figure 9-20.**

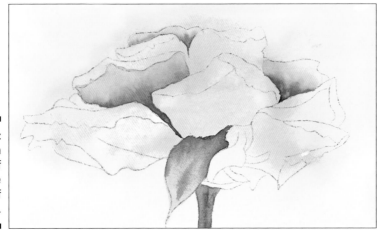

Figure 9-20:
Add a stem
and leaf
at the
bottom of
the flower.

11. **Add a background if desired (see Figure 9-21 for inspiration).**

 Wet the entire background with clear water. Drop in a variety of the colors you used in the rose, leaf, and stem, as well as the wash colors.

Let the water move the paint around. If the paint dries too soon, let the background dry completely and try again in another layer. Sprinkle a pinch of salt around the wet paint for texture.

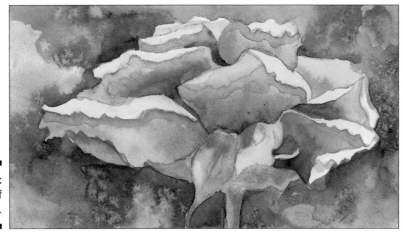

Figure 9-21: A rose of many petals.

Solving Some Common Still-Life Challenges

You've come to the right place if you want some shortcuts to make better still lifes. Trust me, I've made all the mistakes (well, maybe not all — I bet I can still make a few more). But I'm willing to share the easy solutions so you don't have to make all the mistakes too.

Mastering symmetrical shapes

Many of the things you put in still-life paintings are *symmetrical* (the same on both sides). Vases, fruit, cups, bowls, and so on usually have a center axis that makes a mirror image on both sides. Somehow it's easy to draw one side but impossible to draw the other side to match. I have two quick ways to cheat to solve the problem:

- ✔ **Symmetry is boring anyway, so break up shapes that repeat exactly on both sides**. Figure 9-11 is an example of overlapping fruits to break up perfect circles. Putting an object in front of one side of something also solves the problem of making a mirror image. The grapefruit at the bottom of the bottle is doing this task for the symmetrical bottle.

- ✔ **Make the object perfectly symmetrical by drawing just one side and tracing the other.** Draw only one side and trace that side onto tracing paper. Flip over the tracing paper, and voilà! a perfect mirror image. Put graphite paper underneath the tracing paper and retrace the drawing to transfer it onto the watercolor paper.

Wearing pink to the opera

Opera is the name of a bright pink color that I used in the rose painting activity. It comes from duplicating the color of the interior silk of the formal capes worn by men going to the opera in the bygone era when gentlemen actually wore capes. The opera watercolor paint was thought to fade at one time, but you can be reassured that it's lightfast now.

Pinning down elusive ellipses

A circle seen in perspective creates an oval or *ellipse.* The tops of teacups, openings in bowls, the waterline in a vase — all are usually elliptical. The ellipse changes shape depending on the observer's point of view. Imagine looking straight down at a round bowl. The opening is a circle when you look at it from above. As you move the bowl up to eye level, the circle becomes flatter until it's no longer an ellipse, but a flat line at eye level. Elevate the bowl higher yet and the flat line bows upward.

Figure 9-22 shows spools of thread, scissors, buttons, thimbles, and a basket — sewing items that make a very colorful statement. Deeper than that, they're an exercise in ellipses. The eye level of the viewer changes as the threads pile up; therefore, the ellipses change as well.

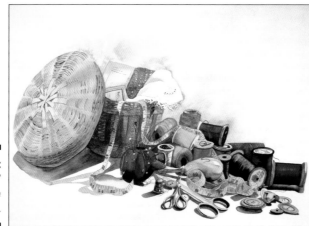

Figure 9-22:
Sew what?
An exercise
in ellipses.

Find some round objects of your own and arrange them in a pleasing still life. Notice what happens as you move your head up or down. How do the round shapes change?

To draw the shapes correctly, you need to keep your eyes in the same place so you avoid distorting the ellipses. If you feel confident, try drawing the still life. More confident yet? Paint it!

Project: Still Life with Pitcher, Fruit, and Cutwork

It's just an occupational ego trip that makes me put pitchers in still lifes. With a name like Pitcher, what do you expect? I also love Fiesta dishes, so I took a picture of a plum-colored pitcher with some wonderful fruit to use as my model. I set up the still life and arranged the apricot, pear, and cherries with the fabric and pitcher. And, in case you don't know what I mean by *cutwork,* the white fabric in Figure 9-23 is an example. The large holes add interest and let the surface show through.

I wanted to enlarge the view to make the items go completely off the page on at least three sides of the paper, so that's what my final painting shows. You can experiment with your own perspectives and modifications. Go for it!

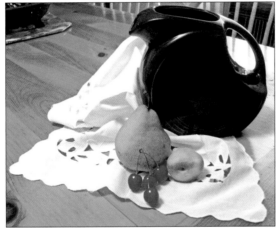

Figure 9-23:
Still-life
reference
photograph
with pitcher,
cutwork,
and fruit.

1. **Choose an 8-x-8-inch piece of watercolor paper, and transfer the drawing in Figure 9-24 to it.**

 Depending on how large you want your painting to be, you may need to enlarge this image before transferring it.

2. **Activate your paints.**

 You'll need lilac, ultramarine blue, burnt sienna, alizarin crimson, yellow ochre, lemon yellow, a light green, cadmium yellow, cadmium orange, dioxazine purple, Payne's gray, a green, and a brown.

 For this painting, you'll mix some of the above paints to create new colors. I tell you in the steps below when you need to whip up a new hue. If you don't plan to paint this still life in one sitting, you may want to hold off activating the paints at the end of the list because those are the ones that you need in the final steps.

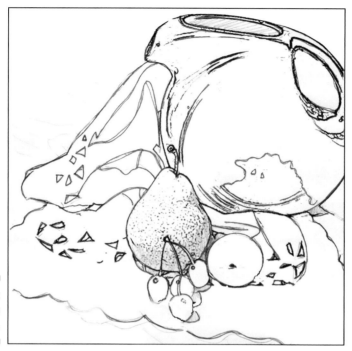

Figure 9-24:
Still-life
outline.

3. **Paint the shadows with a pointed round brush, using Figure 9-25a as a guide.**

 For shadow color, I mixed a blue-gray-purple from lilac, ultramarine blue, burnt sienna, and lots of water.

 I also watered down a lemon yellow for a pale yellow and made a small puddle of very transparent alizarin crimson. Then I dropped the yellow and alizarin into the shadows while the paint was still wet.

 Observe hard and soft edges. To soften an edge, run a clean, damp brush along the shadow color. If it dries with a hard edge, you still can soften the edge with a stiff bristle brush and clear water. The best paintings use a variety of edges. One painting may feature hard, soft, and lost edges. *Lost edges* are really soft and dissolve into an adjacent item like the background or something nearby.

4. **While the shadows dry, paint the background, surface, and holes (refer to Figure 9-25b).**

 Paint yellow ochre (diluted with water) in the background and drop in some burnt sienna around the edges of the paper. Paint the holes in the cutwork and the opening in the pitcher handle, as shown in Figure 9-25b.

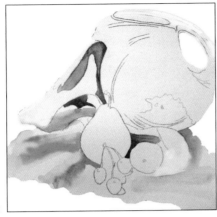 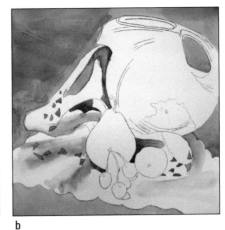

Figure 9-25:
Paint the shadows first, and then paint the background while the shadows dry.

a b

5. **After Steps 3 and 4 dry, give the fruit and pitcher a base coat that will peek through any shadows and details that you paint as a layer over the top (see Figure 9-26).**

A. Start with lemon yellow and paint the pear.

Lift the highlights with a clean, damp brush. Drop in a light green toward the bottom to make the sphere take shape.

B. Paint the apricot with cadmium yellow.

While the paint is still wet, paint a backward letter "C" with cadmium orange to define the round shape. Lift out the highlights by nudging the paint with your damp brush and lifting off the color to reveal a lighter area. Rinse the color out of the brush and repeat until you have the level of lightness you prefer. (Head to Chapter 3 for more about lifting.)

C. Paint the pitcher and cherry shadows when the adjacent items are dry.

Mix a dark purple using dioxazine purple, burnt sienna, and Payne's gray, and use this color for the pitcher.

The fabric is reflected in the center of the pitcher, so I left a white highlight there, as well as on the lip of the pitcher. You can lift the highlights or paint around them.

Paint the cherry shadows using the same dark purple color.

Because red runs when you paint next to it with anything wet, I painted the shadows first and layered the red over the top later.

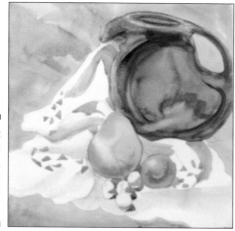

Figure 9-26:
Paint the
pitcher,
pear, and
apricot with
a first layer.

6. **Do all the detail work after everything has dried completely (see Figure 9-27).**

 A. Darken the pitcher with another layer of the same dark purple paint. I did put in some alizarin crimson in the reflected light. See the red-purple in the back curve?

 B. Strengthen the pear with another layer using green and purple. Use the same purple as you painted the pitcher, only dilute it until it's transparent enough for the shadow.

 C. Add a burnt sienna shadow to the holes in the cutwork and the edge of the fabric.

 D. Paint the cherries with cadmium red, adding an alizarin shadow while the paint is still wet.

 E. Soften the highlights with clear water and blotting.

 F. Finish the apricot with another layer of cadmium orange and cadmium yellow, adding a little burnt sienna in the shadow.

 G. Add dots to the pear using the tip of a round brush.

 The dots are green, brown, and black (which is a mix of burnt sienna and ultramarine blue).

 H. Add lines around the holes in the cutwork to indicate stitching.

 The lines are ultramarine blue with a little burnt sienna for a blue-gray.

 I. Add some shadow at the bottoms of the fruit to give them weight.

 The dark is ultramarine blue and burnt sienna mixed.

 J. Finish off with a second layer of burnt sienna and purple near the edges of the surface wood, and behold your finished painting. Mine is shown in Figure 9-27.

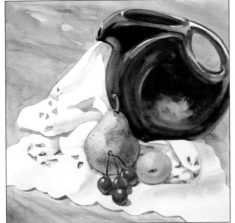

Figure 9-27:
A finished
still life
featuring
a pitcher
and fruit.

Chapter 10

Staying Grounded with Landscapes

*N*ature and landscapes are a great joy to paint. Some landscapes can have a manmade object, such as a barn, in them, while some are pure nature. You can choose whether to add an animal as a center of interest (in which case, see Chapter 12). Pure landscape is just Mother Earth, and in this chapter, she's the star.

Where you decide to paint can influence the outcome. You may want to take your painting show on the road and paint on location. Whether you're on the road or in the studio, enjoy nature's beauty by painting a landscape.

Any time you see something that makes you think, "That would be a great painting," quickly grab your camera and capture the moment. One time I pulled the car over and photographed a barn that had been standing in place for a century. It burned down the next day. Sometimes you're at the exact right spot at the right time. So keep a camera with you. You may not have time to stop and sketch or paint, but a snapshot helps you preserve a moment.

Starting from the Top: Sky and Weather

Watercolor is the perfect medium for easy sky painting. Unless the entire painting is about sky, you can complete the sky area with a few simple strokes. Explore the many types of clouds. Add bright colors to your sky to create a sunrise or sunset. Weather effects are fun to paint in watercolor. Rain and snow are delightful moods to enjoy in a watercolor. You discover how to add each of these outdoor elements in this section.

Achieving a true blue sky

Typically the sky is darker at the top where there are more layers of atmosphere to look through. So start with a simple sky background that is a gradation of dark on top moving to light below (graded washes are described in Chapter 3). The simplest sky can be one color of light to dark or a gradation of color as in Figure 10-1. To create Figure 10-1, I started with damp paper, then I painted a light blue — I used cerulean — toward the bottom. Next came peacock blue followed by ultramarine blue and a mixture of ultramarine and burnt sienna at the very top.

Figure 10-1:
Graded wash for a sky using four shades of blue.

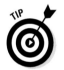

Use the blue colors you have and sort them from light to dark to make a wash suitable for a sky background.

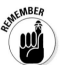

The sky is not always blue. Try some other colors for a different background.

Capturing clouds

Few skies are clear. Clouds come in a variety of shapes and sizes and are good excuses to break up big sky areas and introduce color.

A quick meteorology reminder helps you create realistic-looking clouds. The three most common types of clouds and the types closest to the ground are:

- ✔ **Cumulus clouds** are the big fluffy white clouds below 6,000 feet. These are the rapidly changing clouds that you look at to find shapes that resemble animals, faces, and who knows what else.

The big thunder bumper clouds are a variation called *cumulonimbus* that rise to 50,000 feet. These big clouds rule the sky in the summer and often release hail and rain.

Altocumulus clouds are more evenly regular bumps and appear from 6,000 to 20,000 feet. *Cirrocumulus* clouds are uniform smaller bumps, appearing above 18,000 feet, and are sometimes called a "mackerel sky" because of its fish scale–like appearance.

✔ **Stratus clouds** are the flatter layers that are common on a day when the sun plays peek-a-boo, disappearing and reappearing between the cloud layers.

Variations of this type of cloud are the *nimbostratus,* which is denser and predicts bad weather, and *cirrostratus,* a vaporous high cloud.

✔ **Cirrus clouds** are the wispy clouds pushed by high winds. They hang out above 18,000 feet. Sometimes called "mare's tail," these clouds are very airy and see-through.

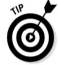

The clouds themselves are your best teacher. My very best advice is to go outside and look to the sky. Clouds are an endless source of fascination. Feel your blood pressure go down. Figure 10-2 is a little chart of cloud types.

Figure 10-2:
Types of clouds.

Cumulonimbus Cirus Cirrocumulus Altocumulus

Cumulus Altostratus Stratus Stratocumulus

To paint clouds, you can use many of the techniques described in Chapter 4, especially those that involve preserving the white of your watercolor paper.

Look for opportunities to use a variety of hard edges and soft edges. You can paint the sky area with color and lift the color when it's wet or dry to lighten areas for clouds. Darken areas by adding some paint in water. Push and lift to sculpt your clouds into the shapes you want. Allow blooms, blossoms, and backwashes to make surprise shapes for clouds. Unequal water creates these bloom areas. By adding more water in a brush than is on the paper surface, a bloom will form. (Check out Chapter 3 for more on blooms.)

Good news: No one will know what your cloud is supposed to look like. All clouds are different. When you're observing clouds, wait 10 seconds, and even the cloud you're looking at will change shape, color, and texture.

Look at the clouds in the paintings included in this chapter to see some different shapes and colors. Figure 10-3 was painted on location in Taos, New Mexico, on a cloudy, rain-threatening day.

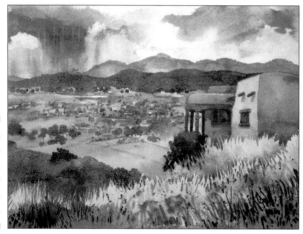

Figure 10-3: Clouds cover the Taos, New Mexico, valley.

Darkening the mood with rain

It was a dark and stormy night. Okay, trite as a story opening. But a rainy, moody sky is a great topic to paint. Your watercolors almost paint this for you.

1. **Pull out a piece of 5-x-7-inch watercolor paper.**

2. **Mix a little burnt sienna into ultramarine blue until you get a blue-gray color that you think will make a moody, rainy sky.**

3. **Paint the area of your paper where you're putting sky with clear water so it's damp.**

 Use a ½-inch flat brush to cover the sky area quickly. Tip the paper so the water evenly coats the paper, leaving no puddles or dry spots in the sky area.

4. **Just as the shine of the water is about to dry, run a stroke of the blue-gray color mixture across the top of the sky.**

 The paint will run into the damp area, but you can help it by tilting the paper so the paint runs down the paper and looks like rain.

 Put another stroke of color across the top if the paint is too light. Let gravity and the paint do the work.

 If the paint doesn't run, try spraying the area with your water spray bottle. You can always let the paper dry and try it again.

5. **When the paint is where you want it, let the paper dry at a slight incline.**

 Propping the painting on an inch-thick book prevents the paint from flowing back toward the top. You can lay the paper flat to dry, but any wet paint will continue to travel where it can. By adding a slant, gravity helps preserve your sky as you painted it.

 Figure 10-4 shows a rainy sky using ultramarine blue and burnt sienna.

Figure 10-4: Rainy sky.

If you want to go a little more dramatic, add a storm to a painting; they're fairly unusual and full of excitement. Put in some great billowing dark cumulus clouds (see the earlier section titled "Capturing clouds"), add some rain in the distance, and there's no doubt that the result is tumultuous.

You can use Payne's gray to paint dark skies gray, but you can create a much livelier gray by mixing ultramarine blue and burnt sienna. As this mixed gray dries, the colors separate and make a nice glow. You don't get this glow when you use gray straight from a tube.

Starting and ending with sunrises and sunsets

One subject everyone likes is a sunrise or sunset. Of course, any rules and generalities can be broken, but generally sunrises are pinker, and sunsets are hotter with more orange and yellow.

Remember your color wheel when painting the sunset. It's easy to want to start with blue sky at the top and a yellow glow around the sun, which is just fine until the two washes meet and make a green sky. Run for cover — it looks like hail! Color wheel to the rescue. Refresh your memory in Chapter 5 or take a look at the Cheat Sheet at the front of the book. Instead of the quick route from

blue to yellow, which results in green, take the long route the other direction: From blue, go to violet, red, orange, then yellow.

Watch a real sunset (or a sunrise if you're an early bird). Notice the colors nature uses, what order they appear in, and what colors they're next to.

To paint a sky, dampen the sky area with clear water first. Then paint sky colors onto the damp paper. I usually make horizontal bands of color. Rinse the brush between colors and blot the brush on the sponge to absorb excess liquid before adding more paint to the sky. You can make some color bands larger and some barely show, but if you gradually change colors in the order they appear on the color wheel, your sunrises and sunsets will look very natural, and you won't get any surprise colors. Skip ahead to Figure 10-6 to see a natural-looking sunset.

Drifting into snow

Snow is another really easy thing to paint in watercolor. After all, the paper is white already! Although Eskimos have a hundred different words to describe all kinds of snow, I break it down into two kinds: falling snow and fallen snow.

Falling snow

Figure 10-5 shows four methods you can use to create the illusion of the white stuff drifting through the air toward the ground. (The methods are described in detail in Chapter 4.)

- ✔ While the paint is still damp, sprinkle a few grains of **salt** on the paint (see Figure 10-5a). Salt is somewhat unpredictable, and if it doesn't work the first time, you can try one of the other ways of making snow as a backup. You also can use salt to simulate other natural textures: Stars, leaves, and wildflowers in a meadow are just a few ideas.

- ✔ Spatter **masking fluid** on your paper before painting on watercolor (Figure 10-5b). Remove it when the paint is dry. Masking fluid takes some planning and requires extra drying time.

- ✔ After the watercolor is dry, spatter **white paint** (Figure 10-5c). The white paint here is Chinese white watercolor. Paint is a good last resort and can be used in combination with one of the other techniques.

- ✔ While the watercolor is still damp, spray **water droplets** (Figure 10-5d). Water drops are also a bit unpredictable, and this sample shows some sizable differences.

As you can see, the technique results are similar but have subtle and not-so-subtle visual differences.

Fallen snow

Snow already on the ground is defined by shadows. Because snow is white, it's the reflection of all colors and can have a number of colors in the shadows. This gives you an opportunity to unify your painting by including the colors you're using elsewhere in the snow.

An easy way to make a mound of snow is to paint a curve of ultramarine blue with a flat brush. Leave one side hard-edged, but quickly soften the opposite side for a soft edge. A snow scene can have as many mounds of snow as you wish.

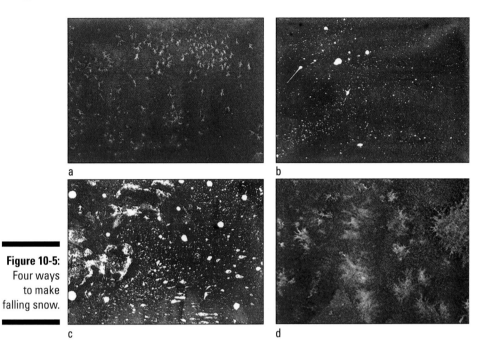

a b

Figure 10-5: Four ways to make falling snow.

c d

Figure 10-6 has white highlights that were saved by masking fluid and mounds of snow painted in blues and purples. The sunset includes sun rays that were lifted in the dark tree background.

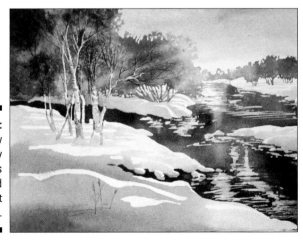

Figure 10-6: Fallen snow is defined by shadows using hard and soft edges.

Arranging Natural Land Elements

Most landscapes have similar land elements in them. Look at the wonderful earth you live on and see a multitude of scenes ready for you to immortalize in paintings. Eventually you run into rocks, trees, deserts, and piles of rocks that become mountains. (I talk about painting water in Chapter 11.) Although you can produce these elements several ways, the following sections offer some quick ways to make them come to life in your paintings.

Pounding out rocks

Rocks are hard, pardon the pun. But that fact helps you think hard edges and interesting shapes when you paint rocks. When making a group of rocks, make the rocks a variety of sizes, shapes, heights, and colors. Some techniques that add to rock texture are plastic wrap and spraying water drops. (See more on these techniques in Chapter 4.)

You can try many techniques but this one is a quick and fun way to make a pile of rocks:

1. **Choose a piece of watercolor paper about 3 x 5 inches, and activate a variety of colors that are slightly grayed.**

 Color choices can include pink-red, gray, blue, brown, and yellow.

2. **Use a 1-inch flat brush and paint the entire area of rocks with the various colors side by side across the paper.**

 Tip the paper while wet to let the colors blend into each other. This underpainting defines the shape of the whole pile.

3. **Spray or flick water drops into the damp paint.**

 The drops of water create a texture pattern by making mini-blooms as the paint dries.

4. **Crumple plastic wrap and place it on the damp paint and leave it in place until the paint is dry.**

 If the plastic doesn't want to lay on the paper, weight it down by placing a jar or cup on top. (Chapter 4 has more on this technique.)

5. **Remove the plastic wrap when the paint is dry.**

 You should see darker color where the plastic touched the paint, something like Figure 10-7a.

Figure 10-7:
From
smudges to
boulders.

a b c

6. **Mix a dark color of paint and divide the large shape into smaller rocks.**

 A line of dark brown painted on with a round brush defines and separates the shape of the pile into individual rocks, as shown in Figure 10-7b. Create different sizes of rocks, but make one rock bigger and dominant.

7. **Soften one side of the defining lines from Step 6 to make the round-ness of the rock shadow.**

8. **Glaze the rocks with color and spray with water for texture.**

 Glaze with any color you want to change the color of the rocks. Break up the same colors by glazing something different in between them.

 Figure 10-7c shows the final rock pile.

Tackling trees

Trees are a popular element in landscapes as in life. Not only do they provide shade and oxygen, they add an interesting vertical element to a landscape.

After you start painting trees, you'll look at them in a new way. Really observe trees. Then look for ways to simplify the shapes to use them in your paintings. The next sections talk about the two kinds of trees.

Leaving deciduous

Deciduous trees have leaves that fall in autumn. There are many species, but most can be drawn and painted in similar shapes with similar guidelines:

✔ **The trunk and branches:** Contrary to popular belief, a tree's trunk usually isn't brown. Make the trunk gray with some variety to the color. As the tree grows from the ground to the sky, the trunk gets smaller. If the trunk widens as it goes up, it looks out of perspective. Each time the trunk or a branch splits, the divisions are smaller in size.

✔ **The leaves:** Think of the mass of foliage as a shape. Simplify the billions of leaves. Rather than paint each leaf, make a whole shape of foliage to represent the mass of leaves. Make the outside edges go in and out to define the shape of the tree. Try not to make the familiar lollipop tree that is so popular in kindergarten classes. Leave some holes in the leaves where the sky can show through. The leaves' color indicates what season it is. Let several colors mix within the foliage shape.

Remember that light falls on the top of the tree, so make this area lighter and warmer.

Techniques that work well in tree foliage are salt, water spray, and spatter. See Chapter 4 for technique details.

Figures 10-8a, 10-8b, and 10-8c show some deciduous trees. These are simplified trees, but the shape and color are all you need to identify a specific species.

Figure 10-8: Deciduous trees.

a b c

Keeping coniferous trees evergreen

Coniferous trees are green all year, like evergreens, pines, and junipers. Their color is usually dark green, and you can make a great dark green by mixing hookers green dark and alizarin crimson.

The shape of the tree defines which species it is. Figure 10-9a, 10-9b, and 10-9c show a ponderosa pine, a juniper, and a blue spruce, respectively.

Figure 10-9: Coniferous trees.

a b c

To make these trees look realistic, keep the edges and shape varied and asymmetrical. Sometimes the trunk shows through the foliage depending on the type of tree, but often, you never have to paint a trunk if you're painting evergreens.

As with deciduous trees (see the previous section), trunks increase in size as the roots spread toward the ground, and water spray and salt are useful techniques.

Climbing mountains

Mountains come in a variety of sizes and age. The gentle rounded mountains of the eastern United States were carved by wind and time. They're covered by colorful deciduous trees. The rugged rough mountains of the West have pine trees and no trees above the timberline at 10,000 feet.

Mountains make great backgrounds and often appear in layers. An easy watercolor technique is to:

1. **Start with a light layer of watercolor for the mountains farthest away.**

2. **Let it dry.**

3. **Paint the next layer and successive layers with less water and more pigment.**

By decreasing the amount of water in the paint mixture for each layer and making the paint darker, you create depth of space because the layers become grayer as they go farther away. Aerial or atmospheric perspective (explained in Chapter 8) is great to use with mountains.

Remember that as things get farther away they become smaller, cooler in color temperature, and less detailed. Make layers of mountains by painting on damp paper to make edges that seem to fade into the distance.

1. **Choose a piece of 5-x-7-inch watercolor paper, turn it vertically, and activate your paints.**

 You'll need cobalt blue, ultramarine blue, alizarin crimson, burnt sienna, hookers green, yellow ochre, lemon yellow, and cadmium red.

2. **Paint the sky.**

 Dampen the paper using a ½-inch flat brush. Before the paper dries, brush in cobalt blue at the top and gradually add water to make a graded wash. (See Chapter 3 for more details on graded washes.)

3. **Let the sky dry.**

4. **Paint the farthest range of mountains.**

Mix ultramarine blue, alizarin crimson, and a touch of burnt sienna for a blue-purple-gray. Add a lot of water so that it's a 20 percent value (pretty pale; see Chapter 5 or the Cheat Sheet for value percents).

Keep the paint somewhat dry in the ½-inch flat brush. Apply the paint quickly and keep the brush hairs nearly parallel to the paper to create rough texture (see Figure 10-10a).

By using rough texture and having the paint touch only the top of the paper's texture, you create the illusion of snow-covered mountains far away.

5. **Soften the bottom edge of the paint by adding water to blend away the edges of the mountains.**

 This makes it easier to cover the paint with the next layer and adds a foggy effect near the bottom of the mountain range.

6. **Paint the next layer of purple mountains.**

 Use the same mixture of color here that you did in Step 4, but add a little more alizarin crimson and use a little less water so the color is a little darker than the first layer (see Figure 10-10b).

 Paint this layer before the paper dries from painting the first layer of rough mountains. You want the paper to hold an edge, but if it's a little damp, the edge will be a soft edge, which looks farther away.

 Soften the bottom of the mountains with water as you did in Step 5.

7. **Paint the third layer of mountains using green.**

 Mix hookers green with a little alizarin crimson to make a dark green. The green warms up the layer to help it come forward in space. Paint this layer with a slightly jagged top edge to indicate tree shapes (see Figure 10-10c). You want to paint these mountains while the second layer of mountains is still wet, thus giving them a soft top edge. Soften the bottom with water.

8. **The tree layer gets added after the mountains are dry.**

 Mix a dark green from hookers green and alizarin crimson. Paint the tree shapes over the mountains as seen in Figure 10-10d. Remember to make the trees different heights and widths, and set them at various distances from each other. Soften the bottom with water as in Step 5.

9. **Add the foreground colors.**

 Yellow ochre was painted at the leading edge of the paper. The same green that was used in the third mountain layer was painted in the foreground with a little less water. While the foreground was wet, I spattered in lemon yellow and cadmium red and water for texture. (Spattering details are covered in Chapter 3.) I even put some birds in the sky to balance the big tree.

You can adjust this exercise to make as many layers and shapes of mountains as you like. What power you have. You now can move mountains! Figure 10-10d shows the finished painting done with this step-by-step method.

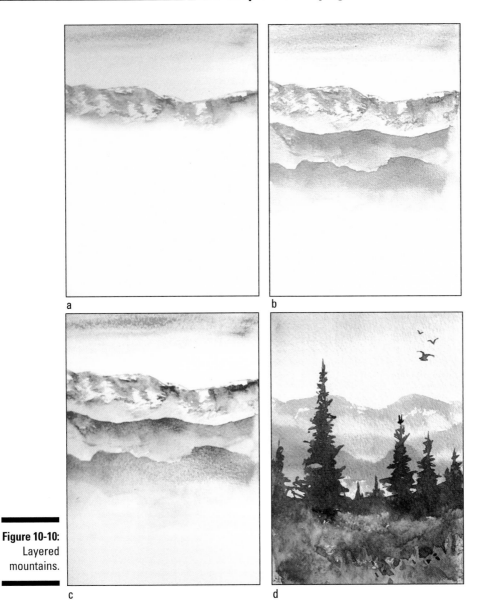

a

b

Figure 10-10:
Layered
mountains.

c

d

Clamoring for deserts and desert plants

While desserts are a sweet topic, deserts are a hot topic. Desert scenes feature palms and cacti and warmer colors.

Paint sand dunes and hills much as you do snow drifts. Stroke on an arc of brown, like burnt sienna, leaving the top of the stroke as a hard edge and softening the underside so it disappears. The tops of hills are lighter because they catch the sunlight, and valleys are darker because they're in shadow.

Cacti

Cacti come in many shapes and colors. When painting a desert scene with these prickly plants, notice the different values of each area. Decide if the next area is lighter or darker to make it different from the first surface.

In Figure 10-11 a little desert scene sports several cactus varieties:

✔ The popular round cactus in the middle of the picture is a prickly pear. Paint each oval separately. When those are dry, paint dark ovals around the first light ovals so the light ones come forward. As the cactus ages, it turns a purple color.

✔ The long tube-like cactus on the right is an ocotillo. First paint the light branches and let them dry. Next paint the dark ones. You can lift the branches in front if you forgot one.

The spines or needles of cacti can be painted dark or scratched out with a razor blade for white needles after everything is bone dry.

Notice the variety in the greens. Start with either hookers green or sap green. Add yellow to make the bright green and burnt umber to make the earthier green.

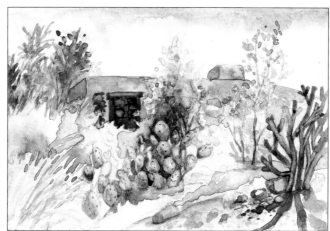

Figure 10-11:
A cactus
garden.

Try neutralizing the green for a cactus with burnt sienna rather than alizarin crimson for a hotter green.

Palm trees

You can simplify a palm tree into a few strokes of your brush — it's a lot of steps, but only a few strokes, and after you get the hang of it, you'll be painting palm trees in your sleep.

1. **Choose a piece of 5-x-7-inch watercolor paper and turn it vertically, and activate your paints.**

 You'll need hookers green, lemon yellow, ultramarine blue, burnt sienna, and violet.

2. **Paint the trunk of the palm tree.**

 Using burnt sienna, make the trunk by starting at the bottom and pushing a round #12 brush down on its side to make the widest possible base.

 Move up the trunk in a gentle arc lifting the pressure off the brush to reduce the size of the stroke until you're using just the tip (see Figure 10-12).

Figure 10-12: Trunk of the palm.

3. **Let the trunk dry before you put some fronds on top.**

4. **Add a _frond_ (a palm tree leaf).**

 Load the round brush with hookers green watercolor. Touch the tip of the brush to the top of the trunk, which serves as the center for the green top. Start at the center, and pull the frond out in an arc, pushing down on the brush as you pull away from the center, so the stroke widens. As you reach the end of the frond, lift the pressure so the stroke gets narrower (see Figure 10-13a).

5. **While the paint is still wet, pull little lines out with the tip of the damp brush (see Figure 10-13b).**

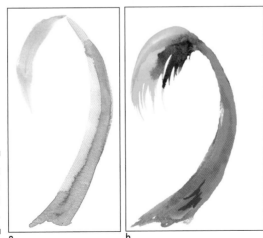

Figure 10-13: Adding the fronds from the trunk.

a b

There should be enough paint on the green palm to pull some little wisps down. If not, load some paint in the brush and paint them on.

6. **Radiate more fronds out of the center by repeating Steps 4 and 5.**

7. **While the paint is damp, drop in some lemon yellow near the top to give the illusion of sunlight touching the fronds (see Figure 10-14).**

Figure 10-14:
Adding
sunlight to
the fronds.

8. **After the paint is dry, add dark semi-horizontal burnt sienna lines to the trunk and lift out some lighter lines (see Figure 10-15a).**

9. **Use ultramarine blue and violet to create a glaze, and use it over the dry trunk to define its round form (see Figure 10-15b).**

Figure 10-15:
Highlighting
and glazing
the trunk.

a b

10. **Use a liner brush to add some simple wriggly green lines to make ground and grass to anchor the tree.**

Figure 10-16 shows the final result of these steps.

Figure 10-16: The finished palm tree.

Painting Structures

Landscapes aren't just about land; they're about the land and everything on it. Buildings, animals, roads, fences, streetlights, telephone poles, and vehicles are just some of the items that can show up in a landscape. Some people view the evidence of human habitation as a sign of encroachment on nature. Others look on structures as just a design element to make a center of interest. Why or whether you add a building to your landscape is up to you. Personally, I like to just enjoy the scenery.

Houses and other structures make for great subjects, but they also can be a challenge to get perspective correct, so review Chapter 8 to get comfortable with geometric shapes and perspective. Most buildings and most typical houses start with a simple cube bottom with a pyramid roof. Breaking down the shapes into geometric patterns helps you simplify a complex structure.

When painting buildings, paint the big shapes first. Approach painting a building in the same order the builder did when he constructed it:

1. **Put the walls up first.**

 Pay attention to shadows on the different walls so you get a building someone could walk into, and not just a few two-dimensional squares. Review Chapter 8 for tips on shading a cube. Get the shapes and lines right.

2. **Put the roof on.**

 Make sure the shadows agree. For example, make the roof darkest on the same side of the house as the wall where you put the deepest shadow.

3. **Add the windows and doors after the house is built.**

4. **Put in the details like shingles, bricks, and curtains.**

 Leave all the details until last.

Because details are so tempting, you may want to paint them first, but waiting until later can save you much heartache. Believe me, you don't want to add a shadow next to some detail you already painted and have the detail disappear underneath the shadow wash.

Greeley, Colorado, the town I live in, was founded by Nathan Meeker. Horace Greeley sent the young newspaper man to "Go west, young man" and start a town more than 100 years ago. Meeker's home is now a museum that just happens to be next door to my studio/gallery and provides a perfect starter house for beginning painters.

Figures 10-17a, 10-17b, and 10-17c show three views of the Meeker house. It would be easy to make the simple structure look less than sophisticated. But hopefully you can enjoy these paintings because of the different angles I chose to paint, the lead-in of the trees, and the extra elements of flowers and the well. You also get a look at painting snow. (For more on snow, see the "Drifting into snow" section earlier in the chapter.)

Figure 10-17:
Three views
of a
geometric
house, the
Meeker
Museum.

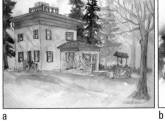

a

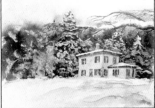

b

c

These views also remind you of one of the nicer thing about art: You can make anything you wish. Emphasize the flowers, push the color, and make it better. Why paint the one measly petunia that exists in reality when you can paint an abundant garden to embellish your world? If you want to make the world a better place, that becomes much easier in a painting than in reality.

Surveying city scenes

City scenes are exciting and brimming with life. The tall buildings are a vertical contrast to horizontal roads. Lights, signs, and people add to the flavor. Streets and sidewalks are a nice visual lead-in to the picture plane.

The way you choreograph the lines and shapes determines how long a viewer's eye stays at your picture or how quickly that eye turns to the next picture. A line can lead you into a picture, but it can also lead you out. Vertical lines, such as the tall buildings in Figure 10-18, stop the eye from wandering away.

Figure 10-18: Cityscapes are interesting and busy subjects.

Cityscapes are full of lines, so begin by deciding which lines to use, which to move, and which to simplify. Draw the buildings, roads, cars, stoplights, and any other elements as simple lines and geometric shapes. Organize the shapes you choose with lines and directions. Figure 10-18 is an example of a cityscape.

Decide on your center of interest. Perhaps it's the small people in the lower third quadrant. When surrounded by tall gray buildings, colorful people become the center of interest even though they are tiny. Or you may choose the vanishing point in a one-point perspective. All lines converge to this point and lead the eye to the focal point as well. The opportunities to solve the cityscape design problem are infinite.

You are the manipulator of space. You tell your audience where to look and what to see by the choices you make. (Check Chapter 8 for advice on using geometric shapes and perspective; Chapter 7 covers composition.)

With cityscapes, the complexity can be a bit daunting to paint when you're starting out, but they're very rewarding when you're ready to tackle them.

Refreshing yourself with country views

I feel a duty to record rural scenes, because they're fast becoming an endangered vista. Farmland is vanishing quickly and being replaced by unscenic housing developments. Barns aren't being renovated because of the cost. Agriculture is becoming corporate and less quaint.

The sweeping vistas, fields, and country lanes leading the eye into the picture make great reasons to paint a country scene. A farm and some livestock add interest. Barns have long entertained artists, and here's the secret why: If the sides lean and the top is a little crooked, it just adds charm. In fact, it makes it better! The pressure for drawing perfection is off.

Rural scenes are naturally horizontal. The horizontal format immediately sets the viewer up for calmness and tranquility. Colors usually reinforce this by using a lot of blue (sky) and green (grass). Figure 10-19 shows these ideas. Make the transitions between colors and values slow, subtle gradations to keep the painting interesting without disturbing the mood. Country scenes should be relaxing, and these methods will help get the job done.

You may want to send a different message, though, and use a vertical format to portray the vastness of space and the comparison to a small human scale. Use your art tools of design to convey your feelings toward what you are painting.

Figure 10-19: Country scenes make charming paintings.

Painting on the Road

Many artists, including me, love to paint *en plein-air*. Plein-air (pronounced *plain air*) is French for *outdoors*. I guess it sounds more appealing in French. That, and outdoor painting was made popular by the French impressionists in the 1800s. They could paint outside because someone invented tubes to hold paint, and artists no longer had to laboriously grind paint pigments and mix them fresh every time they painted. Modern artists take the tubes for granted as well as the many other art supplies that make painting outdoors easier.

A basic checklist of take-alongs includes:

- ✔ **Weather gear:** A sun shade such as a hat or umbrella, and sunscreen and/or bug spray if you need them.

- ✔ **Creature comforts:** Snacks and something to drink let you extend your stay. If you don't anticipate a picnic table or rock being available to sit on, you may want a folding chair, too.

- ✔ **Camera:** Record your scene, or take several viewpoints to capture all the details. If the weather changes, you want a record so you can finish your masterpiece.

- ✔ **Painting gear:** Don't forget to bring the tools of the trade, which I itemize in the next sections.

Think safety when you go into the wild to paint, even if the wild is just the local zoo. Go with a friend. Take a cellphone if you have one. Let someone know where you're going and when you'll return. Ask permission if you want to paint on private property. Park in designated parking spots and stay well off the road.

Folding out an easel

What kind of easel you take depends on how far you're hiking to paint. I personally have a 7-foot rule: "Paint no more than 7 feet from the car." If you stay close, you can haul heavy things more easily.

A nice luxury is a portable easel. Most of the time they are wooden, although you can get metal models too. A portable easel folds compactly into a small suitcase size. Most have a drawer to hold supplies and a shelf with a support to hold your paper, which adjusts to any angle or lays flat. They have legs that *telescope* or fold out. You can leave the legs folded up and use it on a tabletop. Most importantly, using an easel makes you look like an artist. And, if you're performing in front of the public, sometimes how you look is important.

You can choose from many brands and sizes of travel easels. The traditional wooden French easel is a little heavy, but I like it. It has side shelf supports to hold your palette and other extras. French easels come in full size and a half size. The full box measures 6½ inches x 16 inches x 21½ inches all folded up and weighs 13 pounds empty. The half box weighs 12 pounds and is half as wide: 2 inches x 6 inches x 11 inches; but it only carries a third of the stuff.

You can get a backpack to carry your easel if you want to venture farther than a few feet from the car.

Overcoming outdoor challenges

You face plenty of challenges when painting outdoors. The wind blows over your easel, bugs get in the paint, it's either too hot or too cold, and then it starts to rain.

I've painted in every condition. One cold winter day while painting on location, my paints started crystallizing on the paper, and my palette turned to an ice cream–like consistency. I had to put those little chemical warmers in my shoes and gloves. Okay, it can be too cold. I've put sand in a gallon paint can and hung it on my easel to weight it against the wind. Okay, it can be too windy. I've huddled under my car hatchback because it was pouring all around. My painting even had rain dots on it. Okay, it can be too wet. But do you know what? I sold every painting I did in those conditions. Each painting had a great story and carried the feeling of the elements. There is nothing like really feeling the outdoors to make you incorporate those feelings into your painting. Also, working from life gives you a better sense of roundness and reality. Working from a flat photograph often results in a flat painting. Besides, any time you can enjoy the outdoors is a good day.

One time I was painting near Rocky Mountain National Park. My palette was flat on a picnic table. A magpie flew down and landed on the palette. He was fascinated with the bright colors. I got a good close-up view of him. I have also been visited by other Rocky Mountain residents while painting; deer, elk, chipmunks, beavers, raccoons, fox, bighorn sheep, groundhogs, and numerous birds all have been curious and patient models.

You also should be prepared to meet the human animals. People are fascinated with artists working on location. One beautiful Sunday morning while in Taos, New Mexico, I decided to paint in front of the old St. Francis de Asis church. Because I was vacationing, I could enjoy making a painting on a gorgeous morning and go to church by listening outside too. A tourist came by and bought my painting! It was the first time that had ever happened. Now I take a few prints and business cards along just in case.

Transporting your paints, brushes, and the all-important water

I don't recommend traveling with the watercolors you use every day at home. Instead, buy a small travel set of watercolors.

You can choose from oodles of brands, prices, and sizes of travel paint sets. Get one that has at least the basic primary and secondary colors. Usually a set of a dozen colors includes what you need. Most travel paint sets have a built-in palette or mixing area and include a brush. Some of these brushes are pretty small, so I like to take my favorite brush too.

If I don't want to tote the entire dog-and-pony show, I pick up my mini set of paints with a folding brush and a postcard set of paper, put everything in my pocket, and off I go. These little tools are great for being inconspicuous. I like to take them to restaurants to paint or concerts where the performers sit still for long periods of time (this doesn't work at a rock concert, of course).

And to do watercolor painting, you need water. To hold this essential element, you can choose from collapsible or inflatable water containers that fold flat and are lightweight.

Usually a river, lake, or some other water source is available where you're painting, but depending on where you go, you may want to bring along your own water. Liquid laundry detergent jugs recycle wonderfully well into traveling water containers. Bring some drinkable water for yourself as well.

Timing is everything

A half-day outing is a good amount of time to plan. If you're fast, you can do a couple of sketches or paintings in that time.

Some artists collect data by doing sketches on location. Then they take the information back to the studio where they can do their painting under controlled lighting and in comfort. You can "sketch" with your camera, but there's no replacement for studying a subject and sketching it with watercolor and paper. Your hand, eye, and brain learn so much more this way. A camera over- and underexposes light and distorts proportions. Watercolor is a perfect way to record the colors, shapes, and angles you see.

The biggest frustration in painting outdoors is the changing light. As the sun moves, so do the shadows. Here's how I handle the shadows outdoors. If I'm painting the image of a house, I paint the house, its descriptive shadows (like different planes), and all its details, ignoring the shadows cast by the sun. When I have the house under control, I glaze in the shadows at that point and don't worry about them changing. (A *glaze* is a wash using lots of water with a little pigment, and fully explained in Chapter 4.) When you paint shadows, you're essentially painting air, so use a light touch, thinking "air" while applying your glaze.

The very best shadow conditions are at 10 a.m. and 2 p.m. The angle of the sun creates more-interesting shadows at these two times.

Project: Rocky Mountain High

Paint a scene using many of the pieces in this chapter: rocks, sky, mountains, and trees. Later you can paint the scene again, changing a few elements to make all four seasons. You can change the time of day to make a sunset or night scene. Start with an autumn scene with a typical blue sky with clouds as shown in the final frame of Figure 10-24.

1. **Choose a piece of 8-x-10-inch watercolor paper.**

 Cold-press or rough paper is necessary so the rough texture technique works well. Hot-press paper won't give you rough texture as easily. (See Chapter 2 for more about different papers.)

2. **Activate your paints.**

 I used ultramarine blue, burnt sienna, alizarin crimson, white or yellow, lemon yellow, cadmium yellow, cadmium red, yellow ochre, hookers green, cadmium orange, and yellow ochre.

3. **Paint the top edge of the sky.**

 With a round brush held parallel to the paper, paint a blue-gray mixed from ultramarine blue and burnt sienna at the top edge of the paper. As you paint, roll the brush in your hand and wiggle it up and down so that the heel of the brush leaves an interesting edge suitable for clouds. Figure 10-20 shows the result of this technique. Where you choose to leave white will become clouds.

 Soften some edges by adding water. Allow some water to make blooms for cloud edge surprises.

Figure 10-20:
Painting
the layers
of the sky.

4. **Paint the lower portion of the sky.**

 Below the white paper left for clouds, paint a band of blue-gray, using the same brush technique described in Step 2 to define the lower edges of the clouds. Refer to Figure 10-20.

 You can add a touch of diluted alizarin crimson to the bottom edge of the clouds, if you like. Make pink by adding a bit of white to alizarin crimson or add some alizarin to yellow to make peach.

 Soften the bottom edge of the sky area by adding water so you can cover it with mountains in Step 7.

5. **Let the sky dry.**

6. **Paint the next lightest area — the deciduous aspen trees.**

 Plan where you want to have the yellow aspens and paint them next. See Figure 10-21 for guidance.

With a round brush, dot lemon yellow paint at the top of the aspen foliage. As you continue the round shape of the foliage, paint cadmium yellow. Drop in a bit of cadmium red and yellow ochre toward the bottom.

Figure 10-21:
Painting the aspen trees.

7. **Let the aspens dry.**

8. **Add a light layer of mountains using rough texture.**

 Mix some alizarin crimson with ultramarine blue and a touch of burnt sienna to neutralize the mixture to a gray-purple for the mountains.

 Apply the paint quickly and dry (not a lot of water in the paint) around the tops of the aspen trees, using the side of the brush to create rough texture. The mountains define the tree shapes. Figure 10-22 is an example.

Figure 10-22:
Adding the mountains, tree trunks, rocks, and path.

9. **While the mountains dry, work on the bottom of the painting.**

 Put in some pale gray tree trunks, plan and paint a few burnt sienna rocks and a burnt sienna path as well. See Figure 10-22. You'll add some shadows to the path and rocks in Step 12.

10. **Paint in the coniferous trees to outline the deciduous aspens and define the trunks.**

 Check Figure 10-23 to see my final placement.

 Mix a dark green by adding alizarin crimson to hookers green. With the tip of the round brush, paint the pine trees around the aspens. The pine trees define the aspen shapes. Dot in some dark green in the aspens to show the pine trees behind them.

 Paint around the aspen trunks with the dark green. The light aspen trunks show well against the dark.

 When painting the pine trees, try to vary the trees' heights and widths, and the spaces between the trees.

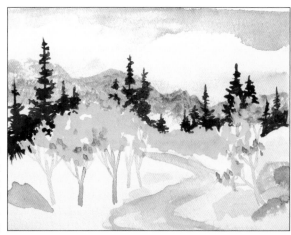

Figure 10-23: Adding in coniferous trees.

11. **Warm up the foreground with a glaze of yellow.**

12. **Paint shadows on the rocks and down the path, and add any last details.**

 See Figure 10-24. The shadows on the rocks and path are a blue-gray made from a mix of ultramarine blue and burnt sienna. Some rough texture strokes using gray on the path look like tire ruts in the road.

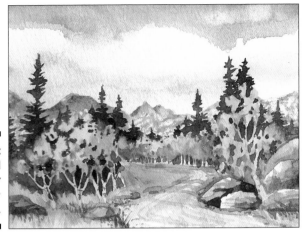

Figure 10-24:
The finished
*Rocky
Mountain
High.*

Chapter 11

Dipping into Seascapes

* *

In This Chapter

▶ Wading through costal living motifs

▶ Embracing waves of watercolor information

▶ Going costal bird watching

▶ Painting yourself into the sunset

* *

*I*magine being on the beach. Hear the crash of the ocean waves. They come up to your bare feet, and the water tries to take the sand out from under them as it recedes into the sea. Watch the waves ebb and flow rhythmically. The empty windows of the beach houses along the ridge above reflect the sky. Sand grasses sway in the temperate breeze. The salty air is heavy with humidity, but the wind is cool against your cheek. A child plays in the sand in front of you using her bright yellow plastic bucket and red shovel to build a sand castle embellished with seashells. Past her, the sea encroaches on the land, and gulls swarm above a rusty fishing boat as it pulls into the old harbor for the evening. You turn your gaze out to the sunset as the evening sky blazes orange over the azure water. In the mood to paint a seascape? I sure am!

Half of the planet's entire population lives near the ocean. Even though I live far from the ocean in landlocked Colorado, it's one of my favorite places to visit and therefore paint. Many artists, myself included, have a spiritual, mystical, enchanting, compelling urge to paint water. Maybe it's because our own bodies are mostly water. Whatever the reason, watercolor is made for painting water.

In this chapter, you discover how to paint things you find by the seaside: water, waves, sand, boats, birds, rocky shores, and seashells.

Seascape Elements

When you think of a seascape, you immediately think of ocean waves and water in general. Some seascapes may be mostly water, but some don't have any water in them at all. A seascape painting can include any number of other items you care to add to the scene: beach, sky, birds, boats, lighthouses. Maybe a pile of fishing equipment implies a nearby ocean without actually showing it.

I think of all these types of paintings as seascapes, but they can also fall into other categories like still life for the fishing equipment or wildlife for the birds. You're the cook. You pick the ingredients to make your recipe for a gourmet seascape painting. I'll show you some of the ingredients I like. And as the simple scene of Tybee Island, Georgia, in Figure 11-1 demonstrates, seascapes don't have to be complicated.

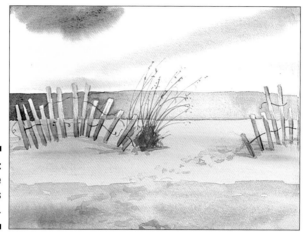

Figure 11-1: Seascape with grass and fence.

When you paint a traditional seascape, you generally divide your watercolor page into horizontal stripes: One stripe for the sky, one for the water, and one for the shoreline. For variety and a better composition, make sure the stripes aren't the same widths. When I painted Figure 11-1, I started by dividing the page into sections to represent the sky, land, and water.

Keep the horizon of the water parallel to the top and bottom of the page. A slanted horizon makes it look like the water will leak right out of the picture plane.

Water, Water, Everywhere

I love putting water in my paintings. Being born under a water zodiac sign may have something to do with it. But how do you paint clear water? It depends on where you find the water. Most large bodies of water, including lakes and ponds, reflect the sky or whatever is near them or on them, especially if the water is fairly still. When the water is moving, the reflections are more broken up. If the water is really moving, the waves make whitecaps and show no reflections. So even though the water is clear, it's a reflection of its surroundings influenced by its movement.

Water isn't always blue. In fact, it's often filled with plankton and algae which can make the water shades of pink and green. If you can see through the water to the bottom, it may take on rock and sand colors. Careful observation is a good

guide. What's better than having to sit still and observe the water? Use the value chart located on the Cheat Sheet at the front of the book to identify the values in the water. You might be surprised at how dark clear water can be.

If you're lucky enough to be painting in the tropics, you may wonder how to achieve that fabulous Caribbean blue color. My secret recipe for turquoise water is cerulean blue mixed with viridian green. I guess it isn't a secret anymore, but it does make a beautiful turquoise color.

Lighten the color of the water as it comes forward in the painting, and let the color be darker as the water gets deeper in the distance.

Showing still water with reflections

Quiet, calm water is a mirror reflecting what is sitting on or near the water. It would be rare to find a still body of water that wasn't reflecting something around it. Not to mention boring. The more movement in the water, the more the reflections wiggle in the water. Each wave and ripple acts as an individual mirror.

Paint calm water using mostly horizontal strokes. Diagonal and vertical directions just don't work unless the water is spilling or splashing.

A calm harbor reflects wiggling lines as in Figure 11-2. I started with a sketch of the boats so I would know where to save the whites. The water was painted by first making a graduated wash starting at the pier and coming forward using light cerulean blue, then cobalt, then ultramarine blue, then burnt sienna, and a little Payne's gray. Next I painted the boats. Then I painted the distant, very diluted purple-gray background. Next I painted the riggings on the boats.

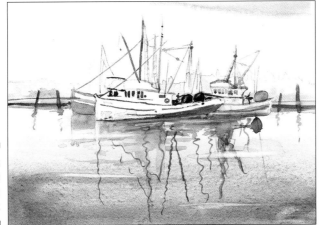

Figure 11-2:
Boats
reflected in
still water.

After you get the subject matter in place, you can reflect it into the water. The reflection is a grayed-down version of the item mirrored in the water. And painting the darker reflection last follows the watercolor rule of painting light colors first and dark colors last. To gray a color, just add a bit of its *complement*, the color opposite it on the color wheel (see the color wheel on the Cheat Sheet at the front of this book or the one in Chapter 5). To establish a little movement in the water, wiggle the lines.

I lifted the white waves by dragging a damp stiff bristle brush across the area and blotting with a paper towel. Quick and easy. The pier was added next to fill in the white area between the background and water. Last, I echoed the blue-gray of the water with a quick sweep of the same color in the sky.

Making ocean waves

A wave is a complete circle of water. Only half of it appears above the horizon; the other half is underwater. The top or *crest* is what you see as the highest point. The center is the *eye* and appears as the lightest area where the sun shines through. The white stuff you see when the wave crashes on the shore is *foam*. Foam can be a line or a pattern of white that allows the water's darker color to show through in a calm wave. A wave and its parts are shown in Figure 11-3.

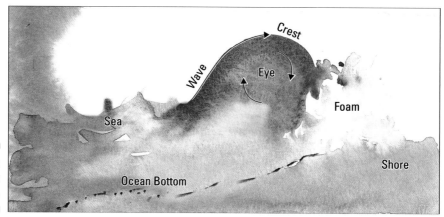

Figure 11-3: Parts of a wave.

Waves are generally horizontal and parallel to the horizon. Of course when the waves crash and splash against the rocks, they splatter everywhere, as they do in Figure 11-4. This painting has horizontal waves, diagonal waves toward the shore, and vertical crashing waves on the rocks. But even if the waves take on one of these diagonal or vertical movements, they have a horizontal base. Waves are fairly parallel to each other too. Don't stress about being exact. Nature is pretty organic. Sure, you can measure with a ruler, but just trust your eye for the most part.

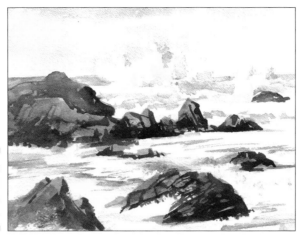

Figure 11-4:
Rocks and crashing waves.

To capture the ocean waves in Figure 11-4, I painted around the whites of the splashing water using a variety of blues. I added a *glaze* (lots of water with a little paint) of a mixture of ultramarine blue and a bit of burnt sienna after the first blues were dry.

Keep in mind that waves have perspective. The closer the waves are to the foreground, the larger, more colorful, and more detailed they are. The farther away they get, the closer together they appear, the grayer they look, and the less detailed and distinct they become.

As with every other watercolor subject, the best way to figure out how to portray ocean waves is to sit in front of the real thing and observe. Look for pattern, shape, values, contrasts, direction, and colors, and don't forget to breathe.

Catching moving, splashing white water

Waves erupt in violent, spectacular splashes. Water flowing down a waterfall or river has an irresistible energy. This stage of high excitement is one of my favorite things to paint.

The key here is *white* water. In Chapter 5 I explain that white is the reflection of all color, so that's how I paint it. I like to add a little of the entire rainbow but keep the colors very pale.

Figure 11-5 shows a vertical waterfall full of rocks and splashing water.

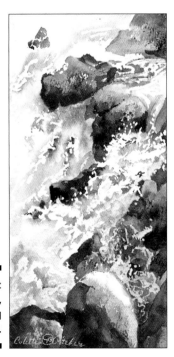

Figure 11-5:
Tumbling,
splashing
water.

In this painting, I first saved the whites using masking fluid (Chapter 4 talks more about saving white and masking). Then I added pale washes in a range of colors to define the water. I glazed very pale yellow, pink, and purple into the water shadows. I painted in the color and quickly softened some of the hard edges with clear water. The rocks were added using dark paint. (I show you how to paint rocks in Chapter 10.)

Splashes are fun and lend a lot of energy to the waves. This riverscape has many little dots of sparkling white water exuberance. Some dots were saved using masking fluids, and some were picked out with a razor blade when the paint was dry and the painting nearly finished.

To cut in exciting little dots, take a single-edge razor blade and use the sharp corner to gently but firmly flick a small dot within some dry color. Be careful not to cut through the paper. This shows up best when the white is picked out of a dark area. Contrast!

The good news is you have choices on white dots: If you're a planner, use masking fluid; if you forgot to plan, use a razor blade.

It doesn't matter whether you paint the rocks first or the water first. In Figure 11-4, I painted the rocks first and used them to outline the water. In Figure 11-5, I painted the water first and kept the masking fluid on until the rocks were painted. After I finished the rocks, I removed the fluid to reveal the white splashes.

As with everything, the important rule is variety. Make the rocks different sizes and create different shapes in the water between the rocks. Make the waves different widths and the splashes different heights. Nothing should line up.

Land, Ho! Spotting Shorelines

Shorelines can be as varied as the water they outline. Sandy beaches come in every color from black volcanic sands in Hawaii to pure white sand in the Caribbean, to pink sand from ground seashells, to earthy brown sand from the sandman. Some beaches lack sand and are rocky instead. Some shorelines are marshy and have grasses and reeds so close together that they don't offer many places to stand. The shoreline you choose flavors the location of your seascape.

Shifting sand

White sand can be like painting snow. The white of the paper is the white sand. The shadows describe the mounds of sand. Details are painted last, if at all. To make a shadow, paint the mound edge with a hard edge brush stroke and soften the other side (away from the mound) with water so it fades into the distance. The way you manipulate the shadow's shape outlines hills and valleys in the sand. Depending on the time of day and the influence of the sun, ultramarine blue or purple is a good shadow color for white sand. Another land formation that lends itself to this technique is sand dunes.

Many beaches have more earth-colored sand. Burnt sienna, burnt umber, and yellow ochre are good choices for an earthy beach. Add plenty of water for a light transparent sand color. A little diluted cadmium red makes the pink beaches. Make a black-sand beach with ultramarine blue and burnt sienna mixed to a dark black.

Observe the edges of the sand as the water covers it. Is it lighter or darker than the dry sand? Is it lighter or darker than the water? Measure these values with your value chart on the Cheat Sheet. Then mix paint that is as dark in value as the measurement value.

The colors and shadows depend on the angle of the sun, the reflections of the sky, the type of sand, and the time of day. Observe and re-create what you see.

Have some fun in the sand. You can make sand as realistic as you want or as impressionistic as the sand in the upcoming activity.

A simple beach with a single seashell can model for a very special postcard from the beach.

1. **Get a 5-x-7-inch piece of watercolor paper, turn it horizontally, and activate your paints.**

 For the shell colors, I used a pink, orange, burnt sienna, a yellow, and a blue-gray mixed from ultramarine blue and burnt sienna. Choose colors you have available that are similar. When it's time to paint the sand, you can use your own color combination or the pigments I used, listed in Step 8.

2. **Transfer the seashell in Figure 11-6 onto your paper.**

 You can place the shell wherever you want. I put mine in the upper right third of the paper. (Chapter 8 has tips on transferring.)

Figure 11-6:
The seashell
outline.

3. **Paint the seashell using a round brush with a pointed tip.**

 A. Paint the seashell area with a transparent pink as shown in Figure 11-7a. By adding water to the paint, you make it more transparent or see-through.

 B. While the color is wet, drop in some other colors like yellow and orange wherever you see the need. In Figure 11-7a, I kept the darker colors on the bottom and the yellow on the top to make it look like light is hitting the shell.

 C. Allow the paint to dry or use a hair dryer.

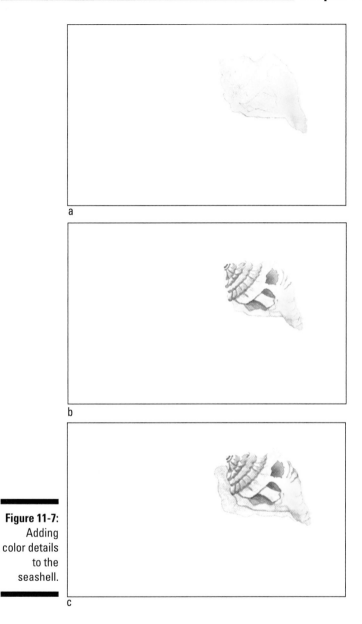

a

b

Figure 11-7:
Adding
color details
to the
seashell.

c

D. Paint bands of seashell detail and the holes with diluted burnt
 sienna and blue-gray, using Figure 11-7b as your guide. Let one
 layer of color dry and add another on top for a darker area like in
 the holes. Under the shell, I painted a shadow of blue-gray mixed
 from ultramarine blue and burnt sienna with a lot of water to make
 it transparent, as shown in Figure 11-7c.

4. **Paint the first layer of sand.**

 Dampen the area around the seashell with clear water. Paint in diluted burnt sienna and a little yellow. Keep the darker area toward the edges of the paper. My first sand layer is shown in Figure 11-8.

5. **Let the sand dry completely.**

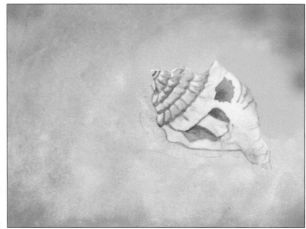

Figure 11-8:
Laying down a layer of sand.

6. **Paint masking fluid over the seashell when the paint is completely dry.**

 I used a mask that looks gray when applied. Dip your brush in liquid soap before dipping it into the masking fluid and cover the entire area of the seashell and its shadow.

7. **Let the masking fluid dry naturally without the help of a blow-dryer, which will cook the fluid into the paper.**

8. **Tilt the painting up (using an easel is a good idea) and spatter paint using a toothbrush to simulate the sand.**

 Dip a toothbrush into wet paint and draw your thumbnail over the bristles to let the paint fly randomly onto the paper (see Figure 11-9a). (Tilting the paper makes the drips of the spatter painting land on the table and not on your painting.) Rinse the toothbrush and try different colors until you're satisfied.

 For the sand shown in Figure 11-9b, I used ultramarine blue, purple, burnt sienna, cadmium orange, cerulean blue, cadmium red, and yellow ochre. You really can't go wrong with the colors you choose. Experiment and have fun. Enjoy the reactions and the random mixes that happen on the paper. (Chapter 4 has more on spattering.)

9. **Let all the paint dry.**

a

Figure 11-9:
Spattered
sand
creates a
natural look.

b

10. **Peel off the masking fluid.**

11. **Touch up anywhere that needs reinforcement.**

 My mask lifted a bit of the color of the seashell, so I glazed over the shell with the same colors and added some details again.

 Postcard complete! You should have something resembling Figure 11-10.

Figure 11-10:
A seashell
on the
seashore.

Skipping sand for sea grasses and so on

Not all beaches have sand. Some are rocky, some are marshy, some have grasses and other vegetation. I cover rock painting in Chapter 10, so turn there for tips if you're painting a rocky shore.

I chose paintings from a variety of coastal regions for this chapter. Each shoreline is unique and to be appreciated. So make use of your observation skills and the tips throughout this book when painting shorelines with vegetation.

Just remember, when you start painting the sandy, marshy beaches of the east coast to put the ocean on the other side — just kidding.

Sailing the Ocean Blue

Boats are favorite seascape subjects. You can capture working boats like fishing trawlers, tugboats, and freighters. You can paint pleasure boats like yachts and sailboats. You can render small watercraft like canoes and dinghies. All are excuses to get the colors flowing.

Look for the general shapes to begin drawing the boat. The main boat can be a shape like a rectangle with a triangular bow (front). (Chapter 8 explains more about breaking images down into simple shapes.)

Keep the boat deck parallel to the water horizon or it may capsize and sink.

Look for comparisons in value and color when deciding how to paint the water and boat relationship. The reflection of the boat on the water should be slightly grayer and less detailed than the boat itself.

A boat needs more room ahead of it than behind it to make the viewer feel comfortable. This also gives viewers a sense of having somewhere to go in their journey through the painting.

Unfurling some sail

Hoist the main sail! Lower the jib. I would, if I knew what they were. Maybe I'd better read *Sailing For Dummies,* huh? I do know that the feeling of wind and the light through the sails make for one fine subject to paint. In Figure 11-11, I chose to paint exactly that. I took a photo of this picturesque sailboat in San Francisco Bay and used it for this painting of a sailboat, water, and fog.

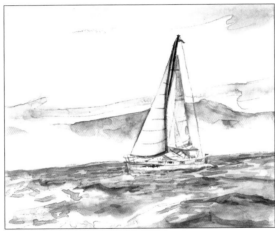

Figure 11-11:
Sailboat
and fog.

A sailboat is simple shapes — triangles, rectangles, and lines. The triangles of the sails are automatically interesting because the sides of each sail are different lengths, the two sails are different sizes, and the bottom edges are slightly rounded. The roundness also gives the viewer the feeling of wind and direction.

The fog looks difficult, but is really easy in watercolor. The technique is a really good example of the soft edge I talk about in Chapter 3. The mountains were painted with a hard edge at the top and a soft edge at the bottom. The ocean was painted with a hard edge. After both of these areas were dry, I dampened the fog area with clear water and dropped a bit of blue-gray into the bottom near the ocean, making it softer and lighter as it reached the middle. I put the boat details in last. Red flags, boat windows, and the railing are icing on the cake.

Laboring on rusty working boats

Give me a stinky fishing port, rusty time-worn boats, and obnoxious bellowing sea lions, and I am one happy camper! My idea of shipshape is old fishing trawlers that have great shapes. Figure 11-12 shows some top models at the beach in Rocky Point, Arizona. These are the kinds of top models I enjoy looking at!

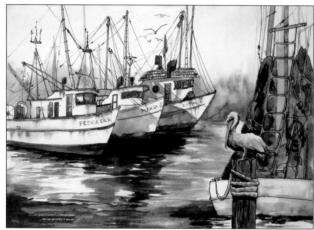

Figure 11-12: Rusty trawlers — my idea of top beach models.

If you paint one of these scenes, before long you'll need to paint rust. Burnt sienna is the perfect pigment for painting oxidized metal, commonly known as rust.

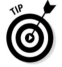

Try this great technique to show the effect of a rusty nail in a pier or a boat:

1. **Paint the nail head dot using burnt sienna, and let it dry.**

2. **Put another dot of burnt sienna on the head of the nail, and while the paint is still wet, put your index finger on the wet paint and quickly pull the color down the paper in a fast flicking motion.**

 You can imitate in a second what it took nature 20 years to oxidize.

Focusing on Waterfowl and Other Feathered Friends

Part of the charm of the beach is the birds. And these feathered friends can serve a variety of functions in a seascape, from being the center of interest to providing a visual element to help balance a painting, or bringing some life and movement to a stretch of sea or sky.

Figure 11-13 shows some great choices for inclusion in your seascapes, but keep in mind that I can only squeeze so many examples into this brief space. You can include many other species of birds in your paintings. Get a good bird book to help with the details — I hear there's a couple of *For Dummies* books about birds and bird watching. You can take up bird watching or enroll in a class. I just finished a bird-watching class at the local community college. While the instructor lectured, I sketched the birds he showed in slides. It was great practice, and I retained so much more information by drawing as he spoke. I even got a few offers from classmates to buy my notes. Sporting goods stores are great to explore for taxidermy specimens and art that has already been produced.

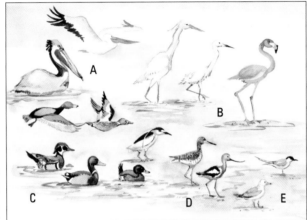

Figure 11-13: Beach birds.

The birds in Figure 11-13 include:

A. Pelicans: The brown pelican is floating and the American white is flying. The difference is the obvious color. In the Pacific Ocean, the brown pelican gets a brilliant red orange under its bill, while in the Atlantic, the American's bill is black with a little orange on the tip. Both have yellow tops of the head.

B. Herons and egrets: You can see an amazing variety of these birds near almost any body of water. The painter's guide to herons and egrets boils down to this: There are big ones and small ones. The figure shows a great blue heron and a snowy egret. I threw in a flamingo, which is also part of the heron family, but you know what they look like from the plastic one in the front yard. You don't have one? Weird.

C. Ducks: Ducks come in 16 species of *dabbling ducks* and 23 species of *diving ducks.* Dabblers tip forward but rarely dive. Diving ducks are generally a bit smaller and do as their name suggests. Figure 11-13 shows a mallard and a wood duck, both from the dabblers, and a ruddy duck represents the divers. Although most of the ducks have a similar silhouette, the ruddy

has a tail that becomes vertical or goes into the water and acts as a rudder. Most ducks are various shades of brown and black, though I chose some with more color and interesting shapes.

D. Shorebirds: This group includes 62 species. They are small to middle-size birds with very long legs and thin, pointed long bills. Some bills are straight and some curve up or down. I include a greater yellowlegs and an American avocet to represent the shorebirds. These birds can be found near the edges of marshes and beaches poking those long bills into the sand in hopes of finding food.

E. Gulls: Gulls are everyone's favorite. And, by the way, it's just "gull" not "sea gull." If you say sea gull, the Audubon police will take away your birder card. But that's better than the art police taking away your composition card. (Just kidding; you don't have to worry about art police, just art critics.)

Of the 27 species of gulls, the herring gull and common tern show up here. All the gulls are very similar with subtle differences in black and gray patterns, and beak and leg color. Terns are a little more streamlined, but could be mistaken for a gull.

In Figure 11-14 I had a lot of fun giving you a gull chart. Instead of making the letter "M" in the sky to represent birds, you can take a little more time and use shapes like these. The images are still simple, but they give a better impression of gulls going about their acrobatic business.

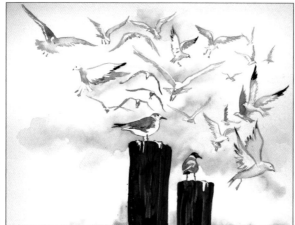

Figure 11-14: Gobs of gulls.

Notice the pier pilings in Figure 11-14. Making old weathered pilings is an easy trick to do in watercolor:

1. **Paint the piling in yellow ochre and burnt sienna and let it dry.**

2. **Paint over that with a fairly thick opaque dark brown.**

3. **When the wet shine is about to leave, use the round corner of an old credit card to scrape through the paint to reveal the underpainting from Step 1.**

 Don't use the thin edge of the credit card because it's more likely to produce a dark line instead of the more natural, uneven line you want.

Project: *Serene Seascape*

This painting project is a fantasy seascape inspired by Catalina Island, California. The pier and beach really exist, but I took some liberties to move the trees to frame the scene. See what power you have as an artist? You can move mountains as well as trees. This technique is a fun way to color a painting. The mood and color suggest a sunrise or sunset.

1. **Choose an 8-x-10-inch piece of watercolor paper, turn it horizontally, and activate all of your paints.**

 Make puddles of cerulean blue, pink, lemon yellow, lilac, and ultramarine blue to use for the sunlight colors. You'll use additional colors as the painting progresses.

2. **Choose where you want your horizon line.**

 Mine is pretty close to middle of the page, a dangerous place compositionally, but this painting has a lot of elements that help break up the space. You usually don't want to divide the page in half.

3. **Use a 1-inch flat brush to wet the area from the horizon up using clear water.**

 Make this even, shiny wet with no puddles and no dry spots. Pick up the paper and let the excess water run off to ensure even wetness. I even tap the edge on a cloth towel to absorb excess water.

4. **Apply sunset colors (see Figure 11-15a for guidance) in the sky (from the horizon up).**

 A. Start at the horizon edge and apply cerulean blue diluted to a pale value using the 1-inch flat brush and making sure the color doesn't leave hard edges. By painting wet paint into wet paper, you should get soft edges.

 Paint long horizontal strokes across the entire width of the page. Paint right off the edge of the paper onto the table. I keep a towel in one hand and pick the paper up and wipe up the wetness that goes on the table.

 B. Apply lilac next to the blue, then pink, then yellow, then ultramarine in the same manner.

Clean the brush by swirling it in clear water between colors. Apply these different colors quickly so the paper won't dry before the paint can blend.

C. Pick up the paper and let the paint drip off, then touch the very edge of the paper to a towel to absorb any excess water.

If the paint is too pale, add more pigment. If the paint is too dark or intense, spray water over it and let some run off. You can work until the paper starts to dry. If one area starts to dry, then let it dry completely.

When you like the colors, you're done. If you don't like the colors, you can work them again in another layer in the same manner. If you got a blossom or a hard edge that you want to remove, wet the entire area and scrub it with a stiff brush.

Figure 11-15:
Painting the fading light of the sunset.

5. **Let the paint dry.**

6. **Wet the area from the horizon down with clear water and paint the water from the horizon line all the way to the bottom edge using the same technique as in Step 4. This will be the reflection of the sunset in the water.**

 From the horizon down, paint yellow, pink, lilac, cerulean, and ultramarine blue. Figure 11-15b shows how this should look. It's okay if you have different colors or different widths of colors.

7. **Let the paint dry completely.**

8. **Trace the drawing in Figure 11-16a, enlarging it as necessary, and transfer the drawing to your painting.**

 Chapter 8 explains the details of transferring. You should end up with something like what's shown in Figure 11-16b.

a

Figure 11-16:
A scene is drawn on top of the water and sky.

b

9. **Paint the silhouettes of the tiny palm trees on the mountain horizon, the mountain, and the pier (see Figure 11-17).**

It's time to mix some more colors. The dark green in the two tiny palm trees on the horizon is a mix of hookers green dark and alizarin crimson. The mountain and pier are a mix of purple, ultramarine blue, alizarin crimson, and Payne's gray. The silhouettes all blend together, but some variety in color within the dark shape makes a better look.

When you paint the mountain, make sure you paint around the trunks of the palm trees. The top of the trunk is painted dark against the light sky, while the main trunk is light against the dark mountain. Use the same color for the top of the trunk as you did for the mountain, but warm up the color with a little burnt sienna added to the purple. This is an example of transposition of value as discussed in Chapter 7.

Figure 11-17: Painting the pier and mountain, and starting the palms.

10. **Paint the tops and bottoms — but skip the middle — of the palm trees.**

The palm tree tops are painted with a light yellow-green at the edge of their foliage. For now, stop with the light green for the large palm tree. And as long as you have light green on your brush, paint some of the grass around the base of the trees too.

For the two palm trees on the right, continue painting the fronds so that they get darker toward the middle and bottom. Add brown to the dark green as you paint down to the trunk.

Paint the bottom of the two trees using diluted burnt sienna from the bottom of the mountain to the base at the beach. Leave the middle of the trunks light for now.

11. **Paint the big palm on the left.**

In Step 10 you started some yellow-green sun-kissed palm fronds. Mix a darker green and fill in the palm, as shown in Figure 11-18a. Enjoy the interesting edges that define the palm. While you have the dark green on your brush, add some dark green grass to the bottom of the two right-side palms.

Use a pointed round brush to paint the trunk using burnt sienna. Paint jagged edges to look like ragged bark. While you have burnt sienna in your brush, wash a little more color over trunks of the right-hand palm trees.

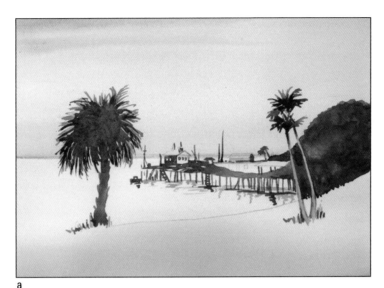

a

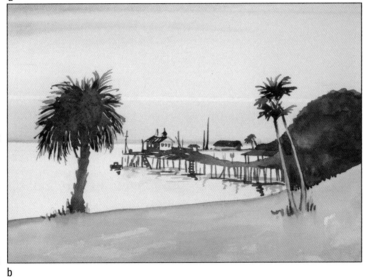

Figure 11-18:
Finishing up
the palms
and coloring
the sand
and
rooftops.

b

12. **Paint a watered-down burnt sienna over the beach. Put the red roofs on the dock buildings while the sand dries. Refer to Figure 11-18b.**

Rough texture works well for sand, so with a relatively dry brush, pick up some pigment and use the side of the brush to quickly stroke the paint across the paper, letting the paper sparkle through. More on this technique in Chapter 3.

The roofs are a mix of burnt sienna and a bit of brighter cadmium red.

Save the red to paint when you're almost finished with the painting because red will run if it's touched by a damp brush, even after it's dry.

13. **Soften the trunks of the two palm trees on the right by nudging the edges with clear water. Add yellow to warm the middle sections of the trunks.**

 Look at Figure 11-19 to visualize Steps 13, 14, 15, and 16.

14. **Use a liner brush and dark green paint to pull some grass up next to the base of all the palms.**

15. **Use ultramarine blue to paint shadows and add waves near the shore.**

 There are shadows for the three palm trees, the grasses, and where the pier touches the water. Make sure the shadows fall toward the viewer and away from the sun.

16. **After everything is dry, add any last details you want, like bark on the big palm.**

 Grab yourself a tall, cool drink and enjoy the view!

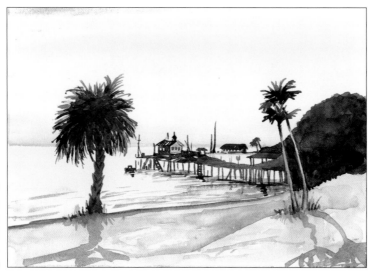

Figure 11-19:
A Catalina
Island
sunset.

Chapter 12

Answering the Call of the Animal Kingdom

I love animals. The big dewy eyes. The unconditional love. The hair on the couch. I've had almost every type of animal as a pet: cats, dogs, horses, peacocks, skunks, chickens, mice, rabbits, cows, geese, pheasants, quail, fish, and Shetland ponies. I still live on a farm, only now the domestic animals have been replaced by plenty of wild critters: foxes, raccoons, owls, deer, hawks, snakes, birds, and bunnies.

Time doesn't allow me to care for pets now. But don't feel sorry for me — or for yourself if you don't have critters running underfoot. If you long for animal companionship, the solution is here. As an artist, you can paint your pets and immortalize them forever. You can own exotic animals without department of wildlife permits. Just paint whatever your heart desires. Easy maintenance, no stray hair, no vet bills.

Animals can be a metaphor for human activity. Your paintings will become that much more interesting if you can incorporate symbols, stories, and depth into them. In this chapter, you paint several animals that are furry, slick, or feathered. You also handle values from black to white in animals, and you can apply this knowledge to other paintings with or without animals.

Finding the Leash: Preparing to Paint Animals

Sometimes animals cooperate and pose for you without asking, but unless you're a quick sketch artist and live in an animal sanctuary where you have access to any animal you want anytime you want, you probably need a camera to help you capture the details on your furry, scaly, feathered, or hidebound subject.

And then there's the issue of black and white. Of course, animals — especially fish — come in an amazing array and combination of colors, but they're also sometimes mostly black or mostly white. The following sections talk about the best ways to capture the details of your subject for your project and painting in black and white.

Painting from life and photos

Working from live models is the best practice. There's nothing better than to see real subjects in all their detail. But painting live is not without its frustrations. Because these models don't stay in one pose for long, as an artist you need to work quickly. Animals move just when you need to observe something most closely.

So work with the best of both worlds: Keep a camera handy for taking a snapshot, and sketch from the live model while the animal will pose for you. Later you can work from your photograph when you no longer have the luxury of the live model. When you're sketching, also called making a *study,* you're becoming experienced with the subject. Familiarizing yourself by sketching is much more educational than just snapping a photo. You may just work on a part of the animal like an eye or foot — the details that often are hard to see in photographs.

Movement is difficult to capture without reference material to look at muscles and positions while drawing the shapes. So sketch with your camera. It's a wonderful tool to explore composition by trying shots and collecting reference materials for later use. Still, take time to sketch with a pen or brush. Quick on-site sketches collect even more information, such as details, personality, and attitudes, that you can use in a painting back in the studio (even if the studio is only your kitchen table).

Working from flat photos often leads to flat paintings. Gather as much information, such as light and shadow (which help define the critter's size and shape), as your subject will allow when working from a live model.

If you're painting animals from life, you're smart to limit your palette to just a few colors, say three, and work with an economy of detail. Use a light color to define the shape of the creature. After that dries a little, apply a second, darker color to capture volume and shadows. Use a still darker color to put in details like eyes, nose, and ears. By that time, your model has usually moved, and it's time to make another quick sketch.

Figure 12-1 shows what you can do with just a few colors and some quick brushwork.

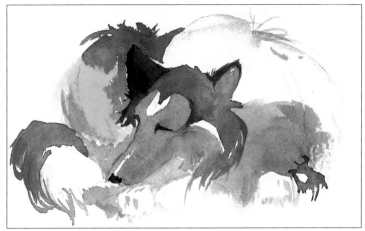

Figure 12-1:
Dog at rest.

Coloring with black and white

Black and white animals present some interesting watercolor opportunities. (It's up to you to take problems and change them into opportunities.)

Achieving a lively black color

Painting black animals is one of those situations where working from life is so much better than working from a photograph. I have wasted a ton of film taking pictures of black animals. Black usually gets underexposed, and the animal ends up as a silhouette with no details. But in real life, these animals have wonderful detail. Use other colors to make blacks come to life; for example, purple and blue make interesting highlights within black.

Avoid using black paint, which looks lifeless. Mix colors to create your own blacks instead. See Chapter 5 for some black recipes.

To make the color darker, use less water and add more pigment. For lighter areas, add water so the paint becomes a gray.

Wonderful whites

A polar bear raises the question: How do you paint a white animal? It's easy! Because the white is the white of the paper, you're almost done before you start. But keep in mind that there's a lot of color in white and that white can reflect many colors as well. When I paint something white, I look for the opportunity to subtly place as many colors around as I can fit.

In the polar bear in Figure 12-2, I chose to add some unexpected and fun colors to the white of the fur and produce a pronounced cool and warm to the light. (This painting project is included in Chapter 13, so you can paint your own furry friend if you want.)

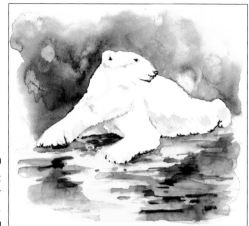

Figure 12-2:
A polar bear posing.

When it comes to the background, you can make the animal look whiter and stand out more distinctly by using dark colors next to the body and for the background.

Make sure the paper is dry before you use a liner brush to add dark eyes and whiskers to any animal. Otherwise, the paint will travel into damp areas when you least expect it. Look for opportunities to have a whisker be white against the dark face and become a dark whisker as it goes past the face. This transposition of value technique is described in Chapter 7.

Presenting Domestic Pets

Some folks stretch the definition of a house pet, but for this section I'm thinking of animals commonly found indoors.

Going to the dogs — and cats and bunnies and other furry creatures

Most furry, small animals fall into the "cute" category. I see nothing wrong with cute when painting furry animals.

You can paint fur several ways. Some artists paint every hair with much detail. I prefer to simplify the fur into a soft texture that defines the shape and shadows of the body. You can make curly hair especially look more free and loose by drawing it with quick, similar lines instead of laboring to slowly duplicate each line exactly. Short, choppy lines are more interesting than heavy, labored outlines anyway.

When painting fur, it's important to know which direction it grows. Look at a cat's face up close sometime. The hair doesn't grow all in the same direction. If you put in this much detail, make sure it's accurate.

My advice is to simplify the detail. It will make your entire life easier. Notice that in the paintings in this section, I don't follow every hair in the drawings perfectly.

To make a rough hair texture, use a round brush and push the tip away from you while the paint is a little dry. Some artists like to use a specialty brush like a rake or fan. The hairs on these brushes are spread out so each hair paints an individual line, like fur texture.

Be a copycat and transfer an outline of the cat on a mat shown in Figure 12-3 onto some paper. Then paint a feline portrait.

1. **Choose a 5-x-7-inch piece of horizontal watercolor paper and trace Figure 12-3. (See Chapter 7 for more on tracing.)**

2. **Activate your paints.**

 For this exercise, you use ultramarine blue, burnt sienna, lemon yellow, brilliant pink (or alizarin crimson with some white), cadmium orange, and a color of your choosing, if you want a different color for the rug.

 Mix a puddle of ultramarine blue and a bit of burnt sienna to make a pleasing blue-gray with a lot of water in it so it's transparent.

3. **Paint the pale blue-gray shadows and markings (see Figure 12-4a) using a pointed round brush.**

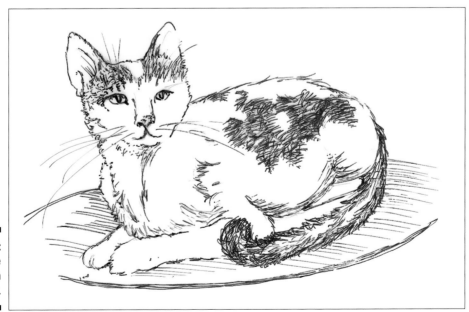

Figure 12-3:
The outline for a cat on a mat.

Follow the dark areas of your tracing and refer to Figure 12-4a to paint these: The paw farther away gets a shadow. The nearer paw gets a shadow defining the shoulder. Paint a shadow under the chin. A little shadow goes under the mouth. The eye sockets get a shadow that defines the nose. The edges of the body get a shadow that defines the roundness of the cat.

Use the same color to make a layer for the cat's markings on the face above the eyes, on the side, and on the tail.

Soften some of the shadows in the body by adding water to fade out the edge instead of leaving it hard.

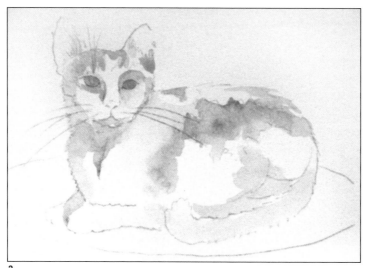

a

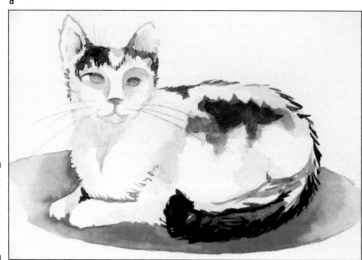

Figure 12-4:
Adding color for fur, shadows, and more.

b

4. **Let the shadows and markings dry.**

 Use a blow-dryer, or check the stock market prices while you wait.

5. **Paint the eyes.**

 I used lemon yellow to color the cat's eyes (see Figure 12-4a). Shadows come in another layer later, as does the black pupil.

6. **Paint some pink in the ears and nose.**

 Dilute brilliant pink with water and put some at the base of the ear (see Figure 12-4b). If you don't have brilliant pink, dilute alizarin crimson or add some white to it for a pink.

 Leave some white, hair-like spaces around the ears.

7. **Let everything dry.**

 Use a blow-dryer for speedier drying, or go change the oil in your car.

8. **Paint the rug.**

 Use whatever color you want on your rug. In Figure 12-4b, I used cadmium orange mixed with burnt sienna with a lot of water in it to keep the paint transparent.

 Let the paint be darker by the cat by sweeping the pigment with your brush toward the cat. I made the outside edges lighter by adding water with less pigment near the edge.

9. **Paint the gray markings on the cat.**

 I used a gray mixed from ultramarine blue and burnt sienna. This is the same as the shadow color used in Step 3, only with less water, so you get a darker color. You can see the results in Figure 12-4b.

10. **Shadow the ears, eyes, and nose.**

 Add a little cadmium orange at the center base of the ear for more depth and interest. Using the same color, create a shadow under the top eyelid and at the top of the nose as shown in Figure 12-4b.

11. **Finish the details (see Figure 12-5).**

 Use the tip of your brush to add all the little gray hairs you want. A liner brush makes nice whiskers. Paint the dark parts of the eyes, nose, and mouth using the dark mix from ultramarine blue and burnt sienna.

 Placing orange in several places — rug, eyes, ears, and nose — balances the color around the painting. If you made the rug another color, you may want to echo that color in other places within the painting — perhaps in the background or fur or whatever you think works.

Man's best friend can also be an artist's best model. Pet parents love to have portraits done of their dogs. Some artists specialize in dogs in general, while others stick to painting one breed. There are national art shows that only have dogs as subject matter. If you love dogs, you might find this to be a lucrative and rewarding topic too.

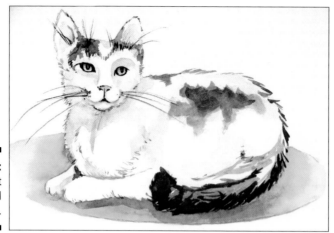

Figure 12-5:
A lovely cat on a colorful mat.

Weighing in on scaly sorts

Not every pet in the house is furry. You may be lucky enough to have reptiles (lucky?) or fish.

The shiny scales of a colorful goldfish make for a great watercolor topic. You may have koi outdoors in a pond, but I keep the fish in this section in a bowl and put it under the indoor category for the following exercise. You can use the same painting techniques for lizards, snakes, reptiles, and other types of fish.

1. **Trace and transfer the fish at the end of this activity (Figure 12-7) onto a 5-x-7-inch piece of watercolor paper.**

 I outlined this fish with a waterproof pen. I find this a successful way to work. If you use this method, you can use the pen first or last. The drawing outlines the finished piece, and the watercolor can almost do anything and still work. You can also paint the watercolor first and draw on top. You can certainly skip the pen and ink altogether and make the paint do all the work.

2. **Activate your paints.**

 I used antique red ochre (burnt sienna is similar) and ultramarine blue in the fish's body. Don't mix them together; make separate puddles of each color.

 You may also want to use purple, yellow, red, hot pink, and orange to make the fish shimmer. Choose whatever shades suit your fancy.

3. **Wet the body of the fish with clear water to make it damp.**

4. **Using a pointed round brush, drop and paint color on your fish.**

 Using antique red ochre or burnt sienna, let the paint diffuse into the dampness (*wet-into-wet* as discussed in Chapter 3). Create a round body by putting darker blue paint toward the edges and leaving the middle lighter, as I did in Figure 12-6a.

If the color travels into the area you want to be left light, pick it up or blot it with a damp brush or paper towel.

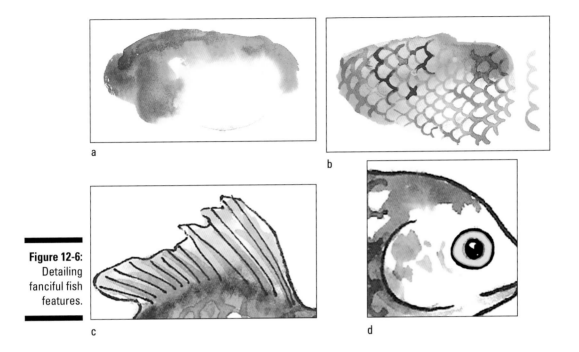

a

b

Figure 12-6:
Detailing fanciful fish features.

c

d

5. **Let the paint dry.**

 Use a blow-dryer, or relax and read the newspaper.

6. **Paint the scales.**

 Make a scalloped line using the tip of your round brush and a color that shows up (I used several, but mostly burnt sienna) vertically across the body of the fish, using Figure 12-6b as your guide.

 Make the next line so that the point touches the round part of the previous line. Paint two or three lines. While the lines are still wet, pick up some other colors with your brush and touch the damp scale lines at random to release the color into the line. Rinse your brush between colors. I dropped purple, yellow, red, hot pink, and orange into the scalloped lines.

7. **Let your fish friend dry.**

 Use a blow-dryer to speed up drying time, or dust the house.

8. **If you don't want all the scales so detailed, soften some with a stiff brush by nudging clear water over the scales you want to disappear.**

9. **Paint the fins.**

 Paint all the fins with the orange color. I left the top tailfin white paper. Drop in a bit of blue as a shadow near the fish's body. Figure 12-6c shows an example of a colored fin.

10. **Paint the eye.**

I gave Goldie a yellow eye since he didn't have much gold anywhere else. The eye and the iris with highlight are shown in Figure 12-6d.

All the black is done with the ink pen. If you didn't leave the white highlight or it got filled in, not to worry. When the eye is bone-dry, take a razor blade corner and pick out the white. One flick will make a highlight.

You should end up with something resembling Figure 12-7.

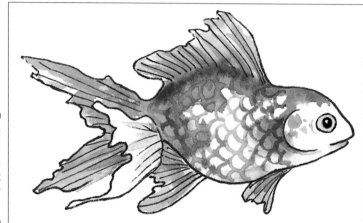

Figure 12-7:
A colorful goldfish is the perfect watercolor subject.

Hunting Big Game

Wildlife sanctuaries, zoos, and animal parks are great places to study animals. If you're well-to-do, you may be able to afford safaris and expeditions, but for most of us, the zoo is a good bet.

This section focuses on tips and techniques you can use when painting larger animals, including the following tips to keep in mind when you're painting a single animal:

- ✔ **Paint around the edges, including the underside, of the animal with a darker color to indicate roundness.** Paint shadows where the light doesn't reach as easily.

- ✔ **Make the eyes your focal point or center of interest.** People are connected by eye contact. Pay extra attention to the eyes, which is where the audience looks first.

- ✔ **Divide the background into smaller areas and do each area separately so you have less real estate to manage.** If you have a natural break in the picture where the animal breaks up the background, this is a good place to stop and start background areas.

> ✔ **Practice continuity.** If a color goes behind the leg in the front, make the same color reappear on the other side of the leg as well.

> ✔ **Ground the animal with a shadow.** Painting a cast shadow anchors the animal on the ground; otherwise, it floats in the air.

When painting on-site, people love to share information with you because you share their interest. You can discover so much and make new friends by painting on location.

In painting the giraffe in Figure 12-8, I painted a blue-gray color first to shape the body of the animal, as if no spots existed. This is sometimes called *modeling* — like a sculptor models the shape of clay. Next I masked the white areas between the spots using the masking fluid and let it dry. After the mask was completely dry, I painted the spots using burnt sienna. The variation of light to dark is simply the amount of water added to the burnt sienna. After time to dry, I peeled off the mask and painted the background. Some leaf shapes are painted, and some are lifted out of the dark green by applying water and blotting. Some leaves were painted around with background outlining the leaf. (This technique uses positive and negative painting as described in Chapter 5.) I painted the grass last to cover the giraffe's legs. While the foreground was still wet, I used a liner brush to pull paint up in long thin lines to make blades of grass.

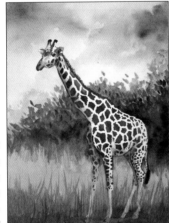

Figure 12-8:
A giraffe
on the
savannah.

Project: Looking into the Backyard and the Barnyard

My backyard is a constant source of inspiration. Maybe one of the reasons I don't need domestic pets right now is because I have so many wild ones. All kinds of birds, squirrels, and several bunnies are hopping about the yard. I laugh when I think about going outside and pretending to be Snow White.

Bird watching is a huge national pastime. With so many species, colors, shapes, and varieties, you can't run out of subjects to paint. You can employ every color on the artist's palette when painting birds.

Birds are so fast that you want to work from photographs. I keep my camera near anytime I think the opportunity to snap a feathered friend's portrait will arise.

Everything in my mother's kitchen included roosters: dishes, towels, rugs, and wind chimes. They have always been a family favorite. I laughed when I attended a marketing trends program and heard the new cool motif was roosters. Mom would say they've been cool for the last 80 years.

This painting project is in honor of Mom's favorite bird. Follow the steps, and you'll end up with a fun and colorful painting that you just may want to display in your own kitchen.

Make sure that adjacent areas are dry before painting next to them in this picture. I bounce around the painting hoping to allow time for each area to dry before going next to it with another wet color. I don't want any colors to bleed accidentally. But if you're a fast painter, you need to be aware that each area should be dry if you want separate colors without mingling them.

1. **Trace the drawing in Figure 12-9 and transfer it to a horizontal 5-x-7-inch piece of watercolor paper and activate your paints.**

 Use tracing paper to copy the drawing. Then place a piece of graphite paper beneath the drawing and on top of the watercolor paper. Retrace the drawing so it transfers to the watercolor paper.

 The colors you need to have at the ready are greens (mix your greens from blue and yellow or have hookers green, leaf green, and shadow green), lemon yellow, burnt sienna, ultramarine blue, cadmium red, alizarin crimson, purple, and cadmium yellow.

Figure 12-9:
Trace this outline to get started.

2. **Paint the shadows on mama hen, outlining her body to make it round, as shown in Figure 12-10a.**

 Mix burnt sienna with ultramarine blue to make a black, and add a little water to some of it to make a puddle of gray. My gray is a bit on the blue side, meaning that more blue is in it than burnt sienna.

a

Figure 12-10:
Underpaint-
ing poultry.

b

3. **Paint the light yellows. I used lemon yellow, but you can use whichever color you have.**

 Refer to Figure 12-10b to see how to put yellow on the beaks of mama hen and papa rooster, paint the chicks, and put a few patches on the rooster's neck and rear hip.

4. **Paint the light green.**

 Add lemon yellow to hookers green for a chartreuse color. Refer to Figure 12-10b to see how to paint some tail feathers on the rooster and a patch on his chest.

5. **Paint the rooster and hen's feet.**

 Use cadmium yellow on the legs and feet, referring to Figure 12-10b.

6. **Paint the rooster's body, as shown in Figure 12-11a.**

 Use burnt sienna to define some feathers over the yellow on the neck, wing, and rear. Paint hookers green around the light green you painted in Step 4. Mix hookers green and alizarin crimson for a dark green, and make another layer of feathers.

a

Figure 12-11:
Layers of
feathers
build up a
rooster.

b

7. Paint the ground.

Use burnt sienna with a lot of water for a pale sand color and paint around the chicks' bodies and the birds' feet (refer to Figure 12-11a for guidance). While the ground is still damp, put a cast shadow under the hen, rooster, and chicks using the blue-gray color from Step 2.

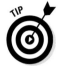

8. Paint the red.

Save the red for the end because it runs if water gets next to it. Use the cadmium red to paint the waddles and eye patches. See Figure 12-11b for guidance.

Add shadows in the red patches by using a darker red like alizarin crimson. Do some *lifting* in the red patches for some highlights, if desired, where light touches the waddles (Chapter 3 tells you how to lift paint). And add a few feather details for a little bright impact. I painted a few cadmium red lines to represent feathers in the rooster's back.

9. Put in burnt sienna details, as shown in Figure 12-12a.

Outline the rooster's beak, the stripes on his and the hen's legs, and the chicks' wings, beaks, legs, and feet.

10. Add the black details.

Use the black you made in Step 2 from burnt sienna and ultramarine blue to paint the birds' eyes and the hen's tail and wings. Outline the hen's beak, referring to Figure 12-12b for guidance. Dot in some chicken feed for the chicks to peck at on the ground. Now you're done!

Mama, papa, baby — or small, medium, large — is a good composition rule. The concept is simple and effective: Include one of each size in your painting. By varying the size of items in your painting, you avoid monotony and make your painting more interesting to the viewer. Any shapes will work with the small, medium, and large variation technique. More information on using size as an element of design is in Chapter 1.

a

Figure 12-12:
Add details
to bring the
birds to life.

b

Chapter 13

More Fun Projects

In This Chapter

▶ Leaving a permanent impression of autumn

▶ Putting paint to paper for a polar bear portrait

▶ Illuminating your skills in a lighthouse

▶ Capturing rainbow-bright horses

*T*he world abounds with subject matter for you to paint. This chapter gives you four more step-by-step projects to enjoy and paint. Try these and then use the techniques and processes on your own subjects. Just change the colors, observe value changes, and in no time you'll have watercolors galore!

Carry your camera everywhere to capture images you can transfer to paper later. Stop and draw whenever you can. Celebrate the beauty of nature and commemorate the world you live in.

Project: Drifting through a Fall of Leaves

Every fall the turning leaves become a focal point. A great way to bring the beauty of the season home is to walk through an area with a variety of interesting leaves on the ground and pick up the ones whose shapes and colors appeal to you. Children love this exercise. When you get home, put the leaves in the telephone book to flatten and dry. They retain their color for quite a while. When you're ready to be inspired by the leaves, get them out and make a painting.

This project involves positive and negative painting (refer to Chapter 4). Some of the leaves are formed by painting dark colors around the leaf and letting that dark paint define the leaf shape, which is what *negative painting* is all about. Other leaves you actually paint, which is the *positive painting* you normally do. The combination makes a lively, interesting painting.

Try modeling a painting on my example first. Then create your own leaf study with different shapes and placement. I painted this project with a minimum of planning. I wanted to experiment with negative and positive shapes within the same composition. I also wanted to create a *vignette effect* where the background fades at one side.

In your leaf composition, you need to choose a center of interest. Choose one or more of the following methods to make one leaf or several leaves the focal point:

- ✔ Put the darkest dark against the lightest light
- ✔ Increase the size
- ✔ Add more detail
- ✔ Brighten the color
- ✔ Sharpen the edges

1. **Get an 8-x-10-inch piece of watercolor paper. Transfer the drawing in Figure 13-1 to your paper.**

 Although I didn't plan this drawing, I give you a drawing to copy so you understand the technique. In your own leaf painting, you can choose to make a drawing or just wing it. If you choose to use the drawing here, enlarge it on a copy machine to the size you want and use watercolor paper in a corresponding size.

Figure 13-1:
A drawing to trace, enlarge, and transfer to watercolor paper.

2. **Activate your paints.**

 I used permanent yellow, antique brown, yellow ochre, burnt sienna, hookers green, rose madder, and cadmium orange.

3. **Wet the entire paper with clear water.**

 Use a 1-inch flat brush to quickly cover the paper with water so it stays damp.

4. **Paint the background by dropping in all the activated colors in a random pattern onto the wet paper to make an abstract multicolored background, leaving white paper on the left and softening edges.**

 Load a big round brush (I used a #12 brush) with juicy paint that can make large drops. Pick up the paper and let the colors move and mingle until you're satisfied.

 To soften the edges, add water to the edge to fade the color so it gets lighter and lighter. Turn to Chapter 3 for more on soft edges.

5. **Flick water droplets into the damp paint for texture.**

 You can dip your fingers in water and flick them, or use a spray bottle for this effect. You'll get blooms as described in Chapter 3.

 You should have something resembling Figure 13-2.

Figure 13-2:
A loose soft
background.

6. **Let the paint dry.**

7. **Negative paint the leaves and stems.**

 Mix a dark green from hookers green and alizarin crimson, and use it to paint behind the leaves and around the stems and leaf shapes as shown in Figure 13-3.

 Add water to the green areas between the leaves, and let the background green get lighter by adding water to the green as it reaches the edges of the paper.

 Drop in other colors as desired. I used antique brown and burnt sienna to break up the green. This negative painting defines the stems and leaves by painting where they aren't.

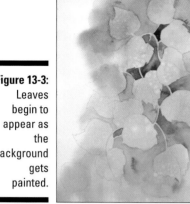

Figure 13-3:
Leaves begin to appear as the background gets painted.

8. **Positive paint some dark leaves against the light background.**

 Figure 13-4 shows the leaves I made darker using antique brown, burnt sienna, cadmium orange, and yellow ochre.

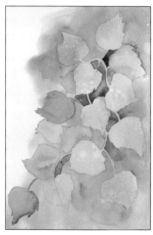

Figure 13-4:
More leaves appear in their darker fall colors.

9. **Paint some distant green leaves.**

 I added water to green and painted some leaves on the left edge a pale green to make them appear farther away.

10. **Use a liner brush to add details, such as veins in the leaves, and do any touch-ups.**

 I used burnt sienna for the veins. My final painting is shown in Figure 13-5.

Project: Grinning and Bearing It

Although I would like to say I met this bear in the Arctic, he was actually in the zoo. His oh-so-cute pose is what inspired the painting in this project.

This polar bear is white, but I painted him in a rainbow of colors. After all, white is the reflection of all colors. The cool blue tints bounce off the ice into the lower shadows. The warm light from the sun gives the fur a yellow cast from above. The bright light washes out the detail like an overexposed photograph. To make the critter really stand out, a dark background and foreground create contrast. There is a subtle reflection of the bear in the ice and water in the foreground.

Notice how the dark color runs diagonally from the upper left to the lower right just to keep the composition interesting.

1. **Get a piece of 6-x-6-inch watercolor paper and transfer the drawing in Figure 13-6 to your paper.**

 Chapter 8 tells you how to enlarge and transfer drawings to your watercolor paper.

2. **Activate your paints.**

 You'll need Antwerp blue (or Winsor blue, phthalocyanine blue, or antique bronze), lemon yellow, cerulean blue, burnt sienna, violet, burnt umber, cadmium red, yellow ochre, and ultramarine blue.

Figure 13-6:
A polar bear drawing for your copying pleasure.

3. **Paint the shadows on the bear, as shown in Figure 13-7.**

Using a #10 round brush, wet the body area in some diluted colors. I used cerulean blue, burnt sienna, violet, and lemon yellow. Use these very delicate pale colors under the chin, across the face including the eye socket, across the tummy, on the back foot, down the right front leg, and at the base of the left front leg.

Figure 13-7:
The bear's body reflects many colors, but still appears white.

4. **Paint the background while the shadows dry with strokes of wet-into-wet color.**

 Wet the background with clear water so it's damp but not puddley, and paint in soft-edged strokes of Antwerp blue, burnt umber, cerulean blue, and a tiny touch of cadmium red. I used a lot of water to dilute these bright colors, and you may not even see them in the printed background, but the colors add a little pizzazz. Mix lemon yellow with Antwerp blue for a green to add to the background. Refer to Figure 13-7 for guidance.

5. **Spatter water in the background and let it make blooms.**

 Chapter 3 talks about blooms; Chapter 4 covers spattering.

6. **Paint the foreground.**

 I wanted the foreground to look wet like ice and reflect the bear for interest and sparkle.

 A. Keep the middle area light because the white of the bear's body is reflected there.

 B. Paint Antwerp blue around the bear's reflection. Add water to make lighter blue. The foreground contains brownish-green ripples among the blue. To make this color, mix Antwerp blue and burnt umber. This color reflects the background. Paint the area wet-into-wet to get some blurred edges. I dropped in some diluted cadmium red in the foreground water in a couple of spots.

 You can let the area dry and make little long oval shapes that retain their hard edges. Follow Figure 13-8, but remember, it was painted quite spontaneously. Use the picture as a reference and just paint similarly for the same look. You can go crazy trying to copy exactly what took a few seconds to paint spontaneously.

 C. Make a *glaze* (layer of diluted paint) of yellow ochre and paint over the white reflection area. This makes the bear's white body be the brightest and most prominent object in the painting.

 Figure 13-8 shows the painted foreground.

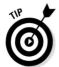

Work on one side or area of your painting at a time to make it manageable. Let one layer dry and paint another layer if needed. I painted the blue first, then the dark brown. After the foreground was all in and dry, I softened some lines by nudging them with a damp stiff bristle brush.

Figure 13-8:
A foreground reflects the bear.

7. **Paint the darks — the eye, nose, ear, mouth, claws, and the dark under the paws, tummy, and back foot.**

Make the black by mixing burnt sienna and ultramarine blue. Use your liner brush to add the finishing details and the smile on the face of your polar bear. See Figure 13-9 for guidance.

Figure 13-9:
The final polar bear smiles.

Project: Lighting the Way to the Lighthouse

This painting shows a different style of lighthouse architecture. It isn't the typical tall cylinder.

I placed the lighthouse in the upper third of the page and wanted a very simple lead-in to the center of interest. I loosely painted flowers with more detail in the near foreground, and I used salt to form flowers in the grassy

foreground. I got lucky in that the salt cooperated and produced larger blooms the closer they get to the viewer. Yes, lucky. You can manipulate watercolor to your will, but sometimes you benefit from a little luck as well.

To capture this lighthouse, follow these steps:

1. **Get a piece of 8-x-10-inch vertical watercolor paper and enlarge and transfer the drawing in Figure 13-10.**

 Chapter 8 tells you how to trace, enlarge, and transfer the drawing onto watercolor paper.

2. **Activate your paints.**

 I used burnt sienna, yellow ochre, hookers green, cerulean blue, light red, alizarin crimson, and ultramarine blue.

Figure 13-10:
The foundational drawing for a lighthouse scene.

3. **Underpaint the first layer of the meadow by wetting the area of the grass below the lighthouse with brush loads of clear water. With a large round brush, paint some burnt sienna and yellow ochre and let the colors flow into the wet areas (see Figure 13-11).**

 Make the edges soft by adding water toward the edge of the painted area to make the grass fade out as it approaches the bottom right, which remains white in the final painting.

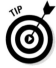

 The unpainted area allows viewers to imagine something of their own. It's a little different. The technique has won prizes at art shows for me (judges like something different), but if it's not your cup of tea, just make the white space into a road or more flowers and grass.

4. **Let the paint dry**.

5. **Wet the same area and paint it with green.**

 Soften the edges and allow some darks and light. When the shine is about to disappear, sprinkle some salt on the paint to create texture. (See Chapter 4 for more about the salt technique.)

Figure 13-11:
Yellow ochre and burnt sienna mingle for an under-painting.

6. **Let everything dry.**

 Your painting should look something like Figure 13-12 after you brush off the salt.

 If the salt doesn't work, you can always try again or spatter paint for some texture instead. (Spattering is covered in Chapter 4.)

Figure 13-12:
Green paint and salt make a textured foreground.

7. **Dampen the area of the sky with clear water and then stroke in some cerulean blue.**

 Leave some white for clouds, but paint blue sky over the lighthouse dome.

8. **While the sky is still damp, paint the distant mountains at the horizon with a purpley-gray mix of alizarin crimson, ultramarine blue, and a bit of burnt sienna (see Figure 13-13).**

 Keep the top of the mountain soft, which is easy to do because the paper is damp.

Figure 13-13: Sky and land make a background.

9. **Paint the gray areas on the lighthouse.**

 Mix a blue-gray from ultramarine blue and burnt sienna. Paint the dark of the dome at the top; then add water for a lighter gray, and paint the shadows on the side of the building, as shown in Figure 13-14.

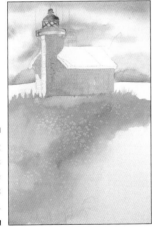

Figure 13-14: Shadows define the building's planes.

10. **Paint the red roof and the blue ocean (see Figure 13-15).**

 Mix a dirty red from burnt sienna, alizarin crimson, and the gray mixture you used in Step 9. Light red is a similar color if you have it. Paint the roof, including the left edge and the box on the top.

Paint cerulean blue in the two ocean areas on either side of the lighthouse. Paint a strip of blue at the horizon and add water to your paint as you come down for a graded wash of dark to light blue ocean.

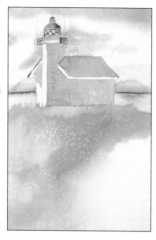

Figure 13-15:
A red roof adds color next to the near-complementary blue ocean.

11. **Finalize the details.**

Paint the windows, the rods, doors, shingles, and siding with the dark gray. Paint grass both positively and negatively at the same time by making a grass mound. First, paint lines that look like grass using a liner brush and dark green paint (mix some alizarin crimson into hookers green); on the bottom edge of the grass, zigzag your brush to make the area around the grass. You just painted two lines of grass at the same time. The positive grass is darker green and the negative grass is lighter because of the dark background.

The stylized flowers are dots of cerulean blue, purple (mix cerulean blue and alizarin crimson, or use a purple if you have one), and yellow. See Figure 13-16 for guidance on these details.

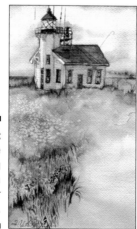

Figure 13-16:
A lighthouse has long been a symbol for guidance.

Project: Rainbow Horse Stampede

Get out all your colors for this one! The wading horses are essentially a trip around the color wheel. The painting may look very complicated, but it's pretty easy to execute. You use masking fluid and repeat the horse shape, choosing one horse on the right as the *focal point* or center of interest. I took a bit more time to detail the red horse so that it commands the viewer's attention. The other title for this piece is *Led by Red*.

1. **Get a piece of paper 11 inches x 4 inches and transfer the drawing in Figure 13-17 to your watercolor paper.**

 Chapter 8 tells you how to trace, enlarge, and transfer the drawing onto watercolor paper.

2. **Paint masking fluid over the dark areas of the horses and their reflections — the black areas in the drawing.**

 I used a masking pen with a super-fine nib. Figure 13-18 shows the masked area as blue, which is the color of this mask. The blue mask is protecting the white paper. (Refer to Chapter 4 for tips on masking.)

Figure 13-17: Get a running start on your painting by transferring this drawing to watercolor paper.

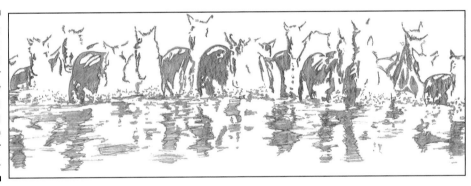

3. **Let the mask dry completely.**

 I let mine dry overnight. Depending on how thick your mask is, it may dry quicker, within 15 to 20 minutes even.

 Don't try to speed the drying process by using a blow-dryer. You'll just cook the mask into the paper so that it will never come off.

4. **Spray water on your entire palette to activate all your paints.**

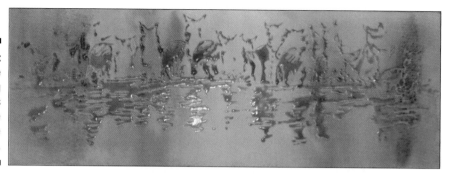

Figure 13-18:
Blue masking fluid covers the white areas of the horses.

5. **Dampen the entire paper with clear water, then use a flat brush to paint vertical stripes in this order from left to right: hookers green, ultramarine blue, alizarin crimson, cadmium red, cadmium orange, permanent yellow, cadmium orange, cadmium red, alizarin crimson, ultramarine blue, and hookers green.**

Let the colors flow together and overlap. If the paper dries, spray it with water and tip the paper so the paints blend. Your painting should look something like Figure 13-18 at this point.

6. **Let the paint get dry — bone dry.**

Again, keep the blow-dryer far away.

7. **Remove the masking fluid by using a rubber cement pickup to rub it off.**

You can get pickups at the same art supply store where you get the masking fluid.

Your painting now looks close to Figure 13-19.

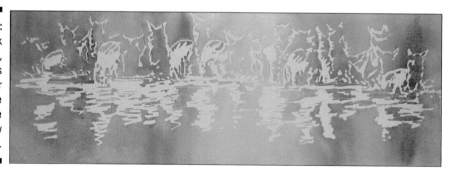

Figure 13-19:
When mask is removed, the horses appear white against the rainbow background.

8. **Paint some clear water over the stark white horses and their reflections in the water.**

If the white is too bright, you can paint a diluted version of the same color over the top (find more on glazing in Chapter 3). Because water reflections are grayer and less detailed than what they reflect, I worked with the reflections more than the horses. This involved tinkering a bit in the water by lifting some areas and glazing over other areas that I thought were too bright.

9. Add detail and soften some hard edges.

Use a brush with a good tip for your detail work. Darken the horse shapes using a darker version of the same color (use less water for darker paint). Notice that all the dark areas are on the right side of the horses. This makes it look like light is entering from the left side of the picture, and the consistency in lighting helps create the dramatic illusion.

I picked the horse in the right third of the paper to be the center of interest. I made it the brightest red, gave it the hardest edges, and added the most details.

I used a toothbrush to scrub some of the water reflections to make a variety of edges. Adjust the painting until you like the result; I'm very fond of the result in Figure 13-20.

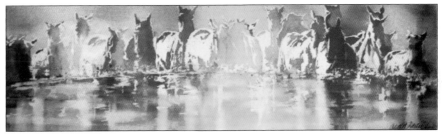

Figure 13-20:
The final stampede, *Led by Red.*

Part IV
The Part of Tens

In this part . . .

The chapters in this traditional *For Dummies* part give you tips on quick ways to improve your painting and ways to promote and market your art.

Chapter 14

Ten Quick Ways to Improve Your Art

In This Chapter

▶ Investing in your tools

▶ Refining your skills

▶ Bettering yourself

As you grow in your art, you may hit a plateau. You may need a kick-start for inspiration or wonder how to improve your art skills. Read the list in this chapter whenever you need a boost. The good news is there are lots of ideas to push you to the next level.

Buy Better Art Supplies

Possibly *the* easiest ways to get better is to upgrade your art supplies. You do get what you pay for. A well-cared-for sable brush can last your whole career and produce the same fine lines on its last day of work as on its first. A better grade of paper helps give your paintings depth and texture. More expensive paints produce richer colors. (Chapter 2 talks about supplies.)

Practice, and Then Practice Some More

How do you get into the Metropolitan Museum of Art? Practice, child!

Improve your drawing skills. Draw every day. Keep a sketchbook and use it. Set up a studio space you use only for creating art. Paint every day. Paint from life. (Chapter 8 covers drawing, and Chapter 2 talks about painting habits.)

Study the Experts

Why reinvent the wheel? Find out what already exists and what is left to say with watercolor.

Take workshops. Watch how-to videos. Read art books. Visit art galleries. Join an art club. Subscribe to an art magazine. Look up art sites on the Internet. Take a life drawing class. Copy an old master work for study. Ask advice from experts. Study with a master. Do the exercises in a how-to book. Explore art movements in history. Read biographies of other artists.

Dig Deeper

Dig within you. You are the only one with your unique perspective.

Observe your subject and really "see" the details. Think of a title that captivates the audience even before you paint. Incorporate symbolism. Tell a story. Communicate. Incorporate feelings. Create mood. Illustrate a cause. Paint what you know. Research your subject.

Make Use of Composition and Design

Design your composition before painting. Plan a color scheme. Plan and use a value pattern. Use thumbnail sketches. Make sure to include a center of interest. Obey the laws of perspective in realistic landscapes. Balance the painting. Take the image all the way to the edge of the paper. Use thick and thin and broken lines. Simplify, simplify, simplify. Make more gradation. Variety, variety, variety. Make no two shapes the same. (Chapter 7 has details on good composition.)

Nurture Your Inner Artist

Watch a sunset. Appreciate beauty. Visit local galleries and museums wherever you are. Put a professional mat and frame on your paintings. Wonder at the world. Collect art you admire. Listen to Mozart. (His symphonies are linked to creative brain stimulation.) Travel for new discoveries and perspectives. Buy a new color of paint just because you like it.

Tend to Your Creature Comforts

Make your work area ergonomic and comfortable. Clean your palette before putting on fresh colors. Set up your painting area in a room with a view. Play your favorite music while you paint. Find a painting coverall you like to wear over your clothes. (Chapter 2 gives advice on setting up your painting area.)

Spark Your Creativity

Look for an unusual angle. Try a new tool or technique. Drink CreativiTea, a blend of herbs said to boost your creativity — look in health food stores. Look at the painting in a mirror. Create a series of related paintings. Portray an odd number of items. Choose a theme. Turn the painting upside down. Zoom in. Include an element of surprise. Wear an amethyst, a gem linked to creativity. Have a camera handy at all times for unexpected subject opportunities. Step away from the painting and look at it from a distance. Create something totally new.

Improve Your Technique

Layer paint. Change colors every inch. Use economy of brush strokes. Loosen up. Add interesting shadows. Leave some white paper for sparkle. Observe light and shadow. (Chapters 3 and 4 offer a variety of techniques to try.)

Pass It On

Teach someone a technique. Show a child how to watercolor. Start a critique group with other artists. Organize a show just for yourself or for your painting group — it's a wonderful motivation to keep painting. (Chapter 15 has tips on how to promote your art.)

Chapter 15

Ten (Plus One) Tips for Marketing Your Art

So you made your first piece of art that you think maybe someone will pay you money for. It's burning a hole in your easel, and you're ready to sell it for a million bucks. All you hear in the media is how art brings millions at the East Coast auction houses. Well, hang on for a minute. Although it's possible to sell art and make a living as an artist, it usually doesn't come quickly. Before you go out to sell your first painting, make a hundred more. Then you have a little experience behind you and an inventory in front of you.

On the other hand, you may not want to show your paintings to anyone. You don't have to show them or sell them. They may be just for you. The same advice applies. Make a hundred paintings. See how you feel after looking at them. Spread them out in the privacy of your own space. Then decide if you're ready to share them with the world or you still need to explore your own direction.

If you're going to show your paintings to the public, they should be presented properly, usually in a mat with glass and a frame. See Chapter 3 for more on presentation. Some shows and galleries have specific rules regarding how work should be presented.

Don't forget to photograph your art before you part with it. Better yet, take a snapshot before it goes behind glass. You want to have a record of all your masterworks for your portfolio.

Figure Out How to Price Your Work

Every artist wants to know: How much should I ask for my art? How do you put a price on your heart and soul? Well, first it's impossible. Second, here's how. Some of the things to consider when you price your art include:

- ✔ **Market:** Visit galleries and art shows to see what amounts similar pieces bring. I said "bring," not "ask." Be realistic if you want to sell. Look at your own spending habits. What do you spend when buying art? That's probably what your neighbor wants to spend as well.

- ✔ **Your reputation:** If you're a famous artist with lots of experience, you can charge more.

- ✔ **Presentation:** Factor in the cost of framing and matting.

- ✔ **Size:** Size matters, so consider how big the piece is. Some artists even have a square-inch formula, so a larger painting costs more to purchase.

- ✔ **The pedigree of the piece:** If the painting won a prize or is better than most you've done or most other works of its type, put a higher price tag on it.

Start with Local Clubs

Almost every community has a local art club, association, or guild. Go visit the group and maybe even join. Even better, volunteer to help with a show the group is sponsoring. Actually working at such an event gives you tremendous insight to what goes on and what you can do to make the process easier for yourself. Most shows have an entry form. Read and follow the rules. Sounds easy, but many artists don't do either. By preparing your work ahead of time as the show rules dictate, you can deliver work to the show in a minimum amount of time and make the show committee grateful.

Associations have field trips, workshops, classes, and programs to inspire you to be your best. And the people who run these organizations have the best leads on shows to enter.

Decide between Solo or Group

Decide whether you have enough work to hang a show by yourself or whether you're better off working with other artists to share the event. Others can help share publicity, hanging, reception catering, expenses, and framing for enough artwork to cover the walls.

My advice is to work your way up to a solo show. Start by entering group shows. If you want more opportunities for the public to see your work, organize a group show. When you're ready and have enough framed work, have a solo show.

Stay at Home (Or Use a Friend's Home)

Invite your friends and relatives and their friends and relatives to a cozy evening with the artist where you can talk about your art and sell a few pieces.

It doesn't even have to be your home! Do you have a friend who wants to support the arts and has a nice house? Ask him to host an at-home exhibition of your work.

At some point, you may just need to clean out the clutter, and an outdoor sale in your own yard can be just the ticket (or tag, if you're having a tag sale). I know an artist who had a quick sale on the lawn and sold quite a few paintings. You can share your work for a bargain price and spread art to those who may not be able to afford big prices. That doesn't mean that your painting is valued less by an owner. Art patrons know they have received a gift and may appreciate the opportunity to own original art.

Partner with a Business

You can send a press release to the local news media about a business-related exhibition. I just had a show at the local auto dealership because I recently finished a series of car paintings. The business got a newsworthy item to promote and bring in more customers, and I got to sell some paintings to appreciative buyers.

Some businesspeople are very good at this sort of joint venture on a more intimate scale. For example, your friendly real estate agent wants to thank clients in a social setting. You and the agent send out private invitations, you hang your art around her office, and new homeowners snatch it up for their new walls!

Get into Local Institutions

The big buildings that abound in your community have a lot of wall space and often attract large numbers of people. Some places to think about include:

✔ **Places of worship:** Churches, synagogues, and temples often have large areas with empty walls and have been one of the best supporters of the arts throughout history. Your own church may enjoy hosting a group show for its members or a solo show just for you. Make the show's theme "exploring spirit" or something else appropriate for the venue.

✔ **Colleges or universities:** Any school that has a visual arts program generally has gallery space, and you don't have to be a student to exhibit in it. Near me, the University of Northern Colorado has several galleries, as does the local community college. I help coordinate one gallery located

in the school library funded by a memorial trust and a friends of the library group. If your community doesn't have visual arts programs available, start a program that appeals to you and other artists.

✔ **Hospitals:** Hospitals these days often hire an interior decorator to put art on the walls, but if that hasn't happened yet in a facility near you, try to make use of the great hallways to hang your work. And, like your local coffeehouse, the hospital may host different works on a rotating basis.

A hospital employs a large number of people, and the staff alone makes a large audience for your work.

✔ **Libraries:** Library groups often host art shows. Some have a specific wall for showing. Easels can fit anywhere and don't leave nail holes in the walls. Incorporate words or books in the paintings for a literary theme.

Institutions are always looking for newsworthy events to bring in more people. An art show can do this.

Sip and Sell

Coffee shops usually need some nice work and are great social hangouts where people can see your art. Locally owned java joints are often especially friendly to local artists and often schedule rotating exhibitions of artwork for customers to enjoy and purchase.

Likewise, restaurants are a good place to be seen. If you don't mind some occasional ketchup splashed on your work, these can be a good venue. And to prevent the ketchup from doing serious harm, make sure your paintings are protected with proper frames and glass. You can do a themed show and paint still lifes of food.

Hit the Festivals and Shows

Many cities across the country host an outdoor art festival. I spend many weekends at such events. They take a tremendous amount of work, but after doing them for a number of years, they've become one of my best sources of income.

It may take a few shows to get established. I think the only thing that really pays off is persistence. Don't give up, even though you may want to often.

At an art show, an organizing group hosts it, charges the artists an entry fee, and provides the space to show your work. Anyone can host a show: art clubs, schools and universities, towns, housing developments, businesses.

Some shows are *juried,* which means that someone, or a group of someones, decides on the artists accepted for the show. If they don't choose you, you can't sell your masterpieces there. Juried shows usually judge for prizes as well.

Because of the large number of artists trying to get included in the big-deal shows, it can be almost a lottery to get accepted. But keep playing and one day you'll win this lottery! To increase your chances, go to shows and see what the jury picks. Remember the juror is only human, has moods, and has an impossible job of narrowing a field of 500 artists to just 100. Tough choices have to be made.

To enter a juried show, you usually have to send 35mm slides or digital images of your work or hand deliver your work itself. Shows often have size minimums and maximums, framing restrictions, and media or subject restrictions (no nudes for example). It all depends on the show. Read the entry form closely and follow all the rules to the letter. Some artists are rejected simply because they don't follow the rules.

Approach Galleries

When you think of selling art, you may immediately think of an art gallery. But before you approach a gallery, you must be prepared. You need a collection of work that embodies a style. You need to be marketable in that the gallery owner thinks he can sell your work.

The gallery may promote your work. In return, the gallery keeps a percentage of the sales, anywhere from 25 percent to 60 percent. Galleries have tremendous overhead, and the cut they take helps keep their doors open. They also have access to buyers, usually lots and lots of buyers.

Co-op galleries, or cooperative galleries, are usually run by a group of artists who share the expenses and work of running a gallery.

Auction Online

E-Bay is probably the biggest seller online, but others are out there too. Search "art sales" for the latest group of online sales sites.

In my frame shop, I have noticed that more people are bringing in art they bought online. Internet sales are increasing. It may be a great way to get started.

I have sold art online, but usually the shoppers are looking for a bargain. You also must worry about shipping — the costs, the logistics — if you sell to buyers around the world.

Connect with Unexpected Venues

This may sound odd, but look for places to show your art that complement the art. Use your artistic creativity to think of places that fit with a group of paintings. Keep in mind that you're not imposing on the makeshift art venue; you're actually providing a service in giving your host an event that helps raise awareness of the business or organization.

Approach a nature center, an animal shelter, a bookstore, a childcare center, a sporting goods store — you name it. The places to show your art are limited only by your creativity.

Index

• T •

Notes

Notes

Notes

Notes

Notes

Notes

BUSINESS, CAREERS & PERSONAL FINANCE

0-7645-9847-3

0-7645-2431-3

Also available:
- Business Plans Kit For Dummies
 0-7645-9794-9
- Economics For Dummies
 0-7645-5726-2
- Grant Writing For Dummies
 0-7645-8416-2
- Home Buying For Dummies
 0-7645-5331-3
- Managing For Dummies
 0-7645-1771-6
- Marketing For Dummies
 0-7645-5600-2

- Personal Finance For Dummies
 0-7645-2590-5*
- Resumes For Dummies
 0-7645-5471-9
- Selling For Dummies
 0-7645-5363-1
- Six Sigma For Dummies
 0-7645-6798-5
- Small Business Kit For Dummies
 0-7645-5984-2
- Starting an eBay Business For Dummies
 0-7645-6924-4
- Your Dream Career For Dummies
 0-7645-9795-7

HOME & BUSINESS COMPUTER BASICS

0-470-05432-8

0-471-75421-8

Also available:
- Cleaning Windows Vista For Dummies
 0-471-78293-9
- Excel 2007 For Dummies
 0-470-03737-7
- Mac OS X Tiger For Dummies
 0-7645-7675-5
- MacBook For Dummies
 0-470-04859-X
- Macs For Dummies
 0-470-04849-2
- Office 2007 For Dummies
 0-470-00923-3

- Outlook 2007 For Dummies
 0-470-03830-6
- PCs For Dummies
 0-7645-8958-X
- Salesforce.com For Dummies
 0-470-04893-X
- Upgrading & Fixing Laptops For Dummies
 0-7645-8959-8
- Word 2007 For Dummies
 0-470-03658-3
- Quicken 2007 For Dummies
 0-470-04600-7

FOOD, HOME, GARDEN, HOBBIES, MUSIC & PETS

0-7645-8404-9

0-7645-9904-6

Also available:
- Candy Making For Dummies
 0-7645-9734-5
- Card Games For Dummies
 0-7645-9910-0
- Crocheting For Dummies
 0-7645-4151-X
- Dog Training For Dummies
 0-7645-8418-9
- Healthy Carb Cookbook For Dummies
 0-7645-8476-6
- Home Maintenance For Dummies
 0-7645-5215-5

- Horses For Dummies
 0-7645-9797-3
- Jewelry Making & Beading For Dummies
 0-7645-2571-9
- Orchids For Dummies
 0-7645-6759-4
- Puppies For Dummies
 0-7645-5255-4
- Rock Guitar For Dummies
 0-7645-5356-9
- Sewing For Dummies
 0-7645-6847-7
- Singing For Dummies
 0-7645-2475-5

INTERNET & DIGITAL MEDIA

0-470-04529-9

0-470-04894-8

Also available:
- Blogging For Dummies
 0-471-77084-1
- Digital Photography For Dummies
 0-7645-9802-3
- Digital Photography All-in-One Desk Reference For Dummies
 0-470-03743-1
- Digital SLR Cameras and Photography For Dummies
 0-7645-9803-1
- eBay Business All-in-One Desk Reference For Dummies
 0-7645-8438-3
- HDTV For Dummies
 0-470-09673-X

- Home Entertainment PCs For Dummies
 0-470-05523-5
- MySpace For Dummies
 0-470-09529-6
- Search Engine Optimization For Dummies
 0-471-97998-8
- Skype For Dummies
 0-470-04891-3
- The Internet For Dummies
 0-7645-8996-2
- Wiring Your Digital Home For Dummies
 0-471-91830-X

*** Separate Canadian edition also available**
† Separate U.K. edition also available

Available wherever books are sold. For more information or to order direct: U.S. customers visit www.dummies.com or call 1-877-762-2974.
U.K. customers visit www.wileyeurope.com or call 0800 243407. Canadian customers visit www.wiley.ca or call 1-800-567-4797.

SPORTS, FITNESS, PARENTING, RELIGION & SPIRITUALITY

0-471-76871-5

0-7645-7841-3

Also available:

- Catholicism For Dummies
 0-7645-5391-7
- Exercise Balls For Dummies
 0-7645-5623-1
- Fitness For Dummies
 0-7645-7851-0
- Football For Dummies
 0-7645-3936-1
- Judaism For Dummies
 0-7645-5299-6
- Potty Training For Dummies
 0-7645-5417-4
- Buddhism For Dummies
 0-7645-5359-3

- Pregnancy For Dummies
 0-7645-4483-7 †
- Ten Minute Tone-Ups For Dummies
 0-7645-7207-5
- NASCAR For Dummies
 0-7645-7681-X
- Religion For Dummies
 0-7645-5264-3
- Soccer For Dummies
 0-7645-5229-5
- Women in the Bible For Dummies
 0-7645-8475-8

TRAVEL

0-7645-7749-2

0-7645-6945-7

Also available:

- Alaska For Dummies
 0-7645-7746-8
- Cruise Vacations For Dummies
 0-7645-6941-4
- England For Dummies
 0-7645-4276-1
- Europe For Dummies
 0-7645-7529-5
- Germany For Dummies
 0-7645-7823-5
- Hawaii For Dummies
 0-7645-7402-7

- Italy For Dummies
 0-7645-7386-1
- Las Vegas For Dummies
 0-7645-7382-9
- London For Dummies
 0-7645-4277-X
- Paris For Dummies
 0-7645-7630-5
- RV Vacations For Dummies
 0-7645-4442-X
- Walt Disney World & Orlando
 For Dummies
 0-7645-9660-8

GRAPHICS, DESIGN & WEB DEVELOPMENT

0-7645-8815-X

0-7645-9571-7

Also available:

- 3D Game Animation For Dummies
 0-7645-8789-7
- AutoCAD 2006 For Dummies
 0-7645-8925-3
- Building a Web Site For Dummies
 0-7645-7144-3
- Creating Web Pages For Dummies
 0-470-08030-2
- Creating Web Pages All-in-One Desk
 Reference For Dummies
 0-7645-4345-8
- Dreamweaver 8 For Dummies
 0-7645-9649-7

- InDesign CS2 For Dummies
 0-7645-9572-5
- Macromedia Flash 8 For Dummies
 0-7645-9691-8
- Photoshop CS2 and Digital
 Photography For Dummies
 0-7645-9580-6
- Photoshop Elements 4 For Dummies
 0-471-77483-9
- Syndicating Web Sites with RSS Feeds
 For Dummies
 0-7645-8848-6
- Yahoo! SiteBuilder For Dummies
 0-7645-9800-7

NETWORKING, SECURITY, PROGRAMMING & DATABASES

0-7645-7728-X

0-471-74940-0

Also available:

- Access 2007 For Dummies
 0-470-04612-0
- ASP.NET 2 For Dummies
 0-7645-7907-X
- C# 2005 For Dummies
 0-7645-9704-3
- Hacking For Dummies
 0-470-05235-X
- Hacking Wireless Networks
 For Dummies
 0-7645-9730-2
- Java For Dummies
 0-470-08716-1

- Microsoft SQL Server 2005 For Dummies
 0-7645-7755-7
- Networking All-in-One Desk Reference
 For Dummies
 0-7645-9939-9
- Preventing Identity Theft For Dummies
 0-7645-7336-5
- Telecom For Dummies
 0-471-77085-X
- Visual Studio 2005 All-in-One Desk
 Reference For Dummies
 0-7645-9775-2
- XML For Dummies
 0-7645-8845-1